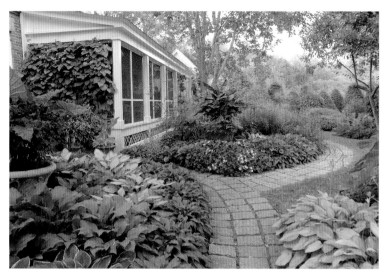

the inspired garden

TWENTY-FOUR ARTISTS SHARE THEIR VISION

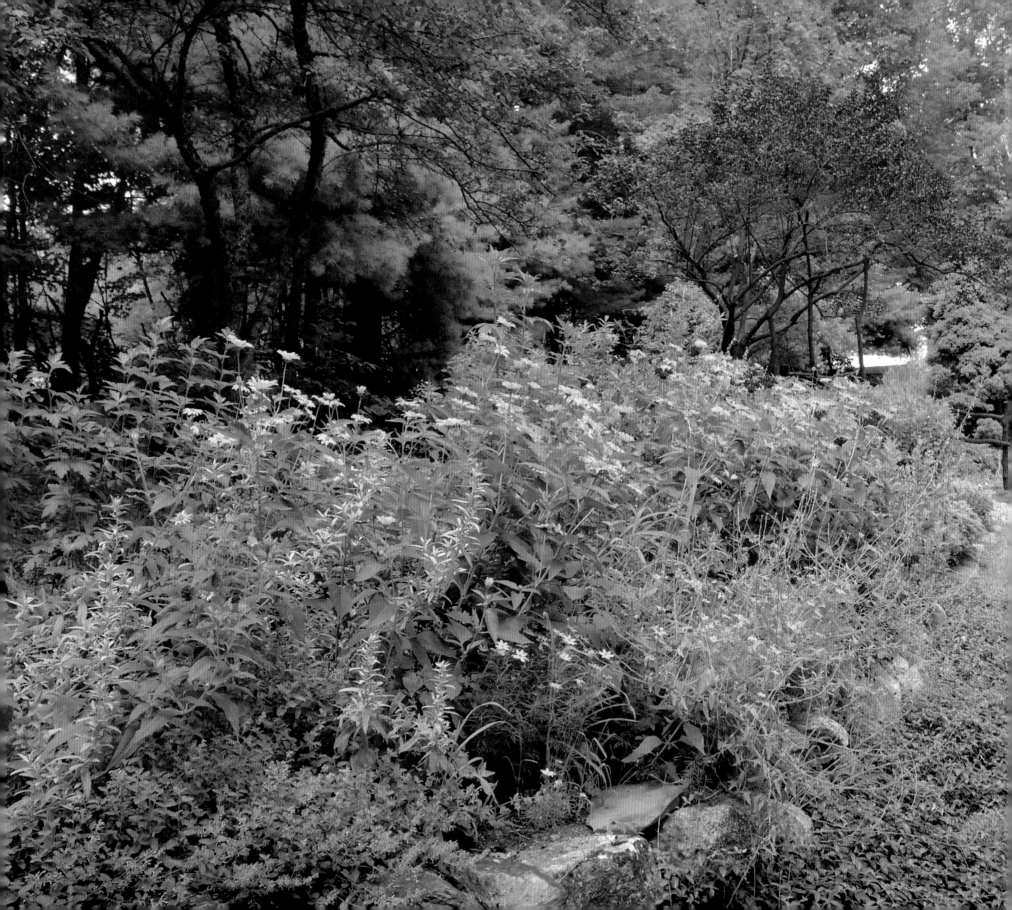

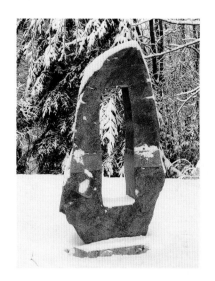

the inspired garden

TWENTY-FOUR ARTISTS SHARE THEIR VISION

JUDY PAOLINI NANCE TRUEWORTHY

Down East

Design by Judy Paolini
Printed in China

OGP 5 4 3 2 1

LIBRARY OF CONGRESS
CATALOGING-IN-PUBLICATION DATA

Paolini, Judy, 1953-
 The inspired garden : 24 artists share their
vision / Judy Paolini ;
photographs by Nance Trueworthy. -- 1st ed.
 p. cm.
ISBN 978-0-89272-737-7 (hc : alk. paper)
1. Artists' gardens--New England. 2. Gardens--
New England--Design. I. Trueworthy, Nance.
II. Title.
SB473.P29 2009
712'.6--dc22

 2008028815

Down East
BOOKS·MAGAZINE·ONLINE
w w w . d o w n e a s t . c o m

Distributed to the trade
by National Book Network

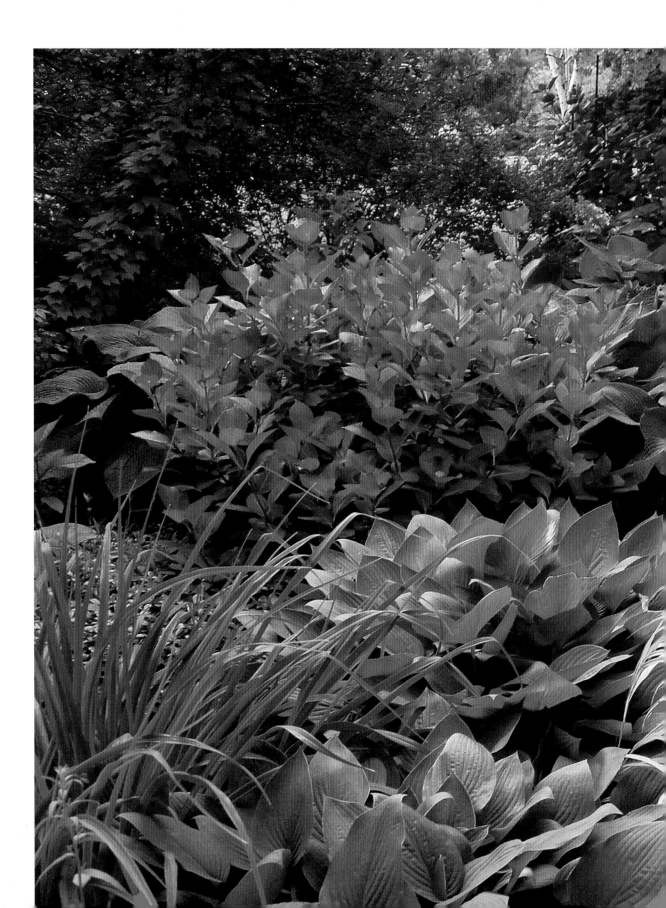

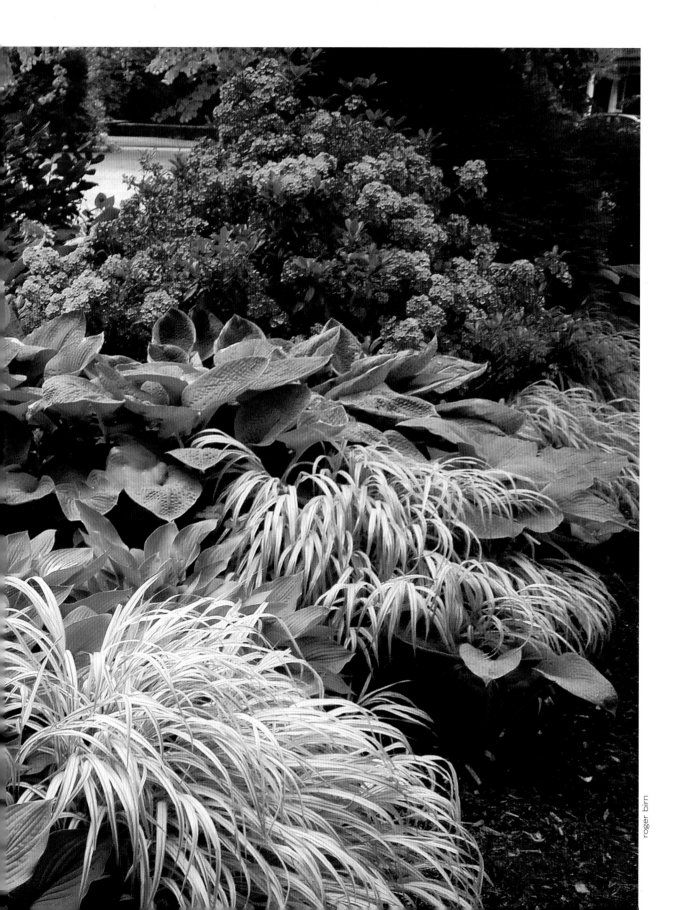

roger birn

To my father, Henry Paolini, from whom I inherited not only my gift of gab but also my love of hydrangeas and peonies. He dug my first garden and, despite any evidence to the contrary, always believed I could make it grow. —JP

Life has bestowed me with many blessings, the biggest one being my family. I dedicate this book to you, my entire family, with all my love. —NT

A summer border in Kay Ritter's garden

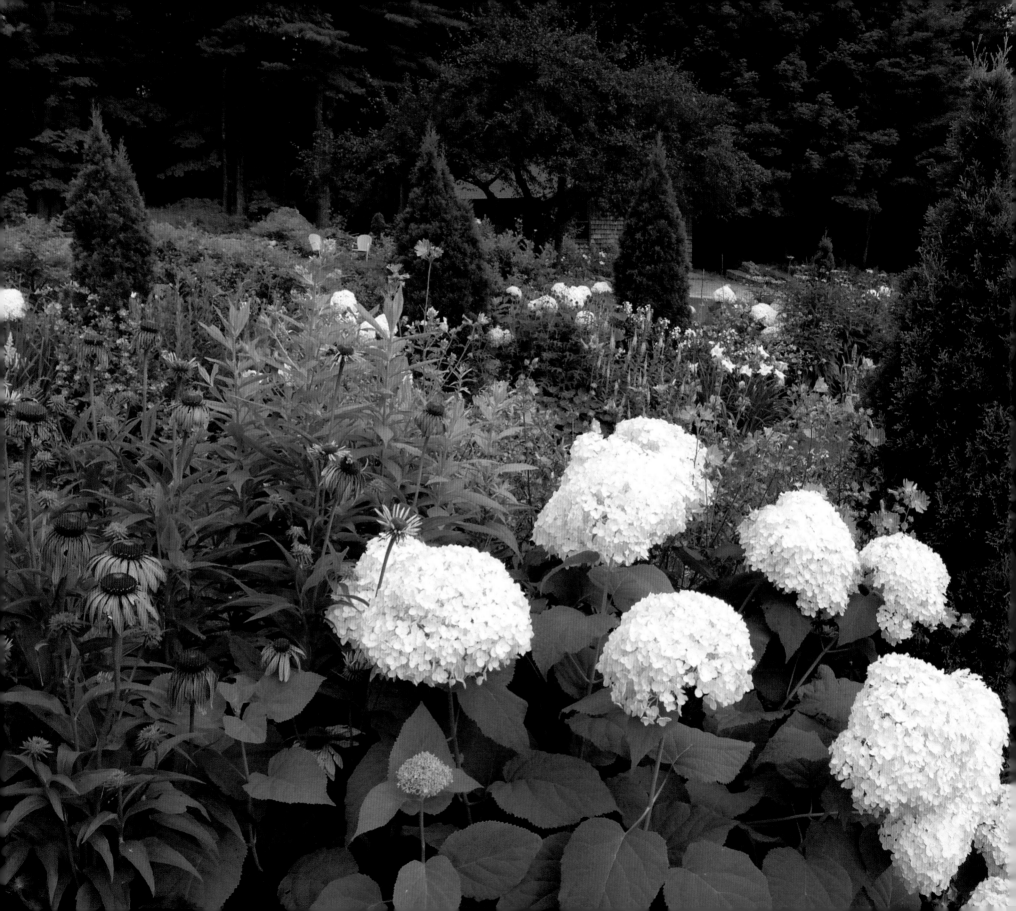

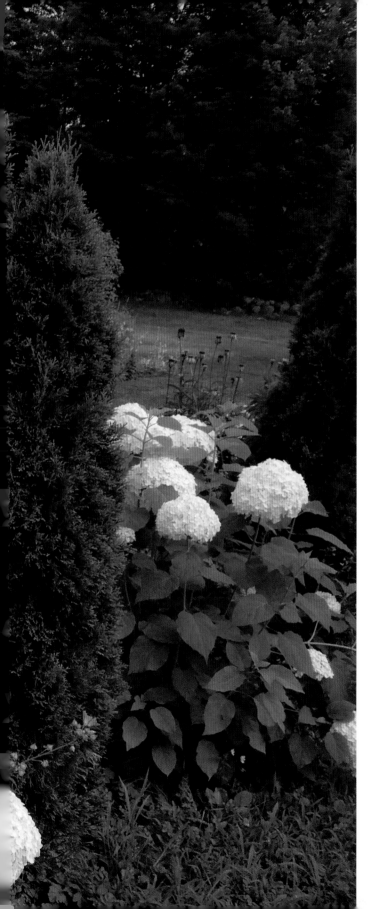

Contents

Annabelle hydrangeas fill the *petite allée* in the
New Hampshire garden of James Aponovich and Beth Johansson.

"Show me your garden and I shall
tell you what you are."

—Alfred Austin

The front walkway to Maggie Foskett's home

Introduction

"Art is the unceasing effort to compete with the beauty of flowers and never succeeding."

—Marc Chagall

Many books have been written about artists' gardens—entire volumes on the most famous: Claude Monet's Giverny, Pierre-Auguste Renoir's garden at Les Collettes, Paul Cezanne's in Les Lauves. So much is known about these gardens that they are now inseparable in our minds from the artists' work.

Later-twentieth-century artists have also been recognized for their magnificent landscapes, courtyards, details, and vistas. Isamu Noguchi's Mure challenges our definition of garden with its minimalist design. Niki de Saint Phalle built her imaginative Tarot Garden from glazed ceramic, mirror fragments, and handblown glass. Frida Kahlo's cobalt-walled home, studio, and gardens at Casa Azul, in Mexico City, reflect the same strong cultural identity evidenced in her paintings. Sculptor Barbara Hepworth used her gardens in Cornwall, England, as an open-air studio and viewing area for her monumental bronze abstracts. Contemporary artist Jennifer Bartlett's multi-level rooftop gardens in Greenwich Village were frequently the subject of her large oil paintings, and a year in her native wetland garden in Amagansett, on Long Island, is depicted in a more recent series of pastel drawings.

Artists bring their visual acuity and innate sense of design to the garden, but they also bring a certain fearlessness, a penchant for experimentation, a willingness to break established gardening "rules" in order to achieve a particular effect. These are often the same characteristics they bring to their art. For the most part they approach garden layout not from a horticultural perspective but from a purely aesthetic one, often eschewing established wisdom on everything from plant combinations and color schemes to hardscaping materials and even garden location. When the need to work from a very personal point of reference outweighs conventions, the results can be quite spectacular.

Gardens continue to be a source of inspiration and a means of expression for artists living and working today—with no less spectacular results than those of their predecessors. In this book we explore the gardens of several extraordinary artists located throughout New England. The beauty and serenity of the region has long been a strong draw for creative individuals. The painters, sculptors, and print-makers, and the ceramic, conceptual, and multi-media artists represented here work in a wide range of materials,

and their art is as different from one another's as are their gardens. But they share a common sense of connectedness to the natural world, a desire to honor and preserve the region's agricultural and horticultural heritage, and a need to express themselves beyond the confines of the studio. They also share an appreciation for the sense of balance that the New England seasons offer.

Summer is the shortest and most treasured season here, concentrating the work and pleasure of gardening into a few months. Many of the artists build their lives around this inevitability—some saving the days of the growing season for the gardens while spending the long winters in the studio. Others take advantage of the warmth and inspiration of the gardens to produce the bulk of their work in summer. This work may exhibit direct reference to the gardens, or it may not. But in all cases the interplay of idea and expression is evident in both pursuits, whether the artist is consciously aware of it or not. We hope this constant, sometimes silent dialogue carried on in the common language of art and garden will inspire readers to search their own personal vocabulary for new ideas for their own gardens.

Maggie Foskett
a small marvel

With steady hands, Maggie Foskett carefully arranges a small piece of red leaf lettuce and a lacy maple seed between two thin squares of glass and holds them up to the light. "I'm nearsighted, so I always need to look closely at things. If something has a vibrant color or unusual shape, I want to pick it up and touch it. They're really small marvels—when I find them I like to record them."

In her darkroom on Florida's Sanibel Island, Maggie spends the winter creating images with a cameraless photographic technique called *cliché-verre*. In a tiny rectangle of glass the size of a 35mm slide, she layers found bits of nature and begins the arduous process of transforming them into large, brilliant Cibachrome prints.

"With photography, I think you're missing something if you don't fool around in the darkroom," Maggie says. She took up photography at the age of fifty-seven and became interested in *cliché-verre* almost immediately. Developed by William Fox Talbot in the early 1800s, the technique originally involved drawing on glass and using sunlight to make a direct print onto light-sensitive paper. Maggie has adapted the technique using an enlarger to capture the colors and details of translucent organisms in compositions that magnify their unexpected patterns and surprising beauty. Over the years she has

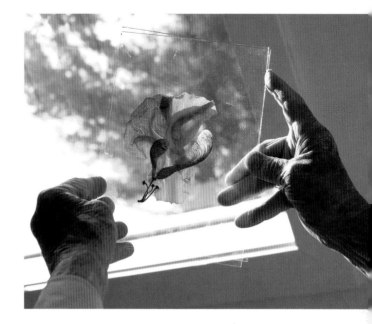

varied the process to include the use of contact-printed X-rays. When utilizing organic material such as a luna moth, she must work quickly and precisely because her chosen material will soon deteriorate, resulting in only one or just a few final prints.

With the same exacting eye and sensitivity to nature's form and detail, Maggie has composed a small marvel of a garden within the rectangular boundaries of her summer residence in Camden, Maine. When Maggie and her husband, John, moved here in 1983, the backyard was a patch of grass. Maggie laid out the plan for her Japanese-inspired garden with string, then hired a down east

LEFT: From Maggie's second-floor studio the view into her back garden is framed by the dense greenery of Weeping Elm, rhododendron, euonymus, and a single Japanese white pine.

RIGHT: Choosing objects with translucent properties, Maggie enlarges them in her prints to reveal the intricate patterns within their structure.

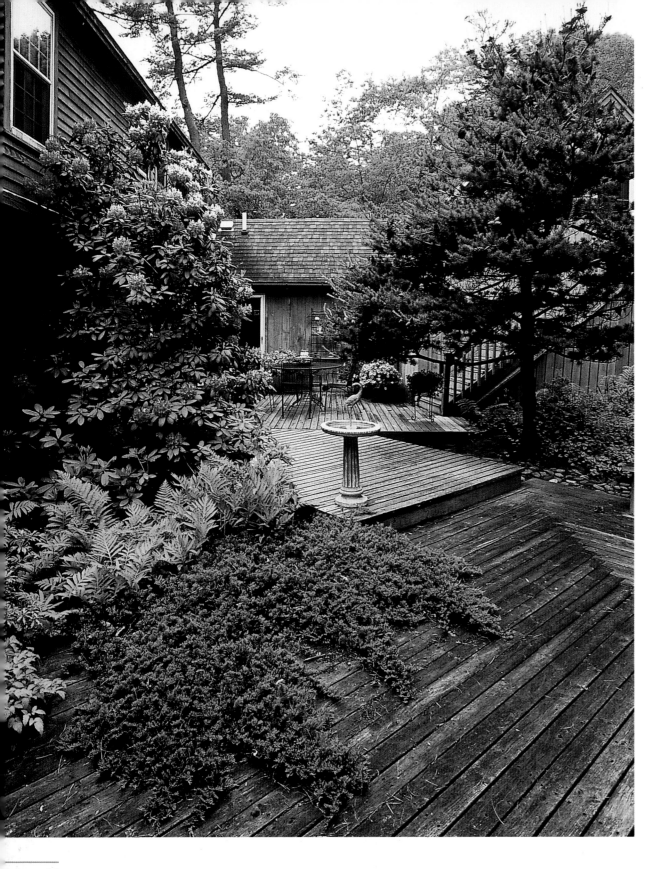

carpenter to construct the deck, which is the centerpiece of the design. Inspired by the bow of a beloved boat they have since donated to a nonprofit institute, the deck is an intersecting series of triangles at varying levels surrounded by and interplanted with a range of hardy, low-maintenance shrubs, specimen trees, and perennials.

The grayed cedar deck creates the framework within which Maggie has constructed her garden of contrast and pattern. In much the same way as she makes her *cliché-verre* compositions, she has chosen and arranged the garden elements carefully. But as she has discovered in making her prints, nature is ever-changing, so the results are often unpredictable. That delights her.

Over the years, the surrounding trees have grown and shaded the yard, helping to define its structure through shape and scale. "My small garden, submerged in shade, is dependent upon shape and contrast—the shape of lichen-covered rocks, the contrast between the texture of foliage and the deck's weathered wood." Maggie loves how the ragged edges of low-growing foliage contrast with the geometric lines of the decking. "A natural flow of line" is also crucial, she

LEFT: The geometry of the cedar decking makes a striking visual statement. Blue Rug juniper is allowed to creep over the edges of the weathered wood and soften its strong lines.
RIGHT: In a deeply shaded rock garden in front of the house, pachysandra, hostas, and low-growing azaleas thrive in the cool, moist soil.

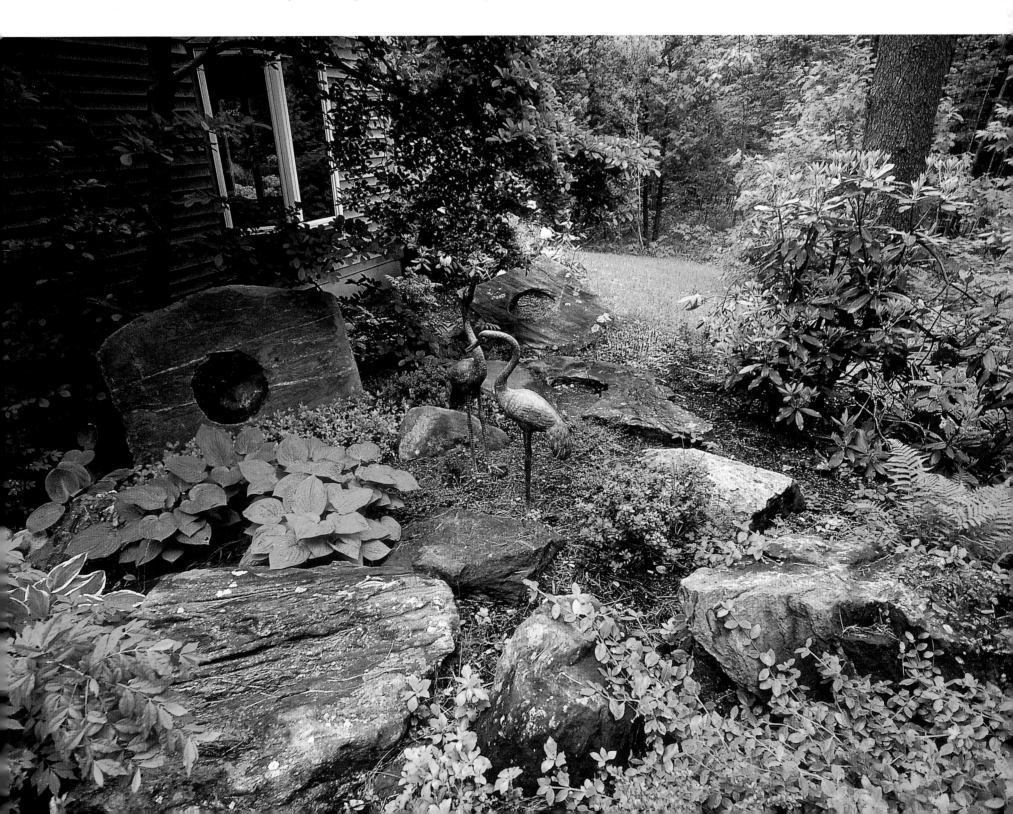

"My small garden, submerged in shade, is dependent upon shape and contrast."

emphasizes. "Nothing is pruned to the precision of a shaving brush."

If a plant survives in the harsh northern climate, it stays. If it fails, Maggie does not attempt to replant. What does survive flourishes. At one edge of the deck, volunteer ferns sprouted and spread, obstructing a large stone. So Maggie moved the stone to another location. "These plants are like characters in a book who tell the author what they want to be. I'm not the boss here."

Maggie may not have ultimate control over the plant life in her garden, but much of the hardscape is a product of her passion for stones. She hauls them from local beaches and arranges them in groups that create visual anchors for the plant material. Sometimes, following the advice of a seasoned local, Maggie pours buttermilk over lichens to encourage their spread. Because they can tolerate environmental extremes, lichens are almost eternal. "If there's any vegetation on Mars, it's likely to be lichen," she says.

Scrambling around the rock yard in nearby Rockland looking for just the right stone, Maggie is attracted by shapes and patterns. When an overgrown cypress began to dominate the center of her garden, she ripped it out and went rock hunting. The focal point of Maggie's collection of stones is a group of three hand-cut well covers. She speculates that the huge granite slabs were hauled by dray horses from hills scarred by retreating glaciers. Farmers placed the slabs over newly dug wells, their circular holes

having been chiseled out by skilled stonecutters. Tilted upright now, these natural sculptures throw patterns of light over hostas and a pair of long-legged cast-metal wading birds.

Perhaps because Maggie was born and raised in Brazil, her choices in flowering plants tend toward exotic colors. Throughout the garden, gray stone and green foliage are punctuated season to season by bursts of intensely rich hues. In spring, the curved wooden walkway to the front door of the house is canopied by the vivacious, frilly blossoms of chrome yellow and deep peach azaleas. The two-story rhododendron that creates a green wall along one edge of the backyard is dotted with bright magenta flower heads until early summer.

Each year, on a raised triangular platform in the middle of the deck, Maggie arranges a display of annuals in large simple pots. Some years the pots hold long-blooming *Mandevilla senderi* 'Rosea', also known as dipladenia or Brazilian jasmine or simply Mandevilla 'Rosea'. Its thick, glossy leaves and deep pink blossoms are still lush when the plants are brought indoors in late fall. Other years, petunias and annual *Argyranthemum* (marguerites) in shades of pink and deep magenta burst from cylindrical white planters. By the back entrance to the house, another mandevilla vine, "Red Velvet" blooms from the Fourth of July until Thanksgiving. It's no surprise that one of Maggie's favorite potted plants is *Passiflora incarnata*, a native form of passionflower whose blooms are smaller

and less showy than those of the cultivated species but no less intriguing.

Maggie's summer garden is a constant source of wonder and reflection, yet she produces no artwork while she's in Maine. From June until November, when she's not gardening, she spends her time visiting galleries, keeping in contact with other artists, and absorbing creative stimulation from her surroundings on the midcoast. She spends the winter months in the self-imposed isolation of her Florida studio. "I think many artists are naturally people of solitude. I never go out, never go to lunch. I need to save any time I have to work."

Into that isolation Maggie brings the raw material of constant observation and study. "There is an infinite variety of patterns in the way plants behave. There is always something else to see." The roots of a hydroponic lettuce that remind her of a rain forest, a slice of grapefruit from her tree in Sanibel—all are transformed in her darkroom into the tonal poetry of color and light.

Maggie's work can be seen as a form of poetry—the unexpected transfiguration of something ordinary, such as an onion, into

PREVIOUS PAGE TOP: Maggie in her Maine studio.
PREVIOUS PAGE BOTTOM: *Whirlybird* derives its composition and color from radicchio leaves and the winged seeds of a silver maple tree.
RIGHT: Picking up on the hues of the neighboring rhododendron, pots of annual petunias and *Argyranthemum* create a strong color focus.

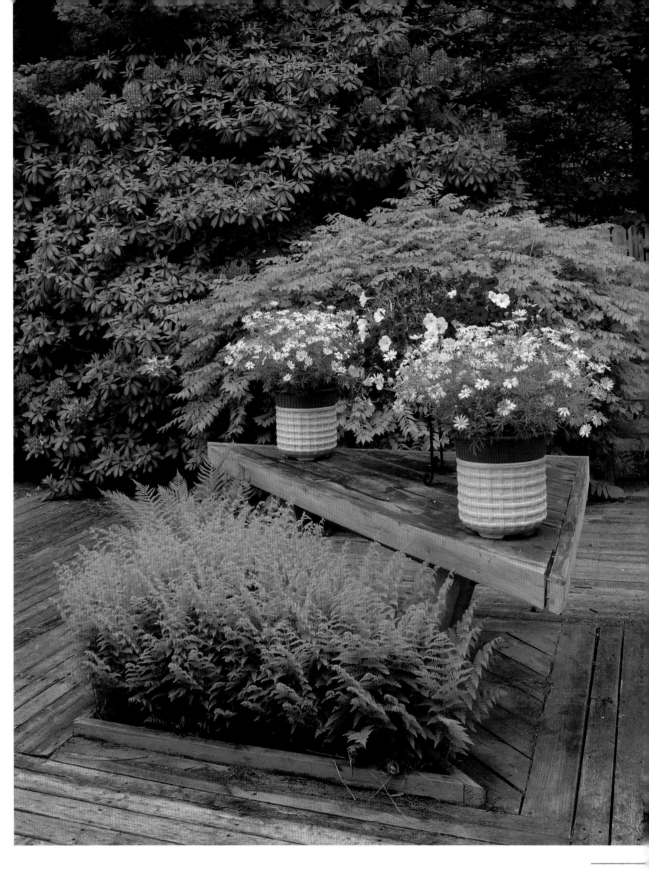

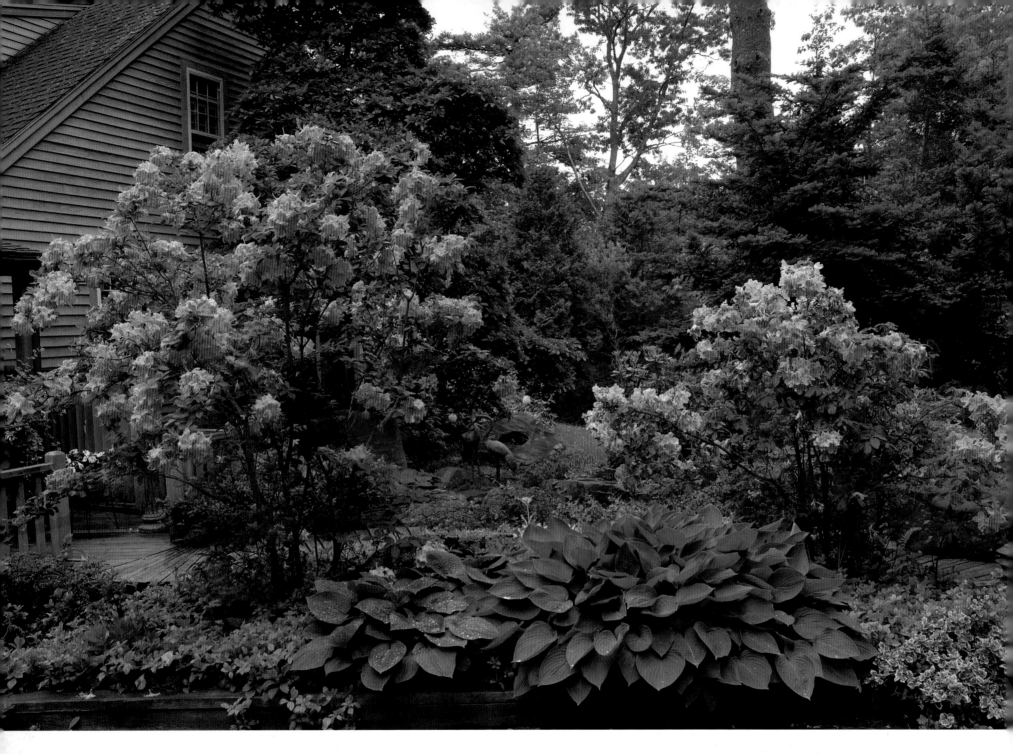

Along the front walkway to the house, surrounded by foliage, structures, and sculpture in shades of greens and grays, these orange and peach azalea blossoms are rendered even more brilliant than they would be in a garden that included other colors.

something quite different. "To me, a slice of onion suggests the constant changes in a human cell. Writers transform the commonplace with words. I try to do the same through *cliché-verre* in my darkroom."

One of Maggie's favorite poets is a fellow Bryn Mawr alumna Marianne Moore. The last lines of Moore's poem *When I Buy Pictures*, could easily be referring to Maggie's work:

> *It comes to this: of whatever sort it is*
> *it must be "Lit with piercing glances into the life of things,"*
> *it must acknowledge the spiritual forces which have made it.*

Maggie refers to herself as a "rag picker of small finds," a collector of the fragments of nature that cross her path. What emerges from her vision is a glimpse of what others often overlook. She believes that all nature is connected: "Thousands of years ago the glaciers of the last ice age melted and left striking patterns that exist around us today. We collect the rocks, and we carry within us the bones and cells of our ancestors. Whether to keep a garden alive or not is to experience the delicate balance of our mortality. As the Greek philosopher Xenophanes said, 'We are all sprung from earth and water.'"

Discovering Form and Pattern

The structure of even the smallest elements in the garden often reveal intricate patterns. Both the early new growth (left) and the blue-green cones (middle) of Japanese white pine (*Pinus parviflora*) are worthy of close examination. Japanese andromeda (right) are best known for their pendulous clusters of white spring flowers, but their equally intriguing seed pods will last until winter.

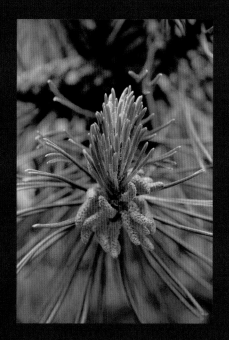 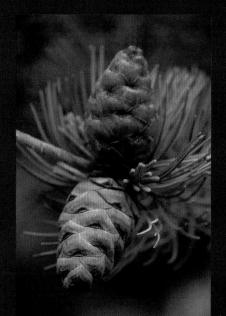

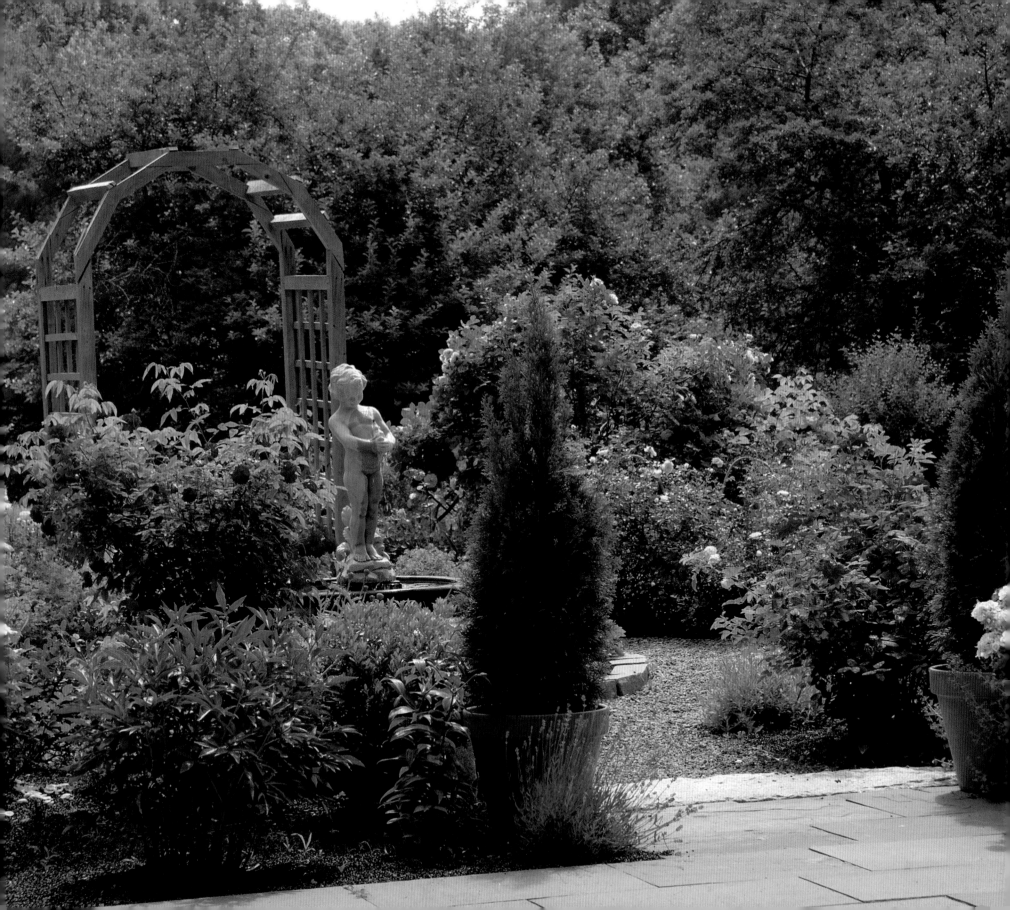

LEFT: Potted annuals and arborvitae flank the entrance to the rose garden where James and Beth have planted dozens of hardy varieties over the years.
RIGHT: Among the many varieties grown in the "peony walk" is this distinctive single pink.

James Aponovich and Beth Johansson

a tradition of beauty and harmony

In the late 1800s atop a hill in the hamlet of Cornish, New Hampshire, a group of like-minded artists came together with a common goal: to escape the stifling heat of the city and take advantage of the spectacular vistas and dense, cooling forests that the region had to offer. They came at first to rent the homes and farms recently purchased by New York attorney Charles C. Beaman. But eventually they bought and refurbished their own properties into resplendent summer homes with large studios and lavish formal gardens the likes of which had not been seen in this part of New England.

One of the first artists to migrate to the area was renowned sculptor Augustus Saint-Gaudens, who purchased a former inn at the base of Dingleton Hill and transformed it and the surrounding land into what is today a national treasure. Through his actions he was helping to fulfill Beaman's dream of creating a "Little New York"—a concentration of creative and intellectual talent that would give birth to the Cornish Colony. Saint-Gaudens was followed by a number of other prominent artists, in particular the sculptors Daniel Chester French and Frederick Remington, painter Maxfield Parrish, a number of writers and poets, and dancer Isadora Duncan.

By the early twentieth century, Cornish was home to some of what were considered the most beautiful gardens in any village in the nation. In the years that followed, the beauty and solitude of the New Hampshire hills gave birth to a number of other artist colonies. The artists used their visual acumen and sharp design sense to create both formal and informal gardens, each unique and perfectly suited to their homes and the natural landscape. The time and care that the artists lavished on their gardens were matched only by their devotion to their art. In both, a sense of pride and friendly competition was infused with and ignited by an endless quest for beauty. That quest is the driving force behind the work and gardens of New Hampshire artists to this day.

Sixty miles south of Cornish lies the Monadnock region, home to meticulously

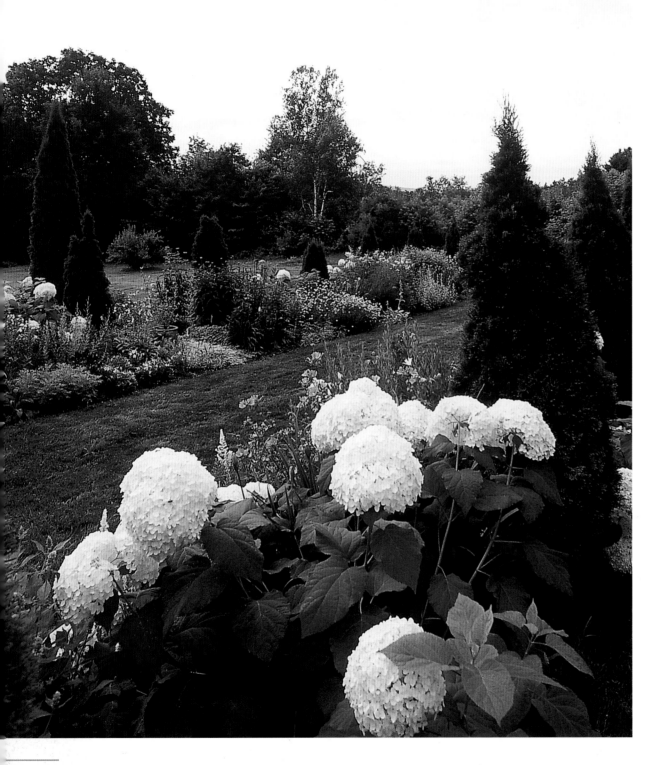

preserved villages, verdant rolling hills, and cool, deep woods—and to New Hampshire's artist laureate, James Aponovich, and his wife, painter Beth Johansson. Their home, studios, and gardens both honor and rival those of their predecessors and speak eloquently of the rich connections between painting and planting.

With the green-black forested slopes of the Monadnock range as a backdrop, James and Beth have built a home and a life filled with color and texture, contrast and harmony, fueled by the visual, physical, and emotional acts of gardening and painting. Their handsome house of cedar and stone is the geographic and creative heart of the property. Radiating from this center, each garden has been carefully designed to evoke a time and place significant to this couple's life and work.

To the south a series of bluestone terraces and granite steps leads down to broad borders edged with fragrant mounds of purple lavender. Tucked behind them are dense clusters of daylilies, their tiny buds just emerging in anticipation of midsummer. But the showpiece of this walk consists of masses of luscious yellow intersectional peonies, a hybrid of herbaceous and tree species from a propagator in northern Vermont. Like much of what grows here, these peonies lead a double life. They are revered by the couple for their color, structure, and hypnotic scent. The buds and flowers are cut and brought inside to fill large porcelain urns. And then the best of them have their

"Everything that we do is about making something harmonious and beautiful from elements."

portraits painted, framed, and hung in museums and galleries across the country.

Both James and Beth have chosen flowers as a subject in much of their work. Over the years the gardens they have grown have fed their painting, just as their painting has influenced the gardens. James is most drawn to flowers that suggest movement and rhythm; then he twists and bends them in ways that nature does not. In one canvas, a blue and white Chinese bowl cradles a mass of flaming parrot tulips much larger than the vessel could actually hold. The individual flowers reach out in all directions, their serrated petals curling and spiraling in an exuberant dance. Echoing the Renaissance still

lifes that influenced this work, the choreography of the flowers is set against a serene landscape, in this case a lone lighthouse on a calm sea.

This painting is part of an exhibition about the historic Isles of Shoals, off the coast of Portsmouth, New Hampshire. Beth's contribution to this exhibit is a painting of red hollyhocks, inspired by the Isles' most famous gardener, Celia Thaxter, whose flowers were the subject of dozens of paintings by American Impressionist Childe Hassam. The color, form, and flatness of individual hollyhock flowers are a fascination to Beth. She often chooses these blooms, as well as those of annual poppies and pansies, for

their open structure and their quality of translucence. But whether choosing flowers for her paintings or the gardens, color is her central theme and the element that brings life to both.

On the northeast corner of the house, a pea-stone terrace surrounds a granite-edged bed of ornamental grasses and low-profile perennials grown mostly for their foliage. Beyond, a lawn and steps lead down to a sizable vegetable and perennial propagation and cutting garden. Until recently, a long bed of tall white phlox, peach- and maize-colored daylilies, purple coneflowers, and blue balloon flowers defined the eastern edge of the cultivated area. Interspersed

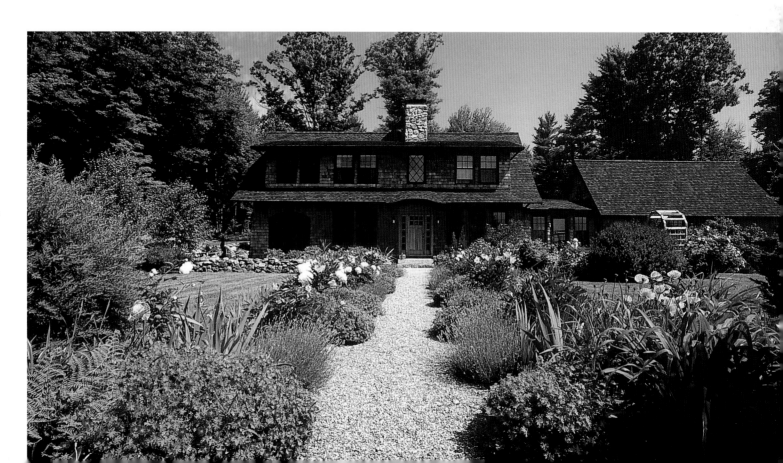

LEFT: White Annabelle hydrangeas alternate with small arborvitae along both sides of the *petite allée*. One side is planted in cool colors where blues, purples, and silvers dominate. Warm reds, yellows, and fuchsias are more prevalent in the opposite bed.
RIGHT: The pebbled walk to the front door is bordered by an ever-changing spectrum of flowering perennials, including the couple's beloved intersectional peonies.

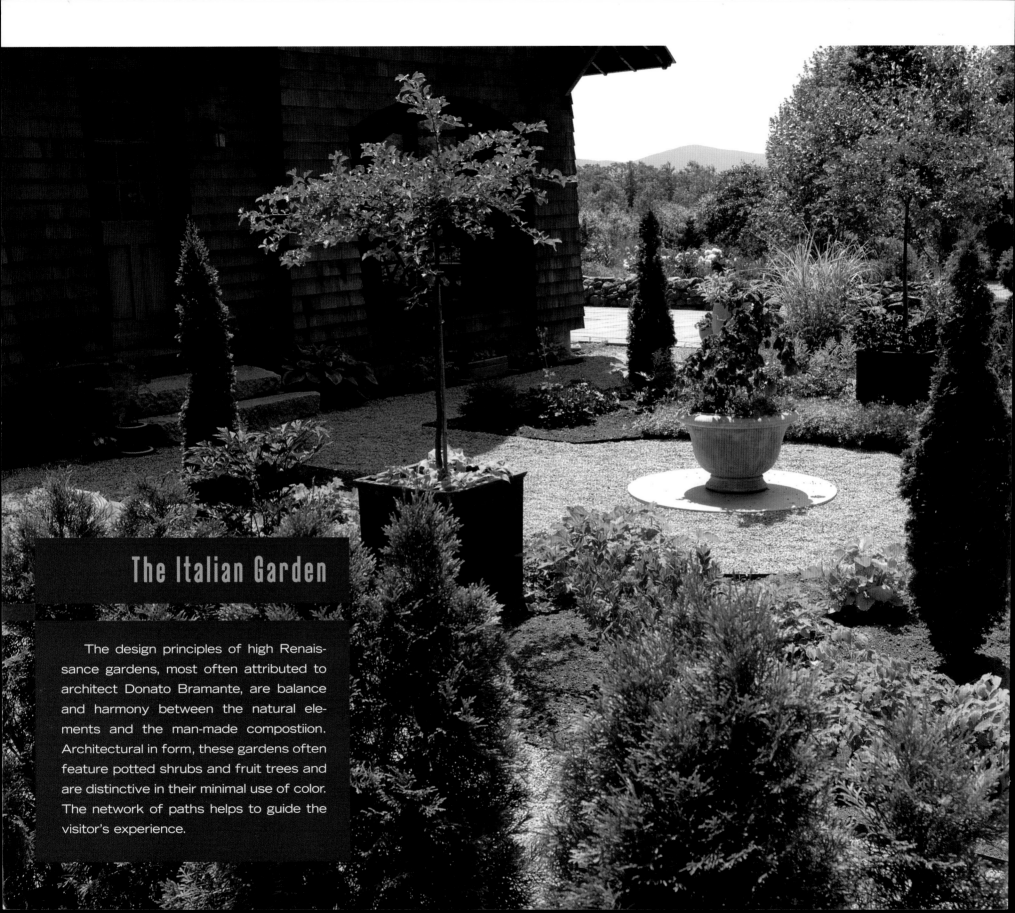

The Italian Garden

The design principles of high Renaissance gardens, most often attributed to architect Donato Bramante, are balance and harmony between the natural elements and the man-made compostiion. Architectural in form, these gardens often feature potted shrubs and fruit trees and are distinctive in their minimal use of color. The network of paths helps to guide the visitor's experience.

among them, atop tall, sturdy pale green stems, were the saucer-size heads of dozens of pastel yarrows. Called the "Maine Border," this area paid homage to the couple's fifteen summers on Eggemoggin Reach in Penobscot Bay, and to Julia Martin, the professional Maine garden designer who mentored Beth all those seasons.

Most of the plants in this bed were transported from Maine, but because of the longer growing season here in southwestern New Hampshire, they acted quite differently. On the coast, bloom time for most of these perennials is condensed into a few warm months. In this more extended summer, the yarrow and phlox seldom flowered in tandem. The spirit of the Maine border remains, but for practical reasons it has been divided and dispersed to more hospitable parts of the property or to fellow gardeners.

In fall James and Beth plant a thousand tulip bulbs for cutting and painting. Recently the local white-tailed deer have discovered this delicacy, so future plantings will be scaled down and fenced. This plot acts mainly as a nursery for the species that will eventually end up in one of the planned formal gardens that are the signature of this beautifully designed property.

Every year since 2001 James and Beth have conceived, drawn, discussed, revised, and finalized a plan for a new garden. This year's project is a Florentine-style courtyard inspired by the garden at the Hotel Monna Lisa in Borgo Pinti, where James and Beth have stayed on their frequent trips to that Tuscan city. The couple's garden, modeled after the high Renaissance style of design, has at its central axis a large terra-cotta pot holding a fig tree. Each quadrant is planted with small-scale arborvitae and groupings of perennials—astilbe, lady's mantle, epimedium, baptisia, and anemones—primarily chosen for their texture and the forms of their foliage. The garden's horizontal axis is marked by a pair of Sargent crabapples in square iron planters. At the back edge, the columnar form of a beech tree balances pairs of lower-growing intertwined smokebushes. Their dusty purple and bright yellow-green foliage will grow together to reinforce the garden's palette of purples, reds, and chartreuse. Broad paths of pale brown pea stone, the human scale of the vegetation, and the symmetrical layout add to the accessibility of this, the most formal and sculptural of the gardens.

When James and Beth purchased this land, much of the open space was a rocky pasture overgrown with chokecherries and bittersweet. Once it was cleared, the couple had the ideal site for creating one of their most alluring garden features—a *petite allée* with mirroring pairs of arborvitaes and Annabelle hydrangeas anchoring lavishly planted beds of silvers and whites punctuated with colors in opposing temperatures. Silver-leaved artemisia and salvia and white-flowering phlox, echinacea, and astilbe create a base for chartreuse lady's mantle; apricot daylilies; peach-colored perennial foxglove; purple veronica, campanula, and

The stability of a white marble column provides a counterpoint to spires of pale blue delphinium as they sway in the summer breeze.

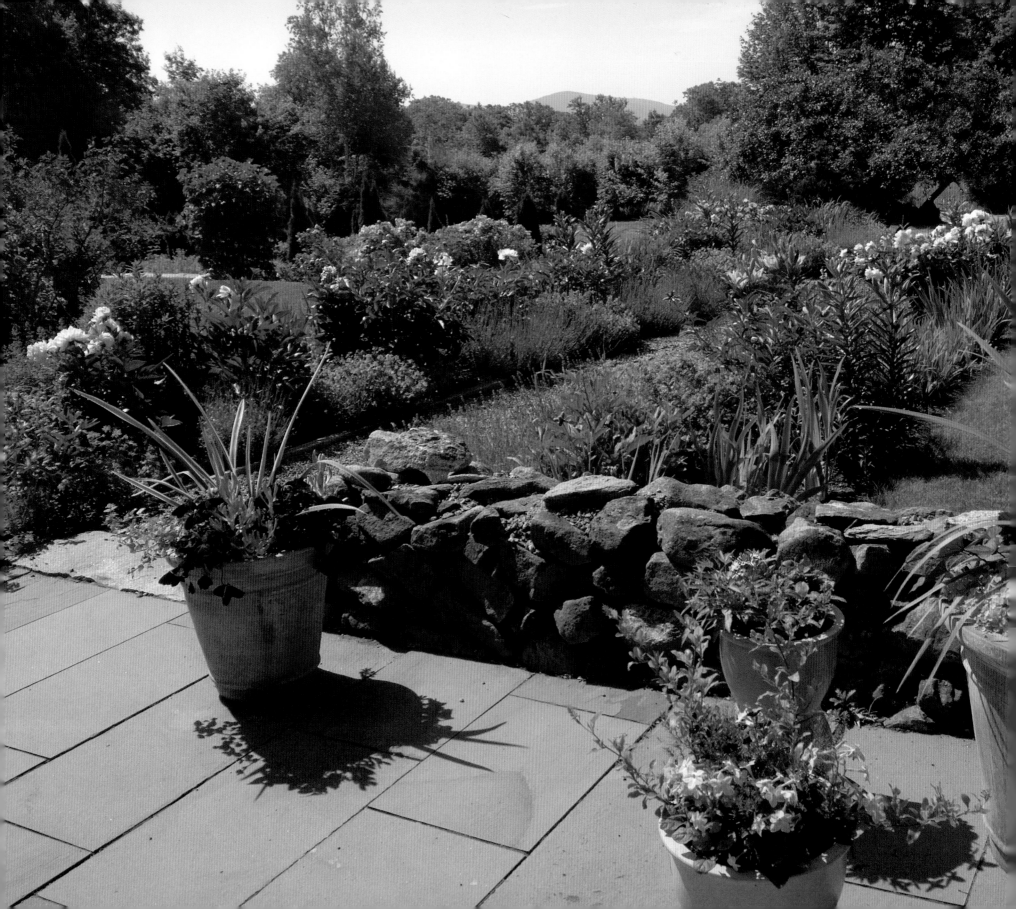

globe thistle; and blue delphinium. This classic European construct, softened by American cottage-garden plantings, ends in a wall of arborvitaes flanked by dwarf Korean lilac hedges, a stone bench, and a large iron urn, raised and left unplanted for its strikingly graphic silhouette. It is in this exuberant show of colors and textures, structure, and scale that the balance between formal and casual is perfected.

In contrast to the formality of the front gardens, the wooded back side of the house has been opened to create space for an homage to Charles Savage's magnificent Asticou Gardens on Mount Desert Island, in Maine. The Japanese-inspired design of wooded paths, giant conifers, and small-scale specimen trees bursts to life each spring with the vibrant colors of dozens of azaleas. James and Beth plan to integrate elements of the Maine gardens into their own naturalized landscape of deciduous trees, rhododendrons, and azaleas that will imbue this more private space with a serene beauty. The long New Hampshire winters have also inspired the couple to create a back garden specifically for viewing from inside the house. The centerpiece of this garden will be a three-foot ceramic orb by 2005 Lotte Jacobi Living Treasure Award recipient Gerry Williams. Specifically designed to withstand the cold northern climate, the orb will be flanked by weeping hemlock, Japanese maple, and other key plantings specifically chosen for their year-round interest. A six-foot-square lattice will back the garden, completing a composition in which the trees, the grid of the lattice, and the round orb will create a study in line through the leafless winter.

Both artists show inexhaustible enthusiasm for their gardens. From the stone walls that James built with rock excavated on the land, to the peonies that Beth picked and refrigerated in an experiment to determine their viability for daughter Ana's late-June wedding, they welcome and revel in every aspect of gardening. They design the gardens together, often working through five to ten loosely sketched layouts and elevations before finding the one that clicks. The task of building structures falls to James. Beth's talent for color and her extensive knowledge of cultivation are employed in choosing plant materials. They labor in tandem to plant and tend the gardens, evaluate their works in progress, and envision next year's project. James once wrote in an exhibition catalog, "Everything that we do—*we* meaning Beth and me—is about making something harmonious and beautiful from elements. Cooking. Gardening. It's not always conscious, but you find it happening. That's a part of living in the environment here."

Potted annuals punctuate the broad bluestone terrace from which James and Beth enjoy a sweeping view of their gardens and a glimpse of Pack Monadnock Mountain in the distance.

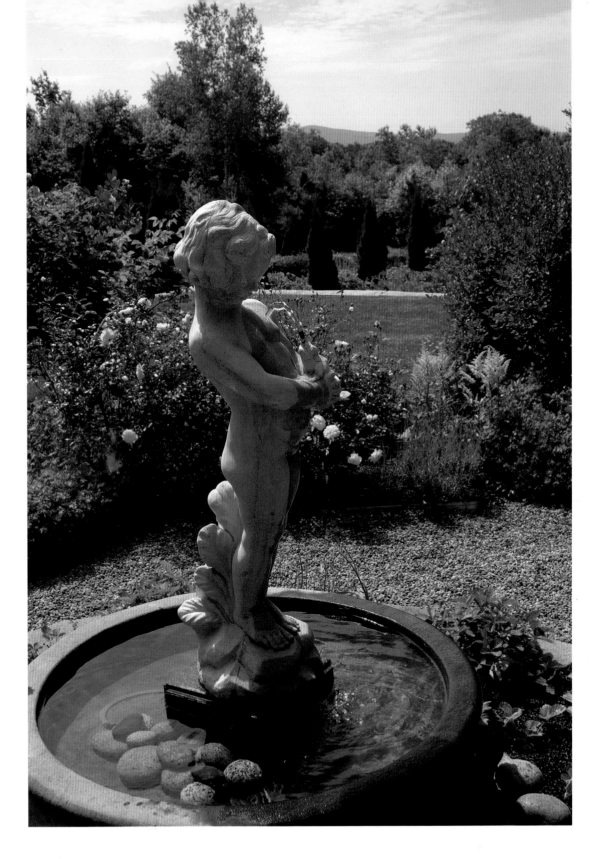

But beyond this, the couple credits the balance in their gardens to the symbiotic relationship between their male and female natures. James, with his rugged stature and gregarious manner, characterizes his approach as angular, rigid, forceful, and challenging. He theorizes that men are drawn to certain landscaping features, such as ponds and water gardens, as an opportunity to control nature. Beth's quiet, contemplative demeanor nearly masks her depth of horticultural insight and passion for gardening.

For this couple, the day—and indeed the year—revolve around the interwoven activities of gardening and painting. During warm weather they spend mornings ensconced in the needs and pleasures of the gardens. Spring is the time for transplanting from the nursery beds, shopping for and adding new varieties, realizing the latest design plan. Through the summer, plants are watered, weeded, and deadheaded; the connecting lawns are mown but otherwise left to nature. In fall, perennials are cut back and composted, and tender shrubs are protected from the north winds. The afternoons of the growing season are reserved for painting the flowers that are in bloom. The long winters are spent completing their canvases.

LEFT: As an important feature of formal garden design, fountains can add elegance, whimsy, and year-round interest to the landscape.
RIGHT: Granite walls, steps, and edging, built from local stone define each beautifully conceived terrace within the garden.

Both Beth and James love living in New England for what it offers and what it does not. The ability to garden year-round would disturb the balance they have so carefully created. They look forward to leaving the garden under a blanket of snow and retreating to a fireside chair with a stack of gardening books. Knowing that their months of hard work will be rewarded again come spring, they devote their winters to work in the studio, interrupted only by annual trips to Italy, where they gain added insight into the history of the art that inspires them. In the continuing dialogue between gardening and painting, both artists become more energized as their landscape matures, and their work reflects this expanding dynamic.

In adjoining rooms on the light-filled north side of their home, James and Beth paint, talk, swap oil colors, listen to music, critique each other's work, and at the end of the day come together to share their progress. Some days they travel to teach classes at one of the state's premier art institutions, discussing their work and their gardens along the way. Another couple whose lives are so intertwined might find this a source of distraction, but for James and Beth, this constant contact keeps them each focused while challenging them not to exert too much influence on each other. They have succeeded by producing two very different bodies of work from a single source of inspiration.

The interplay between their artwork and their gardens is not only personally

significant, but also contemporary manifestation of the region's heritage. An artist colony centered around professional achievement and horticultural pursuits is already beginning to develop in their area. Printmaker Peter Milton and musician, composer, and conductor James Bolle also choose to balance their time between their creative work and their gardens. An air of benevolent competition pervades their relationships. Beth and James envision reviving this heritage as a way to honor the past and build on what they have so successfully started—a life in which gardening and painting are equal and inseparable parts of the whole.

Over the years Beth has produced several series of beautifully rendered oils depicting stacked spools of brilliantly colored ribbons and towers of elaborately wrapped boxes. The ribbons glisten with sheen and translucence, the minute details of the paper testify to her keen eye and extraordinary skill. Yet it is the tranquil, ordered composition of these works that gives them their presence. There is a life to these inanimate objects, and the artist presents it with a confidence that comes from experience and wisdom. It is no wonder then that Beth is drawn to the architecturally uniform structure of particular flowers, and those have become the subject of her newest works: the smooth, repeating petals of pansies; the minutely ruffled poppy flower; the tall stems of open-faced hollyhocks.

artwork photos: Glen Scheffer

LEFT: James and Beth share equally in the creation of the gardens.
ABOVE: James's *Still Life with Daylilies and Watermelon* and Beth's *Appledore: Still Life with Poppies*

Beth overcame her initial reluctance to expand the gardens away from the house by viewing it as an opportunity to stretch herself and test her acumen. Now she considers the entire yard a frame within which to experiment, learn, and create. For her early flower paintings she chose containers of cut annuals brought into the studio, but with the hollyhocks she began a foray into the garden with her easel. As this new venue will undoubtedly impact her work, it will also likely begin a shift in her view of the garden.

Long a master of exacting detail, James pays attention to surface quality, manipulation of scale, and precise compositional choices. These have set his interpretation of "realism" apart from that of his contemporaries. Early portraits, beautifully realized in oil and graphite, established his reputation and his style. The topography of southern New Hampshire and coastal Maine inspired large landscapes, a subject he has returned to occasionally over the years. But it is the radiant and energetic still lifes of his beloved flowers that currently define his career. Although he had worked in the genre for some time, a journey to the Renaissance centers of Italy in the mid-1990s exposed him firsthand to the art he had long admired, and that experience stimulated a shift in his approach. He began to "place" his bowls and vases of flowers in the foreground of lush, deep landscapes, real and imagined. By changing the setting and lavishing even more detail on each element, James moved the work from masterful to magical.

Choosing Roses

The sole source of flowers for James's still lifes is the home garden. He uses the nursery bed to propagate his subjects, or chooses live specimens from local sources that later end up in the perennial borders. He admits to a weakness for the superficial—roses named for artist Henri Fantin-Latour and architect Charles Rennie Mackintosh, and the idea of hollyhocks "that aim too high," referred to by T. S. Elliot in one of his *Four Quartets*. Each year James paints a new version of large semi-double pink-striped Rosamondi roses (top), named for the beautiful Rosamond de Clifford, mistress of Henry II of England.

In contrast, Beth selects roses, as she does all plants, guided by her horticultural expertise. Hardiness is an important characteristic because of New Hampshire's challenging and often fickle winters. She grows Pink Ballerina roses (middle) for their beauty and vigor. From the defining fragrance of the ancient apothecary rose to the peony look-alike David Austin's Corvedale (bottom), her carefully chosen and lovingly tended rose varieties keep this garden vibrant all summer.

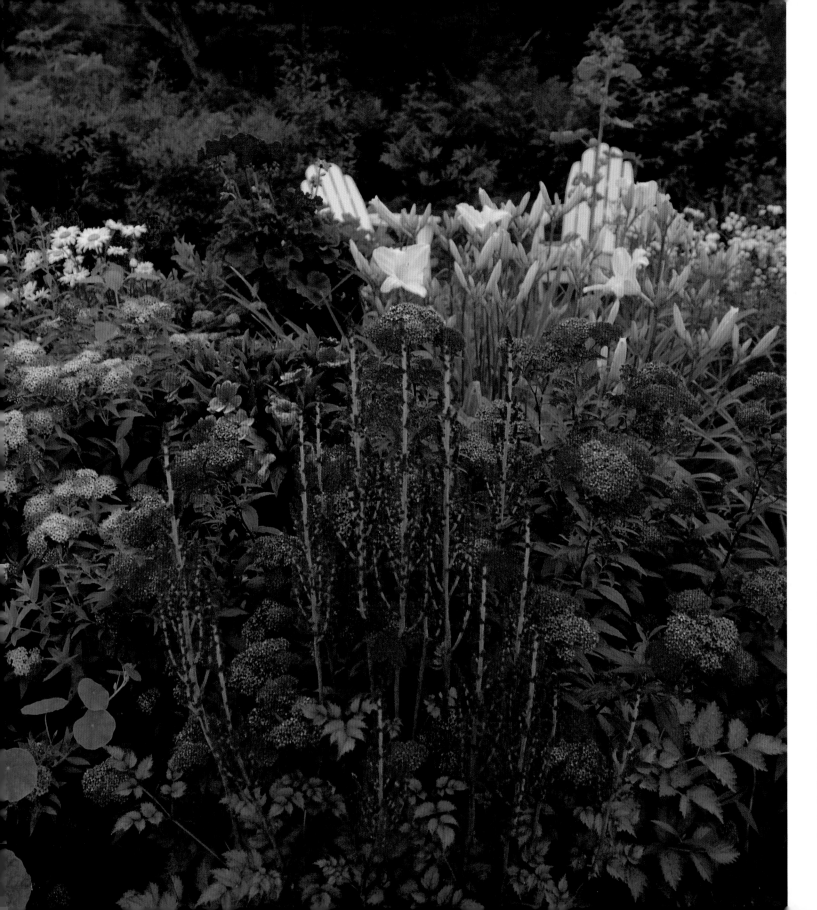

LEFT: Pink astilbe, spirea, yarrow, and phlox in varying shades and textures create the main color story in mid-summer, supported by pale yellow daylilies, white Shasta daisies and peniculata, and blue delphiniums. A raised pot of geraniums adds a touch of red to the composition.

RIGHT: Holly considers the entire yard part of her canvas, balancing the small white shed with carefully placed Adirondack chairs.

Holly Ready
on color and composition

There is consistently so much color in Holly Ready's perennial bed that it's hard to believe these gardens lie in northern New England. On an overcast morning in August, a half-dozen shades of pink play off one another in tone, value, scale, and texture. At one corner of the garden, purple-cast sprays of Anthony Waterer spirea snug up against the warmer hues of peach-toned perennial yarrow and magenta-blossomed phlox. Among them, thick stalks of astilbe are covered in pale cranberry buds ready to bloom at the first show of sun. Just beyond this rosy swath is a stand of pale yellow daylilies flanked by creamy clusters of lacecap hydrangea and the golden eyes and pure white petals of Shasta daisies. Tall blue delphiniums and pale purple alyssum complete the composition.

Holly learned to maximize color in art school. Inspired by her grandmother's example, she has been both an artist and a gardener all her life, but it was at the Maine College of Art that she developed the skills that allow her to make practical use of her exceptional color intuition. The language she uses to describe her gardening choices echoes the way she talks about her paintings: "I know the feeling I want to achieve—I start by putting down color and texture—but nothing is preconceived. In order to bring some

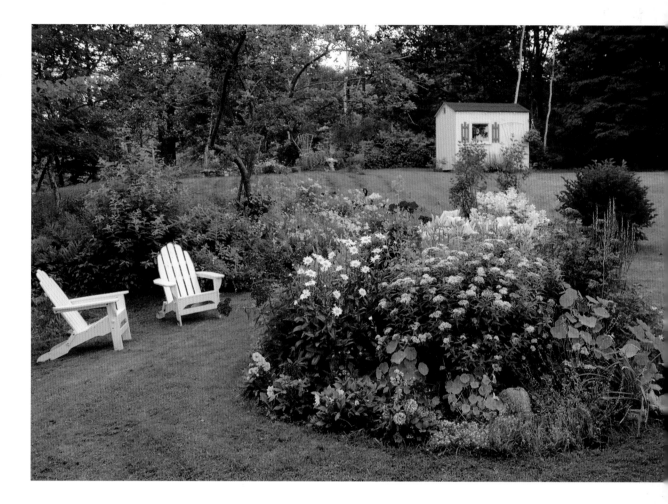

colors out, I need to use other colors that support them."

With this knowledge and the discipline to start small, Holly has created a remarkably mature garden in a few short Maine summers. She considers every plant in terms of shape, hue, flower form, and bloom time, and groups them to create broad, flowing strokes. When she is unsure of how she wants to handle a certain area, she plants annuals as place-keepers to "test" for a certain color or form. "When I can't find a perennial in the right shade of warm red, I plant nasturtiums to add the right color and create a

hierarchy leading up to the tall yellows and blues." She describes a recently added border of low dahlias as "yellow ochre with a little cadmium red light mixed in." And she loves how a spectrum of warm to cool whites adds points of light throughout the yard all summer.

As viewed from the window in her beautifully renovated little house, the perennial garden is a burst of activity in an otherwise serene setting. Holly uses this window as a frame to view and assess her gardens. As in her paintings, she strives to create a flow reminiscent of an expansive sea interrupted only by a distant craft or a crashing wave—vast areas of a single color with varying textures, values, and temperatures, punctuated by some unexpected hue. She often chooses white to achieve that goal, using strategically sited perennials or annuals, or simply positioning a pair of white painted Adirondack chairs in just the right location.

To maintain areas where the eye can rest, she plants large sections in a single variety. The process of painting has taught her that fewer colors and textures in unequal proportions will create the desired rhythm and flow. A large portion of Holly's backyard has been left as green lawn, which creates a sweeping curve to a new, distant garden at the back edge of the property.

As perfect as the composition now seems to be, it is not fixed; Holly will add and move plants every year until the lawn is just a pathway through the garden. She's already planning to transplant a row of lilacs in the fall. "If you can take anything out of the composition without diminishing it, it doesn't belong there," she explains.

Looking across her garden work in process, she says, "I think it's a strong start, but I'll keep working until it all congeals and the yard becomes a finished canvas."

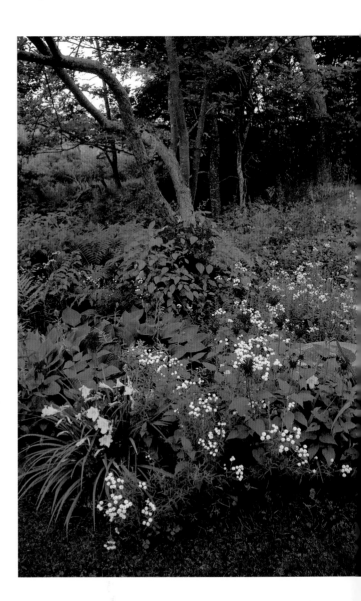

designing with color

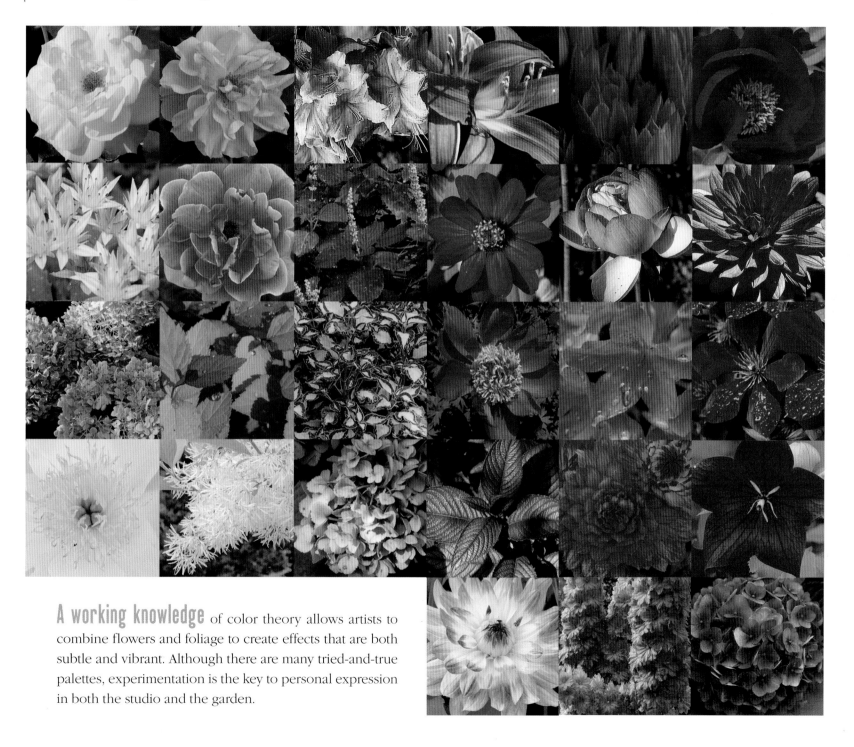

A working knowledge of color theory allows artists to combine flowers and foliage to create effects that are both subtle and vibrant. Although there are many tried-and-true palettes, experimentation is the key to personal expression in both the studio and the garden.

Nadine Schoepfle
form and hue

The massive rhododendrons surrounding Nadine Schoepfle's house provide a profusion of bright blossoms in spring, welcoming shade in summer, and inspiration for her oil painting throughout the year. Their bold and frilly flower clusters are the ideal form for Nadine's quick wet-on-wet brushwork style. Although she can appreciate the perfect structure of a rose, the delightful frowziness of annual poppies, and the sinuous curves of bleeding hearts, they almost never make it to her canvases. "As subjects, I like flowers I can play around with—ones I can suggest in paint as masses of shape and color." Not surprisingly, peonies are one of her favorites. "They have everything I look for in a flower: fabulous color, strong shape, and lush, lovely fullness." Because of their pure forms and rich hues, asparagus, leeks,

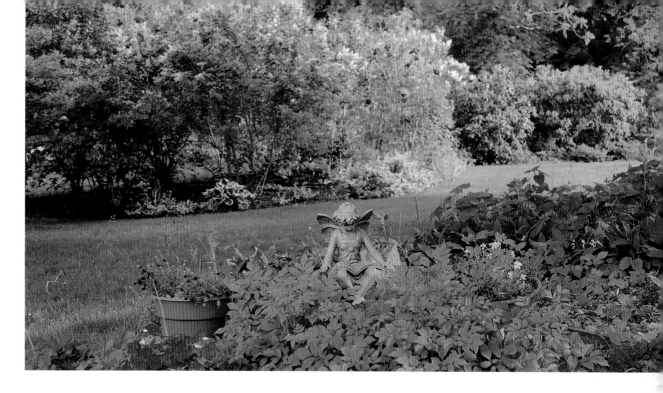

and red bell peppers are also prized subjects for Nadine.

Although she will occasionally use a vase of newly opened blossoms as reference, she works primarily from her memory and imagination and always in her studio. With a demanding schedule and an aversion to insects, she prefers painting indoors, which allows her to control the environment and better concentrate on the piece in progress. When asked about her favorite painting, she quickly replies, "The next one!" Even though this sometimes causes her to leave work unfinished and to destroy canvases she doesn't like, Nadine's work ethic, energetic style, and practiced skill result in dozens of completed paintings each year.

When Nadine and her husband, painter John Schoepfle, first moved to Maine, they ran a successful gallery for several years, yet even then they found time to garden. Daffodils, irises, and daisies still bloom among the statuary and ground covers in the original rock garden. The lawn is edged with mature pale and deep purple lilacs, blue hydrangeas, and brilliant orange Brazil azaleas. A bed of astilbe and forget-me-nots rings a stone statue of a reading child, and lily of the valley meanders through the shade of a towering Norway maple. The glossy leaves and sturdy flower spikes of a large gas plant (*Dictamnus albus*) lend their lemony scent to the summer air. A colorful mix of annuals

and perennials—sweet autumn clematis, oriental lilies, poppies, cleome, rudbeckia, and yarrow—share an arbored flower bed. Along the back walk, a stone-edged raised bed is densely planted with Stella de Oro daylilies, bleeding hearts, and Miss Kim lilacs. Perennials and shrubs dominate the landscape,

but Nadine and John add up to one hundred and fifty tulip bulbs each fall.

After thirty years of expanding the garden, they are now reconfiguring to reduce the amount of planting and care required. In addition to constant weeding, the gardens need protection from deer, raccoons, woodchucks, slugs, damaging beetles, and invasive bittersweet. By allowing some areas to revert to lawn, the couple can concentrate on the parts of the garden and the gardening chores they enjoy most.

Nadine has painted the rhododendrons many times already, and chances are that they will remain a vital part of this property as they continue to inspire her. Because no two years, or even two days in the garden are the same, she approaches each day in the studio with fresh eyes. "Every experience I have had has served as a catalyst to my creative endeavors. Each foray into the world of color and medium is a new adventure—and always exciting."

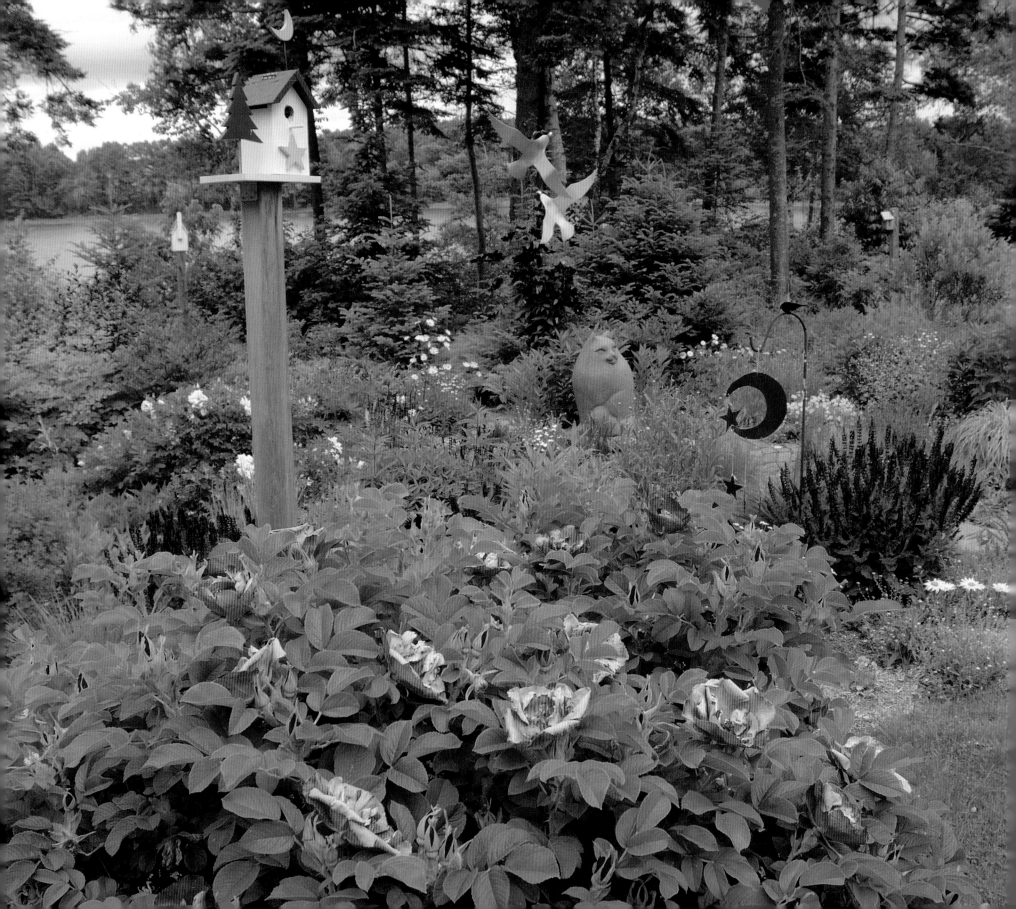

Loretta Krupinski
a respect for site

For Loretta Krupinski there's an upside to having a plant fail in her coastal Maine garden: It leaves a precious soil-filled hole for planting something new. As with many gardens in similar locations, there was no real soil here to begin with. Gardens built on riverbank clay, shale ledge, or beach sand exist only because of the gardener's hard work and resourcefulness. Loretta's gardens thrive and grow more beautiful each year, her skilled hands and sharp eye constantly fine-tuning the beds and borders into marvelous living compositions.

As a small child in school, Loretta was given a little packet of seeds to plant, and she recalls the joy she experienced when they sprouted and grew. She has retained much of that same enthusiasm for gardening to this day, although her success can also be attributed to years of study, observation, curiosity, and experimentation.

These are the same qualities that make her an accomplished and prolific artist. With a degree from Syracuse University, she embarked on a dual career as a fine artist and an editorial illustrator. After working only in black and white for the newspaper *Newsday*, she was prompted to try color after a trip to Maine. Choosing classic wooden racing boats, lighthouses, and working harbors as her subjects, she delved deeply into the

world she would represent on canvas. "Every artist knows the importance of painting what you know. To be a marine artist you have to be a 'wharf rat.' You have to know clouds, wind, weather, lighting, water conditions, sailing experience, and yacht designs."

After vacationing on the Maine coast for twenty years, Loretta and her husband, Bill, relocated from Connecticut to a tidal cove on the St. George River, where she is now surrounded by the world she had painted for so long. Over time, this led to a shift in thinking about her work, but from the first season it forced her to garden differently. Her previous house was in a wooded location, and her gardens there were planned and executed around what grew

LEFT: Stone, metal, and wood sculptures create consistency as Loretta's waterside garden changes from season to season. Here the pinks, purples, and vibrant greens of early summer create a cool color palette.
RIGHT: It's not unusual to find small treasures tucked among the stones, bricks, and groundcovers.

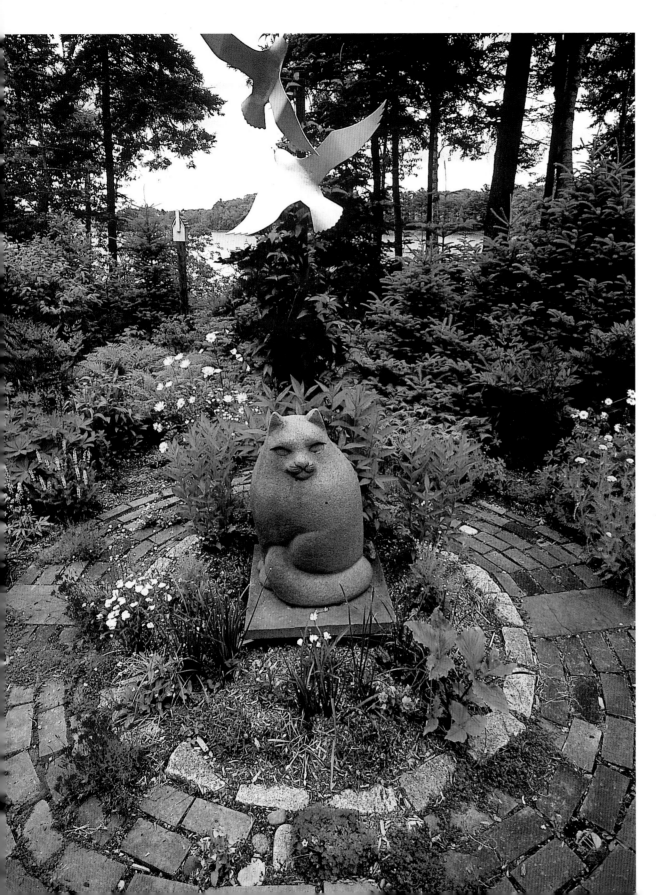

well in shade. This house, on its sunny, open lot, presented new opportunities and new challenges, including coping with the region's famous northeasters.

A year of living with water views partially obstructed by wild blackberries, asters, and goldenrod prompted Loretta to create a more gracious vista along the spruce-lined river embankment. (She did not disturb the vegetation on the banking, so it continues to function as an important erosion deterrent.) Because the entire peninsula is primarily clay, all topsoil for the gardens had to be purchased. After clearing the area for the new gardens, she laid down landscaping cloth and cut holes in it where she wanted to position the new plants. She then dug out the existing clay beneath each hole and replaced it with a mixture of topsoil and just enough clay to help retain moisture.

Inspired by a trip to the Grass Garden at Kew Gardens in England, she began by planting several species of ornamental grasses, flowering shrubs, perennials, and annuals in yellows, whites, and purples. To minimize maintenance, she added hardy rugosa roses, which tolerate the northeast winds and salt spray.

Countless additions and refinements later, on a sunny June day Loretta's sweeping seaside garden lives up to her vision. A delightfully varied composition in form and

From this circle of brick and stone, paths radiate in all directions, creating both a visual and physical center for the garden and a showcase for some of Loretta's favorite pieces.

LEFT: A profusion of violas and forget-me-nots self-seed each year in the borders, providing both color and texture.
BELOW: No coastal Maine garden would be complete without lupines, which thrive in the sandy acidic soil so common here.

learned that not all plants offered by local garden centers will survive the winter. In contrast to the interior, the coast is tempered by ocean waters and winter rains often wash away what protective snow cover these gardens may collect. Exposure to harsh winds and ice can compromise even the healthiest plants. In a recent nearly snowless winter, Loretta lost eighteen perennial grasses.

The challenges don't deter Loretta from experimenting with new varieties, but they have informed her choices. At the edge of the seaside bed she grows rows of high-bush blueberries and hardy lingonberries, as well as beach plums and purple-leaf sand

texture, it is not dependent on color for its beauty, although it is nevertheless c. in~ed by the vivid accents of her original scheme. Amid the varied greens of grasses are the contrasting foliage of early- and late-blooming perennials, the sculptural forms of shrubs and small trees, and the lush purple clematis 'The President'. Dense, spiky salvia and tall, vigorous lupine bloom in intense hues of purple-blue. Lively clusters of osteospermum, potentilla, yarrow, helenium, and heliopsis provide the yellow complement. Rugosa roses, fringed bleeding hearts, and ox-eye daisies add a white accent, and self-seeding tricolor violas preserve the full palette in a single flower.

Although New England is a small region, the growing environment can vary dramatically from state to state. Many of the plants that Loretta cultivated successfully in Connecticut simply will not grow here. Others flourish beyond her expectations. Montauk daisies, with their thick, waxy leaves and oversize flowers, have grown into shrub-size masses in this yard. A perennial veronica called 'Fascination' consistently grows much taller than its expected three feet, reaching to a full five feet. Although midcoast Maine is considered Zone 5, experience has taught Loretta to plant for Zone 4; in the case of roses, she searches for varieties that are hardy to Zone 3. She has also

cherries. Foliage color is beginning to play a more important role in the garden with the addition of striking golden spirea and the dark bronzy-purple leaves of *Cimicifuga racemosa*. Loretta does not cut back their tall, plume-like flower spikes after they have bloomed because, along with her many grasses, they add structure and motion to the winter garden.

To retain her water view, Loretta has kept the plantings deliberately low, interrupted only by a few strategically placed birdhouses designed by the artist and built by her talented husband. In the center of the main garden, a small path leads to a brick-encircled bed of bulbs and annuals over which a great stone cat presides. Circling above his head are a pair of bright soaring gulls, sculpted in steel by local artist Gil Whitman, that reflect the garden colors and cast their ever-changing shadows on the flagstone walk.

Although Loretta has lavished the bulk of her attention on the seaside garden, she has fully wrapped her house in beds and borders, each with its own unique features. The wide brick and bluestone walk that leads to her front door is edged with a frothy mix of forget-me-nots, violas, and sweet woodruff. The spaces between the pavers are filled with spreading creepers: hen and chicks, woolly thyme, creeping baby's breath, rockfoil, and blue star. Nestled in this patchwork is a variety of small cast stepping-stones that the artist has collected over the years. At the opposite corner of the house,

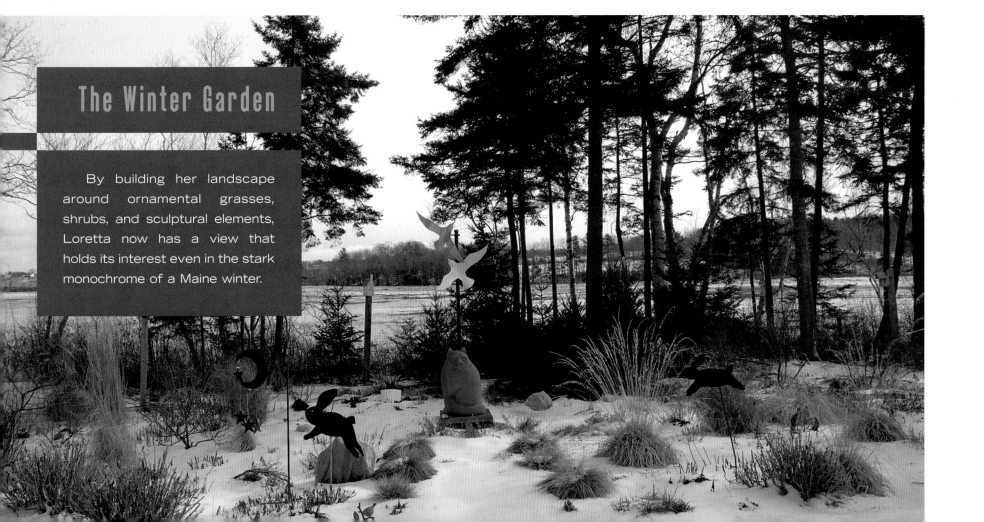

The Winter Garden

By building her landscape around ornamental grasses, shrubs, and sculptural elements, Loretta now has a view that holds its interest even in the stark monochrome of a Maine winter.

under her studio windows, is a long bed of showy oriental lilies, which she is in the process of replanting in mauves, pinks, and lavenders for a more uniform color story. Near her back stairs she has managed to control an invasive pink *Filipendula* in order to enjoy the cotton-candy plumes it produces for a few short weeks every year. Butterflies are attracted to the delicate star-shaped flowers of ragged robin (*Lychnis flos-cuculi*) that she has planted nearby.

A dedicated journal keeper, Loretta tracks her successes and failures from year to year, a habit that led to her first book for an adult audience. Since 1990 she has written and illustrated twenty-seven children's books, garnering praise and awards for the fine-art quality of her work. In 2006 she published *A Maine Artist's Garden Journal*, a charming chronicle and guidebook for gardening on the coast of Maine. She continued

to paint the coast she loved, but she felt the work was becoming predictable and perhaps too easy. When an exhibit of historical photographs depicting the working waterfront in nearby Rockland caught her imagination, Loretta was energized by the idea that she could research these places and people, many of them ancestors of local residents, and bring them to life in her work. She knew that all her years of studying and painting the coast—the moving water, boats in the wind, weathered wharves and fish houses, stormy skies—were leading her to this new venture. She spent the next four years scouring historical societies, maritime museums, and public and private collections for the information and images that would inform her paintings. The result is a series of large, detailed, atmospheric canvases that trace the maritime history of the Maine coast with an integrity and beauty that only Loretta could offer.

She also continues to write and illustrate children's books, and her collection of historical paintings will be published in a new book on the maritime history of midcoast Maine. She can't seem to stop painting, spending the dark nights and long, cold winters in the warmth of her studio. But when the shy white blossoms of snowdrops begin to peek through the blanket of white in Loretta's yard, and the great blue heron returns to the tidal cove, she will shift her attention once again to her gardens, and a new season will begin.

LEFT: *Bringing Home the Herring–Matinicus Island, Maine, 1913* is one of Loretta's meticulously researched paintings depicting Maine's maritime history. BELOW: The artist and her Maine coon cat, Max, who is a frequent model for her children's book illustrations.

Annette Kearney

a freeform mosaic

The many rooms of Annette Kearney's spacious Victorian home are filled with art. Walls are covered with paintings, drawings, prints, and collages; tables and countertops display sculpture and pottery; larger three-dimensional works inhabit hallways and stair landings. While most are pieces she has collected over the years from fellow artists, a good many are her own creations, yet, because of the diversity of her work, it's almost impossible to identify with any certainty which are which. Stacked on one wall are four small abstract encaustics from a series of Annette's recent explorations in that medium. An elegant settee is filled with her intricately embroidered pillows depicting flowers, fish, and figures. On a lacquered grand piano in the front parlor stands her favorite "fetishman"—a two-foot-tall mixed-media sculpture inspired by the *minkisi minkondi* of the Congo, which are believed to possess magic powers.

Annette's skill in manipulating these disparate media is impressive. She has a degree in political science, but she has spent a lifetime teaching herself the tools and techniques that allow her to express herself so adroitly in wax or fiber or paint or clay. With each material, she has produced a body of work that is prolific by any standards. The pieces can be counted in dozens or even

hundreds. Her third-floor studio is filled with boxes of her latest collaborative efforts with a fellow artist—jewelry that has been artfully assembled from slices of painted papers, then sealed with a glossy, durable finish. In an adjoining room, bins of intricately glazed majolica tiles await firing for a commissioned installation. Her mastery of media and her expressive use of color come through in all her pieces. Whether she's making crocheted sculpture, encaustic collage, tile mosaic, or sculpted assemblage, Annette doesn't ever seem to exhaust her enthusiasm for the work. The one unifying theme of it all is constant experimentation.

LEFT: Surrounded by a profusion of foliage and blooms, this "fetishman" is right at home on the front porch steps.
RIGHT: Pots of colored wax, oil pastel sticks, and a variety of artist's brushes are the staples needed to produce Annette's colorful encaustic paintings.

The same can be said for her gardens. This corner lot in a graceful old city neighborhood has been the perfect place for her to experiment with an even more challenging medium—nature. As with her artwork, Annette doesn't do much preliminary planning or have any preconceived ideas of how things will work out. She starts by choosing the raw materials—perennials, vines, annuals—that interest her. Her choices are driven not by detailed botanical information (she doesn't bother to read the tags on the nursery pots), but by color or form or foliage, or perhaps because there's a fabulous deal she can't pass up.

Just as nature abhors a vacuum, Annette doesn't tolerate blank spots in her gardens. She plants any new finds where she has room in this densely packed yard and watches what they do. If they work, if they take to that particular spot, if they create a visual that Annette is pleased with, they stay. If, for any number of reasons, the location doesn't work out, she moves the plant and continues to try others in that spot until she finds one that does work. But that might not be the end of it. If the plant becomes overgrown or spreads too much, it might be moved again or be given away to a passer-by. Working in this way might frustrate some gardeners, but it fits Annette's personality just fine.

For Annette, the gardens are a work of art she began twenty years ago and doesn't plan to finish. What she started with was a hedge, some sparse plantings, masses of maple tree roots, and a lot of very infertile soil. With the help of a friend, she created a border around the house and has been moving outward ever since. From spring until fall, the sunny front garden is a shifting spectrum of blooming bulbs, perennials, annuals, and vines. The sidewalk is overhung with arching stems of pale purple hosta flowers. The stairs to the front door are lined with potted annuals in every color, and saucer-shaped leaves of lady's mantle nearly conceal the treads. Even the tree belt between sidewalk and street curb is filled with silver artemisia, ligularia, and some prolific yellow-flowered mystery annual. Years of adding nutrients to the soil have created a rich growing environment, so now Annette uses only top-feeding fertilizers. Annuals and perennials—malva, cosmos, artemisia, nicotiana, sweet peas—self-sow throughout the yard. In this mix of sun and shade the only thing that will not grow is a lush green lawn, something Annette loves but has learned to do without.

Growing up in Virginia, Annette developed an appreciation for manicured yards and well-tended flower beds. Because she inherited her mother's acute sense of color and design, both art and gardening came naturally. As a young woman she honed her horticultural skills in the fertile environs of southern Florida and northern California. She continued to garden in northern New England and began a large collection of houseplants so she could be surrounded by growing things even in winter. Rather than part with them in the family's move from

Vermont to Maine, she, her husband, and their three preschool-age children lived for weeks in a hotel room amidst dozens of pots and planters. Many of the plants survive to this day in the sunny windows of this fine old home.

Gardeners seek gardeners, and as Annette started to transform her new property she met a number of like-minded and generous neighbors. She especially admired the beautifully precise style of one woman, and in spite of their very different approaches they became close gardening friends. Wanda Grasso's gardens were planned and laid out within a carefully considered color scheme, and just the right amount of space was left between each exquisite plant, yet this formal design had a marvelous life to it. Over time, half of the plants in Wanda's garden were divided and moved to their new home on Annette's wild corner lot. Annette would strive to create the same effect in her yard, but, like different cooks working from the same recipe, the results were never the same.

Without a grand plan to follow, Annette's gardens have evolved into a magnificent free-form mosaic of foliage and flowers, hardscape and sculptural detail. The acid-soil–induced intense blue of Endless Summer hydrangea and the velvety royal purple of

LEFT: Architectural elements are tucked among the foliage in a shaded garden that includes goatsbeard and mini hostas.
RIGHT: Lady's mantle is allowed to creep across the stone steps to Annette's front door.

Clematis X *jackmanii* play off clear orange daylilies and golden yellow self-seeding sunflowers. White mop heads of Annabelle hydrangea droop gently with their full summer weight, while purple phlox, pink cleome, and giant blue delphinium stand at full attention in the midday sun. The shady side yard is a haven for a dozen different hostas, many of which were left here by well-meaning neighbors before the versatile cultivars became popular. Other shade-loving perennials sprout up among them, adding color and texture: rosy astilbe, creamy goatsbeard, silvery lamium, pure pink bleeding heart, and a variety of ferns. Through this lush foliage, a path winds its way to the brick patio that Annette built years ago over huge tree roots and the clinkers of an old coal dump in her backyard. Along the edges of the path, tucked into nearly every bit of space between plants and dotted liberally around the patio, are dozens of blooming annuals in pots made of clay, stone, iron, and decorative cement.

Russet-, pink-, and burgundy-accented leaves of three different coleus plants share a single large urn on a raised platform. A pale pink fuchsia that survived the winter in a simple clay pot is tucked among the ground covers. A twelve-year-old clivia spends the warmest summer months in a sunny spot by the back porch. But of the ninety or so pots in this yard, most are filled with impatiens, the one plant that Annette has complete confidence will grow here. Because she adds new plants directly to garden beds only in spring and spends the rest of the season "ed-

iting," wherever she creates a blank spot, she fills it with one of these potted impatiens. Then in late summer and early fall, as many of the perennials are dying back, Annette buys large flats of annuals and pots them up for instant foliage and color. Although she tends toward pinks and corals when choosing plants, she doesn't follow any color rules in the garden. This year almost all of the potted impatiens are pure white.

Annette is quick to admit that nature gardens for her. Over the years, spots in the yard that were once sunny have become shaded by the spreading branches of maple and spruce trees. When the city offered her an Asian katsura they were discarding, assuring her it would not grow large, she planted it near the street corner. Nearly two decades later the twenty-five-foot tree creates a broad canopy of heart-shaped leaves that turn brilliant yellow in fall. When she recently lost a large maple, she filled the spot with a sun-loving species of hydrangea. Other felled trees have left natural pedestals for planters of annual flowers.

Casual visitors assume that it requires less work to create this loose, free-flowing type of design than it does a formal, planned garden. But Annette works at it every day of the growing season the same way she creates art every day of the year. In some ways nature influences her art as well as her garden. On a cool June day she will retreat to her studio to work with the warm melted beeswax she uses to create encaustics. The wide variety of lilies she grows has inspired

LEFT: The structure and color of daylilies and clematis flowers are the inspiration for the artist's majolica tile mosaics that grace both private and public spaces around the country.

BELOW: What started as a simple ring of hostas has grown to the edges of the yard. Some of Annette's favorites include 'Sum and Substance,' 'Blue Wedgewood,' and 'Iceberg.'

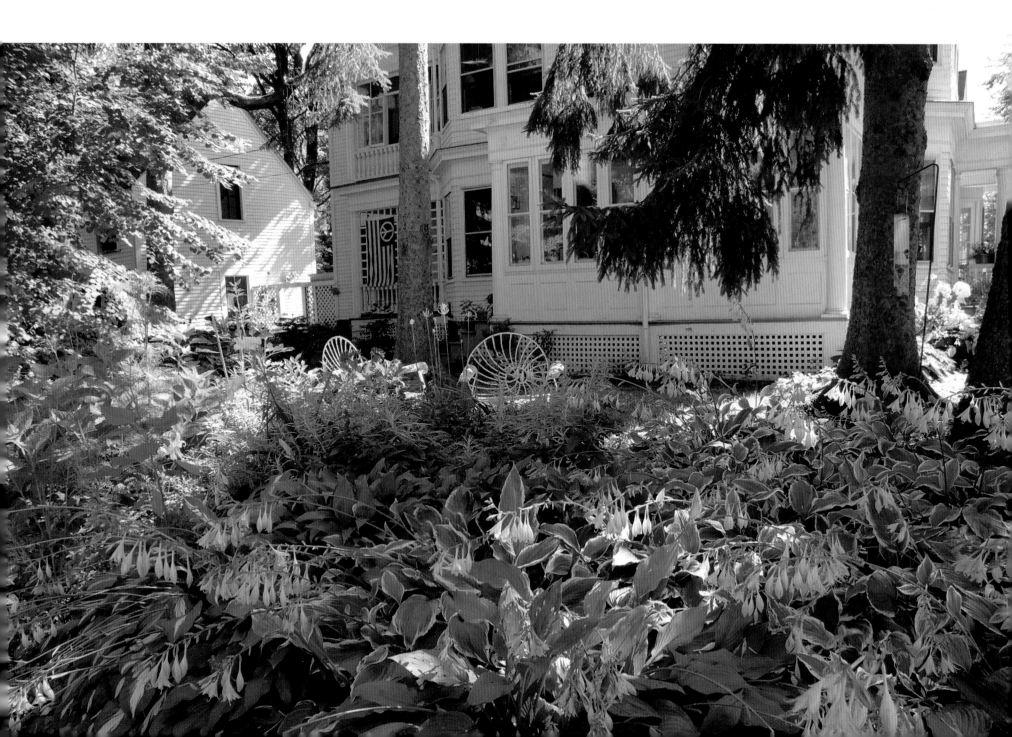

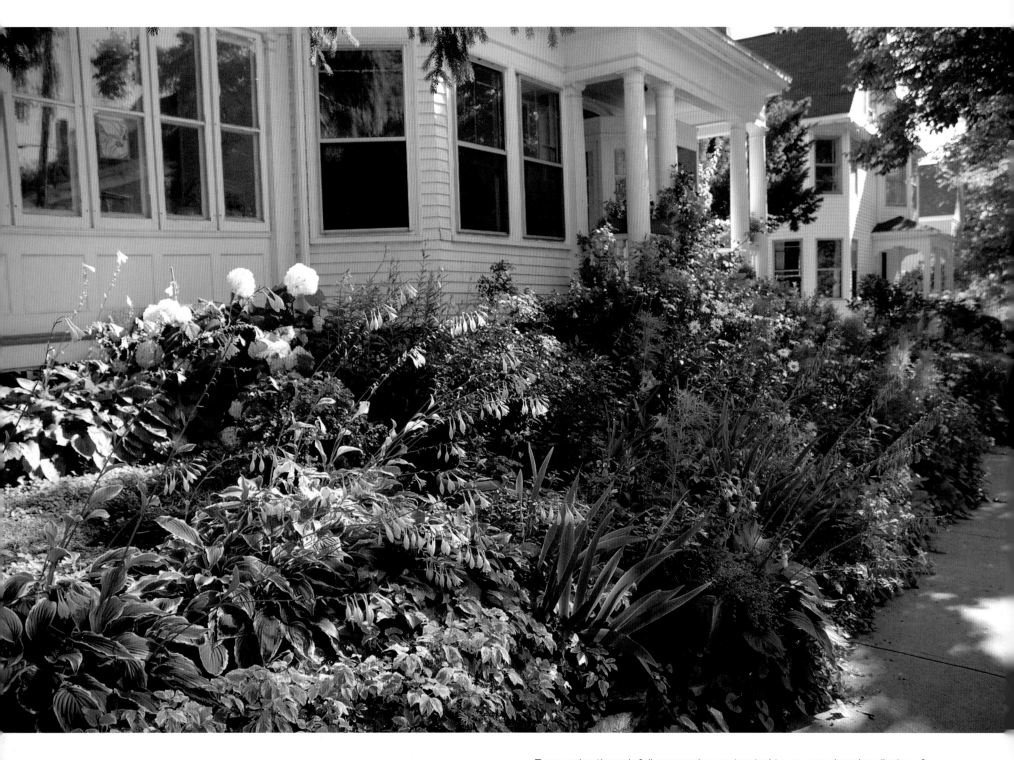

From spring through fall passers-by are treated to an ever-changing display of color, texture, and scale spilling over the stone walls that wrap two sides of Annette's corner lot in this gracious urban neighborhood. Rare blank spots are quickly filled with potted annuals as one season's blooms give way to the next.

scores of art tiles. She borrows colors from her gardens to use in her work and seeks out plant materials that satisfy her sense of form and texture.

For Annette, gardening and making art are a compulsion not to do the same thing day after day but to create something new each time. Even with artwork that exists as a series, such as her mosaics, no two are the same. Nor can she re-create a work from the past in exactly the same manner. She works across several different media at the same time, sometimes within the same piece, other times on seemingly very different pieces. If she discovers a medium or a process that interests her, she'll turn to books to learn the technique and work until she has mastered the skill. But it is her passion for experimentation that allows her to make the materials her own. She once felt that this broad-spectrum approach made her a jack-of-all-trades but master of none. Years of working between her studio and these gardens have changed her thinking. Unwilling to settle into one narrow means of expression, she knows she is still honing her eye and that the material is irrelevant.

It's no surprise, then, that nothing remains of the original garden Annette planted here twenty years ago. Instead, like an old canvas that has been overpainted many times, this space has hosted several different gardens. Each has been both the result of and the reflection of her development as an artist. Now this compulsive artist and gardener is preparing to do some serious thinking about what type of garden might come next on her corner lot. She could choose to dig it all up and start again, but one thing is certain: Just as it is today, this garden will always be a magnificent work in progress.

Tucked among her brightly patterned pillows, Annette takes a moment to relax with Twiglet. The pansies, daylilies, and leaf forms from her gardens are evident in her needlepoint designs, as they are in much of her other work.

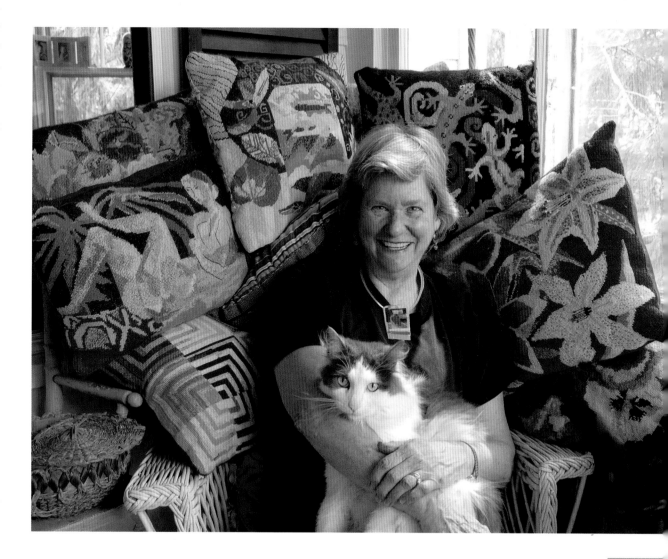

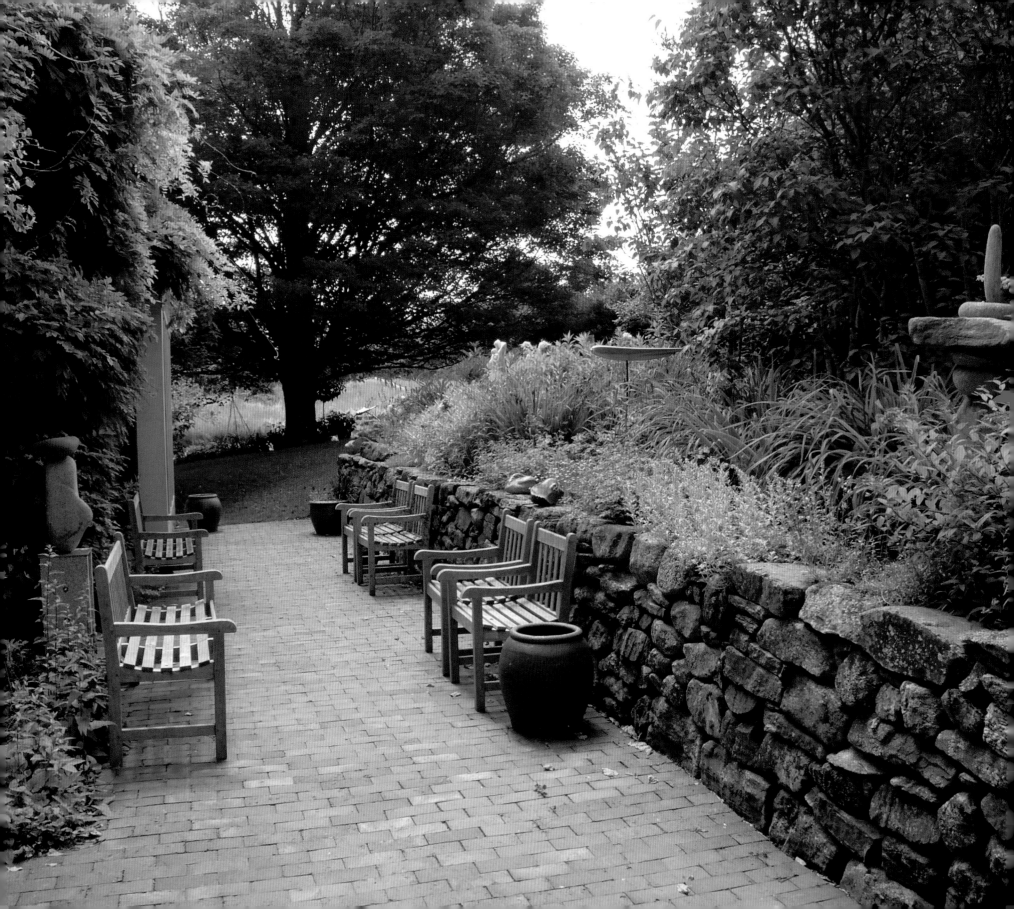

June LaCombe
giving voice to place

It is not easy to define June LaCombe in simple terms. She is an accomplished gardener and a dedicated artist, but she is also a very successful curator, a serious art collector, a lifelong naturalist, a student, an educator, and an advocate. She has so seamlessly integrated these many aspects of her life that, in every endeavor, she is never just one but all in differing proportions. When she speaks of the inseparability of one aspect from the others, she communicates in such a thoughtful manner that her quiet demeanor nearly belies the deep passion she feels for what she has created, and continues to create—a life built on exploring and challenging the boundaries between the ideas of "art" and "garden."

The back roads of Maine are full of surprising treasures, and June LaCombe's gardens are a wondrous example. Hawk Ridge Farm, at the end of a long gravel road, is the home and studio she shares with her husband, Bill, and the center of her creative expression. Purchased thirty years ago, this working farm had a fine core of old maples and ancient pear and ash trees. Today the meticulously restored and expanded house is entirely surrounded by gardens, fields, and woodlands that June has designed specifically to showcase works of art from her own extensive collection as well as from the

artists she represents. In 1996 she curated her first exhibition of sculpture in this environment as a way to "give voice to place." This concept, originally expressed by earth artist, art historian, and photographer James Pierce, resonated so strongly with June that she has been exploring the relationship between sculpture and setting ever since. "Sculpture, like the landscape, has a resonant energy. When, through careful siting, it becomes the focus of a place, you start to see both with greater acuity."

From the handsome, light-filled addition where June hosts art collectors' groups from around the country, sets of French doors open to a long brick patio backed by a wall of dry-stacked native stone. Lined with weathered cedar benches and large, simple

LEFT: The stone wall that encloses this side patio was specifically designed to display sculpture at eye level. RIGHT: On a sunny ledge in June's office, peony blossoms fill a carved stone urn by Stephen Parmley.

Gary Haven Smith's *White Line* is tucked among the foliage in a shaded spot.

urns, the three-foot wall is specifically designed to exhibit smaller sculptures at eye level. A precisely balanced stone piece by John BonSignore and an elegant marble by Constance Rush reside among the double pink peonies, irises, lady's mantle, rosy spirea, and silver artemisia that tumble over the edges of the densely planted bed. The permanency of the sculpted materials, backed by a deep green screen of late-blooming Japanese lilacs, enhances and is enhanced by the shifting colors and textures of the surrounding flowers and foliage.

Curving around the back of the house are large specimens of honeysuckle, native aster, witch hazel, and a flowering almond shrub that June has pruned into tree form—its fragrant creamy peach flowers covered with bees each spring. The yard is edged with a mix of mature shrubs that define the space: highbush cranberry (*Viburnum trilobum*), autumn olive, quince, double-file viburnum, rose of Sharon, and shadbush. A hedge of forsythia, started with cuttings from June's grandmother, balances a row of sweet-scented mock orange, her grandfather's favorite.

Toward the house, the gently sloping lawn leads down to a low semicircular stone wall, which wraps around a giant pear tree before fading into the ground at the far end. This earthwork, along with a mirroring pair of paisley-shaped beds that bloom with cream-colored tulips in spring and white impatiens in summer, was created specifically

for the purpose of presenting the tree and was inspired by the work of early earth artists. June has studied the art and artists of this still-evolving movement for many years and in 2004 completed doctoral studies at Antioch New England in a self-designed program researching the integration of environmental art into the field of environmental studies. She believes that the work of artists such as Lynne Hull, Agnes Denes, and Ana Mendieta can teach us as much about our relationship with the environment as can scientific study. "The arts engage the emotions, and that may be the spark needed to stimulate action," she says.

At the edge of the lawn, a rustic gate opens to a stone path that wends its way down a fern- and hosta-covered slope under a canopy of shade trees. Fittingly nestled in the vegetation is a striking set of white terra-cotta *Fiddleheads* by sculptor Sharon Townshend. The path leads to a discreet swimming pool, lined black in order to more naturally resemble a pond. The surrounding

ABOVE: Works in stone of varying colors and textures blend and contrast with the hardscape and plantings throughout the property.
LEFT: *Chairs* by Melita Westerlund and *Eros Snake Eros Woman* by Squidge Liljeblad Davis are shown by the poolhouse.

brick patio includes a small post-and-beam pool house, its flush board siding covered in lattice and climbing vines. At the far end of the pool, a large flat-topped rock serves as a diving platform. Whimsical, brilliantly colored metal chairs by Melita Westerlund offer a place to sit and study the wildlife that frequents the fields beyond.

In addition to creating a venue for sculpture, June's reverence for the land inspires a stewardship that includes organic gardening practices and the creation and preservation of wildlife habitat. She also raises peacocks and a small flock of chickens, which are let loose in the perennial beds each spring so they can gently 'till' the newly thawed soil. In wide fields that parallel the gardens, her horses canter and frisk in a rotating landscape of fresh clover. Indigo

buntings, attracted to movement and sound, frequent the stone fountain just outside June's office window. In their dedication to resource preservaton, June and Bill have replaced their inefficient windows, added insulation in the original parts of the house, and installed a wood-pellet furnace, which uses the waste wood so abundant in this forested state. They use an old-fashioned clothesline. They hope their home can become a model for sustainable life practices as well as a living gallery.

June's senses are acute and tuned into this rich environment, and she is particularly attracted to sculptors who share her sensibilities: those who work with earth's elements —particularly stone and wood—and who listen to the materials in order to create work that goes beyond what it might represent.

Sculpture in the Landscape

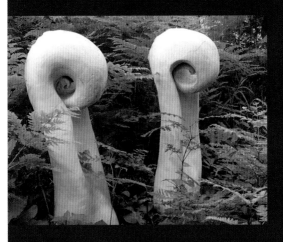

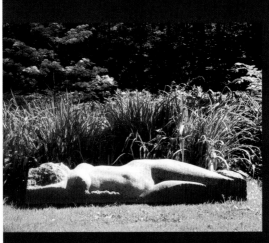

"My goal is to find the right piece of sculpture for the setting so that both will resonate in new ways. Sculpture can help us explore our relationship with our environment and give years of contemplative pleasure. There is a changing role for sculpture today. Sculpture holds a place in a garden or landscape, making us more aware of natural forces. It sets up a relationship with the land and enlivens a place. Sculpture can provide a focal point for a contemplative garden. A strong piece of sculpture will continue to reveal itself over time and celebrate the beauty of the material, the sensual appreciation of form, and its setting."

–June LaCombe

Over the years June has sited sculpture in temporary exhibits on her property.
TOP: *Fiddleheads* by Sharon Townshend
MIDDLE: *Daphne* by Celeste Roberge
BOTTOM: *Landscape* by Cabot Lyford

Many of pieces she shows bear evidence of the material in its raw form, before the artist's hand touched it. In selecting and siting this work on her land or elsewhere, she hopes to expose the viewer to a different way of interacting with the natural world, to engage with a material or a place without dominating it.

The opposite end of June's property is divided into three distinct environments. At the far edge is a large field of tall meadow flowers that sway rhythmically in the gentle wind. Mown paths lead the way through clover, fragrant lady's bedstraw, starflowers, vetch, milkweed, and blackberries. Along the far hill, June has planted a contour of lupines that have spread among the native dock, buttercups, daisies, and hawkweed. Placed throughout this field are a half-dozen large sculptures in stone, steel, and wood. Upon encountering them in this setting, one begins to experience the work in the way June intended. A set of large wire figures by Jean Noon seems poised to reveal the negative space between them. The bristled form of Celeste Roberge's steel and copper *Daphne* reflects the structure of the wild vegetation around it. At night a plum tree at the edge of the field glows with pod-shaped orbs by light sculptor Pandora LaCasse. Under the tree a stone table provides an ideal midsummer setting for a feast of locally grown organic food; June regards cooking and sharing these meals as another component of the art process.

In the center of this vast front yard, June has designed and planted a garden that produces many of the organic vegetables, fruits, berries, and herbs she serves. The garden is laid out in a herringbone pattern of diagonal rows—increasing in length and planted according to crop need. Shorter rows toward the front of the bed are reserved for smaller crops of herbs; longer rows are for larger plantings of lettuces, peas trained on twig trellises, green onions, tomatoes, broccoli, and corn. Along the center path, the rows terminate in annual flower varieties. A grapevine rambles along a simple back fence and over an arbor that leads to the field. In the bright sunshine of the lawn, Andreas von Huene's black granite *Raven* watches over a bed of rhubarb.

Across the yard, the road is edged with a meandering bed of pagoda dogwoods and

The soft curving forms of *Seed of the Soul* by Constance Rush and *Leda and the Swan* by Katie Bell are perfectly suited to the colors and textures in this bed of double pink peonies, both tall and creeping phlox, silvery artemesia, and irises.

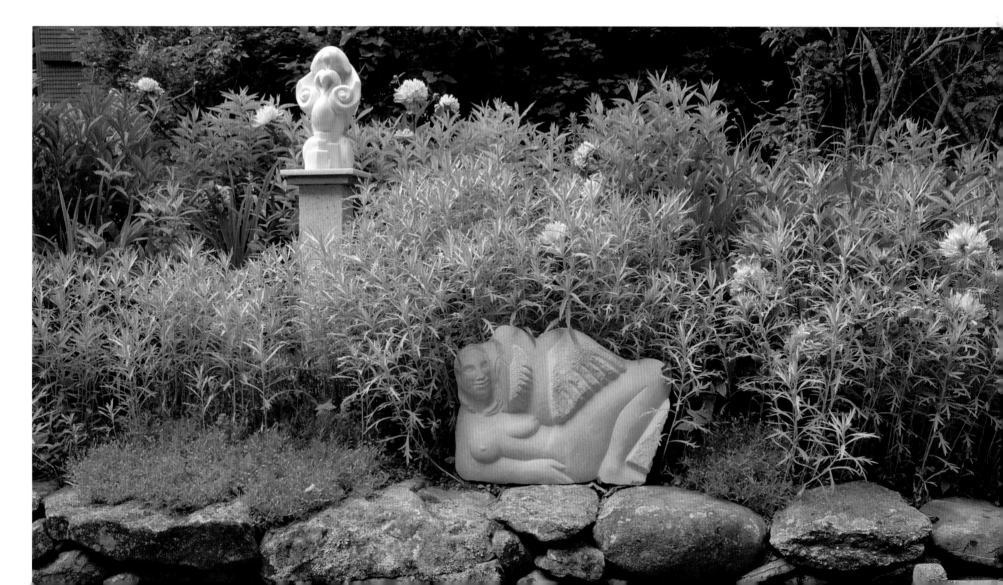

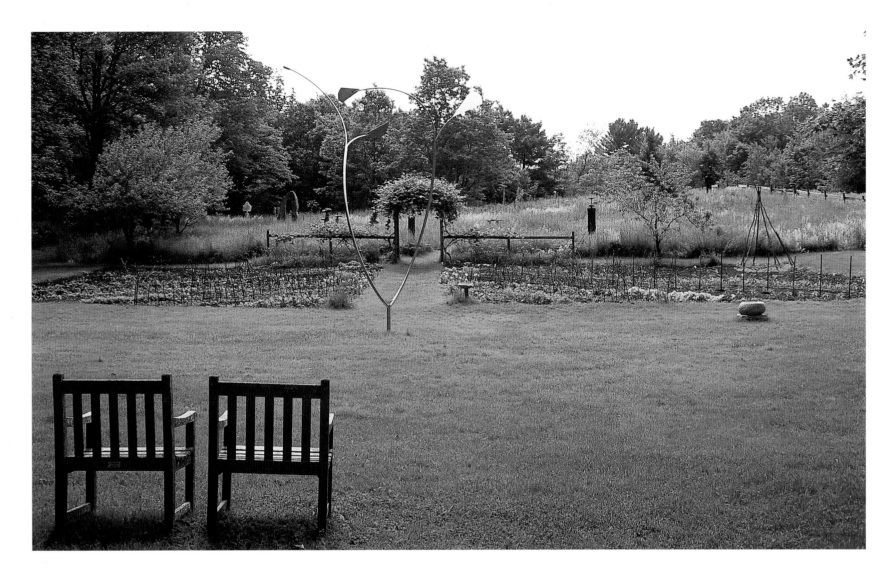

June's property includes several diverse growing environments. On the open southeast side of the house, George Sherwood's kinetic sculpture, *Curves of Life* rotates slowly in the breezes that sweep across the wide lawn. The opposing pair of angled rows beyond are planted with herbs and vegetables to take advantage of the full sun. A grape arbor marks the entrance to the field of wildflowers and sculpture beyond.

hawthorns under towering stewartias. Groupings of old roses in a spicy, deep velvety pink are interplanted with lilies and dozens of varieties of antique columbine. Sprouting from seeds that June discovered around old house foundations while exploring the woods on horseback, the single, double, and triple columbines bloom purple, pink, and white each spring. Sited along the edge of the bed is a magnificent reclining nude, *Landscape*, by celebrated sculptor Cabot Lyford. Beyond the row of boulders,

midday shade provides an ideal location for Gary Haven Smith's granite and moss piece.

The remaining lawn is left open but for a select few sculptures that balance this expanse of green in form, scale, and material. The opposing arms of George Sherwood's kinetic *Curves of Life* rotate with the movement of the surrounding air. A pair of figurative gray granite abstracts by Roy Patterson glisten almost white in the strong sun. A line of mature maples that shades the house in the summer heat seem perfectly spaced to

BELOW: A trio of stone pieces by Jon BonSignore rise precariously from the tall grasses.
RIGHT: June sculpts leaves on a fall day.

accommodate smaller works, such as one of Cat Schwenk's *Earth Books*. Come fall the maples also provide shade for June as she creates her own artwork.

Considering June's strong connection to place, it is not surprising that she often uses the raw materials around her as her medium. A decade ago when she and her husband returned from a ten-month residency in New Zealand, she saw her home with fresh eyes. She began to collect the big downy feathers shed by her peacocks, the vines from her grape arbor, iron ochre from the Indian paint pot mine in her own back woods, and shards of mica that littered the local landscape from an old feldspar quarry. With them she created a series of spheres that became touchstones for her journey back to these places she loves and the materials she had missed in her absence. Today she works primarily in clay because of its tactile nature. She remembers creating pinch pots as a child, and in her years as educational director of the Maine Audubon Society

she often worked with groups of children digging clay from the riverbeds and experimenting with open-pit firing.

Hers is a meditative art process; on brisk autumn days she will sit with the leaves swirling around her and absorb the beauty of this place, then work to express that beauty by hand-sculpting the twisting, curling leaves of clay. Her pieces are a form of note taking. When fired, the light, fragile bisque leaves evoke the essence of place.

June believes that living with art can be an important next step in our development as a society, nurturing a more contemplative, less consumptive lifestyle. With her own work, her exhibitions and patronage of

sculpture by other artists, her continued study and frequent lectures on the integration of environment art and education, she strives to engage people in a process that is her source of constant exploration. Each year the sculpture she exhibits changes, but the meaning remains the same. "Celebrate the place, stimulate the senses, and understand with greater depth our connection with the earth." June's gardens are a living example of that connection, and her advocacy is strengthened by sharing the gardens with others. At Hawk Ridge Farm we see how sculpture in the living landscape can nurture the poetics of place, and the boundaries between art and life begin to blur.

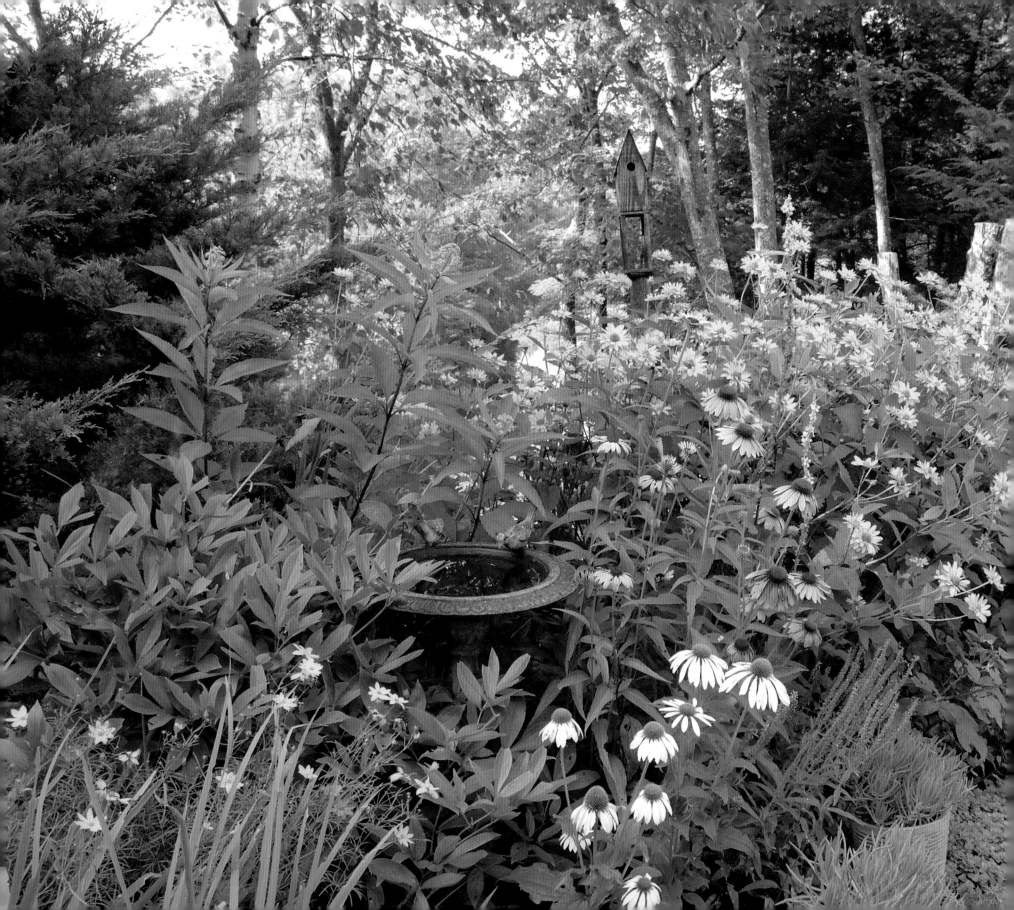

Sara Crisp

an impulse for pattern

"A lot of people loved the mill, but no one knew what to do with the house." Artist Sara Crisp is referring to the low, rambling 1970s California deck house where she has lived and worked for the past seventeen years. Nestled into a neighborhood of traditional Maine saltboxes and capes, this midcentury, West Coast–style residence does not fit the vernacular. And that was just fine with Sara. The two-hundred-year-old sawmill, which sits thirty yards below the house over the Lesser Piscataqua River, now functions as the studio and workshop of Sara's husband, fine-furniture maker Gregg Lipton. Together the couple has transformed this unconventional property into a magnificent sanctuary for their art and their lives. And this property has transformed them.

When Sara and Gregg bought the house, there was a bare lawn and a few plantings—an old rosebush and some pale pink peonies, which bloom to this day. On the ledgy slope behind the house were tree stumps and great mounds of sawdust—the remains of what had once completely covered the hill until the late 1950s when the mill ceased operations. Today the house is fully surrounded by paths, sculptures, water features, and a magnificent mix of trees, shrubs, perennials, and annuals.

In her characteristically humble way,

Sara explains that she knew little about plants at first. Her previous city home provided her with a small area to garden, but not much of a sense of place. In the beginning, fellow artist and accomplished gardener Greg Parker walked her around her new property and told her what each plant was, identifying the weeds and getting her started by giving her what are now some of her favorite plants, including a wide variety of sedums. Sara appreciates them for their structure, a characteristic that plays an important role in her art and this garden.

The work started with a broad bluestone patio that connects the back of the house to the borders on the embankment's edge. Conceived by an old friend, master

LEFT: A sweep of brilliant gold heliopsis, pink and white echinacea, and yellow coreopsis create a natural repetition of shape and form.

LEFT: Sara is attracted to the radial structure of allium flowers even after their color has faded.

Lichen-covered rocks are surrounded by lush green moss that thrives in the cool shade of the house. Across the bluestone patio, a border of sun-loving perennials glows against the deep green of the juniper beyond.

gardener Lynn Shafer, the patio was the first step in creating a loose symmetry of formal and informal plantings that suited the lifestyle of a young family. Shafer went on to design a landing at the bottom of the embankment as well as hardscape for the front gardens. Connecting the patio and the landing below is a set of recycled curbstone steps built by Lance Linkel, an accomplished mason who constructs piers and other stone structures along the coast. The backdrop of evergreens on the embankment was opened up a bit to provide a view of the river. To reconcile the living, working, and recreational areas of the property, the gardens near the house were made the most formal; they become less so as they move down toward the river and give way to the wild.

Sara subscribes to the theory that there are two differing impulses in the creation of art. One compels the artist to orchestrate the viewers' experience. The other leaves the viewers on their own to experience the work, often taking from it much more than

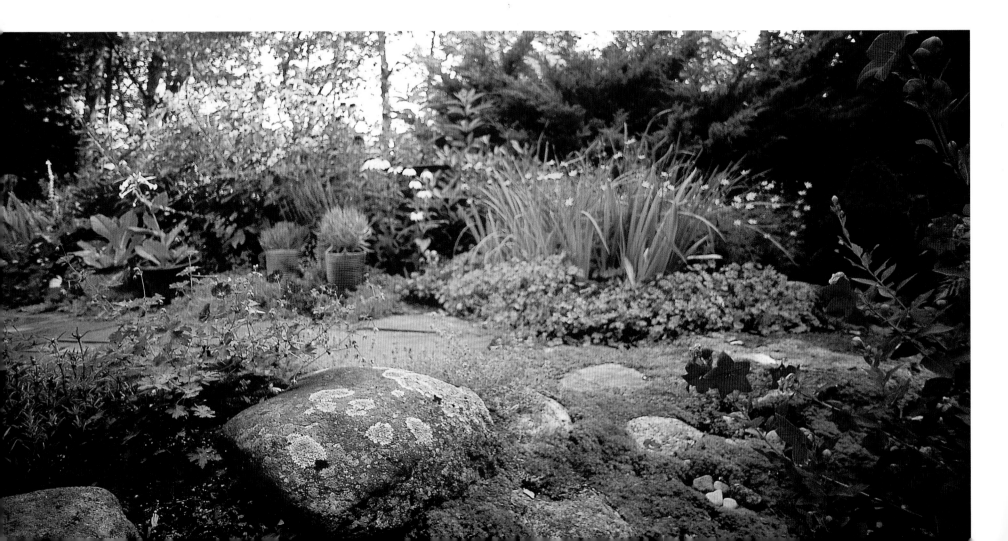

the artist had consciously intended. Sara's approach falls into the second category. The work flows more naturally and is more successful if she doesn't overthink it. It is the same way in the garden. When the bones of the plan were in place, Sara took over the planting, discovering by trial and error what works and what does not. The results in midsummer are a dense mix of colors and textures, varying shapes of foliage, masses of bright blossoms, and the real sense of the joy that Sara feels in this too-short season. She loves the volunteer columbine and mullein that crop up amidst the peonies; the ferns that continually creep in from the woods; the pathways overgrown with creeping phlox, volunteer portulaca, and pink perennial geraniums; and the blue-green leaves of an enthusiastic baptisia that obliterate some of the sculptures.

So it is not surprising that the technique that has become the signature of her artwork came to her in an almost unconscious moment. For most of her career, Sara worked on the edge between two- and three-dimensional media. After studying in Maine, she earned her BFA in painting at the Rhode Island School of Design, where she began experimenting with handmade paper in various guises. She transformed the flatness of the paper by creating sculptural

The perennial garden at the edge of the embankment frames a view of the mill below. Sara has learned that letting plants spread and intermingle results in constant foliage and color interest through the short growing season.

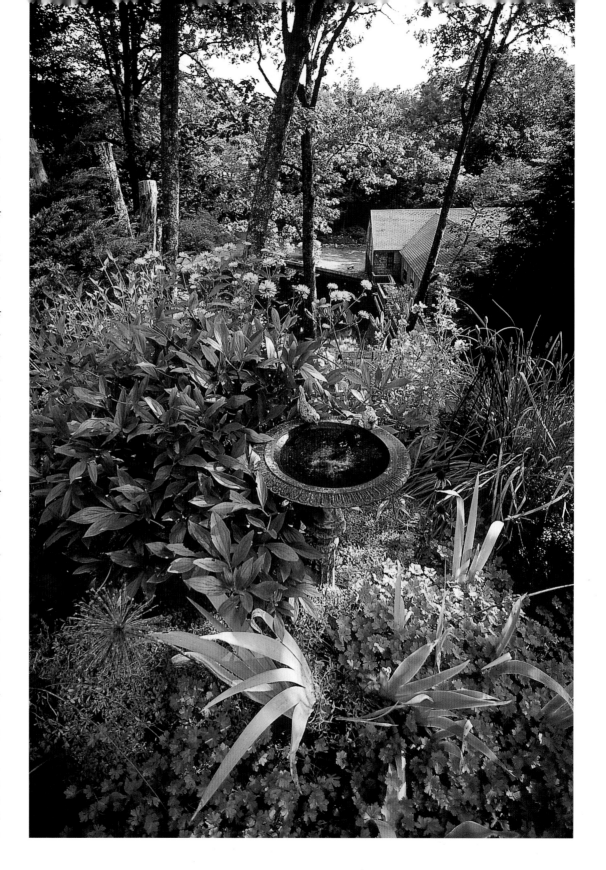

A shallow metal bowl makes a perfect reflecting pool and contrasts with Sara's collection of terra-cotta pots. The grays and greens of the hardscaping and foliage create a neutral base for the spectrum of floral color.

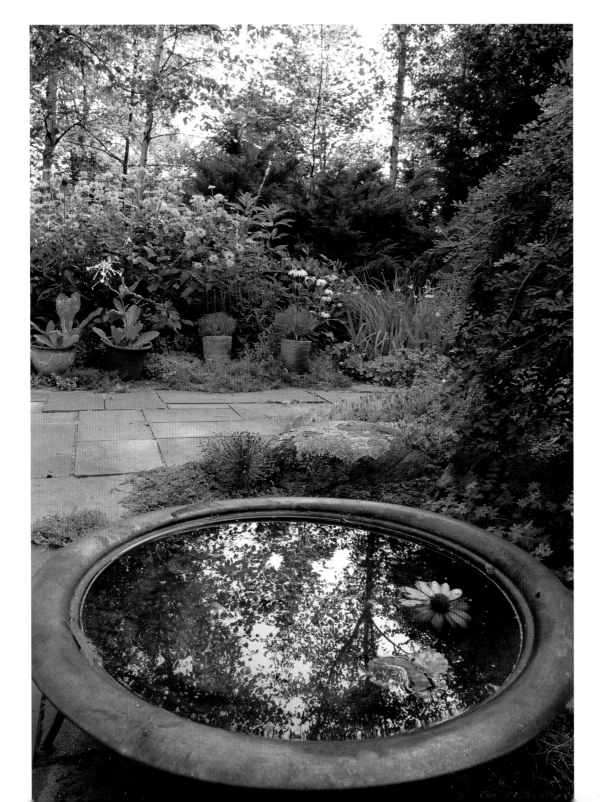

pieces from the sheets and casting found objects such as lengths of Concord grape vine directly into the material. That same vine continues to produce fruit in Sara's yard. She created handmade paper from the long fibers of daylilies and irises, a fairly traditional technique that takes advantage of the flowers' fiber structure. But the process was labor intensive and gave off an offensive odor, and she wanted to start working in a smaller scale. After finding some small squares of colored wax that she had picked up at an art-school sale, Sara abandoned paper for the intriguing medium of encaustic.

The ancient technique of painting with melted pigmented beeswax has its origins in several cultures; it enjoyed a resurgence in the mid-twentieth century with the work of modern master Jasper Johns. Because the wax is impervious to moisture, it will not darken or deteriorate and does not have to be protected under glass. One day while working in her studio, Sara impulsively embedded a dried protea blossom in the hot wax and immediately knew she had created something that would change her art.

She began to collect and use a wide variety of natural objects in the paintings. Starting with a gessoed board, she layers wax and pigments, then draws and carves patterns into the layers. She then selects the objects she will include in the piece. Often they repeat the patterns already created on the surface. Working from the back, she cuts a hole in the board, fills it with wax, and arranges the objects in the opening, both encasing

and preserving them. She won't see the final result until the wax has set and she can turn the piece over. As precise and exacting as the preparation and pattern seem to be, Sara has no problem working blind. Her time in the garden has taught her to both expect and rejoice in the unanticipated.

The patterns Sara uses in her paintings have evolved over the years from a grid to a honeycomb to her latest fascination, the "flower of life." Created from a series of intersecting circles, this universal symbol has been imbued with sacred meaning by many cultures. This has compelled Sara to study pattern in more depth. She is captivated by the theory that humans have a natural impulse to create pattern for no other purpose than itself and that all of us relate to certain patterns because they have meaning—if not intellectually, then physically.

The items Sara embeds into her pieces have also changed over time. For a while she used objects such as bones, mica, butterflies,

and insects, which have more permanence than flowers and inherent meaning than she came to feel her work needed. She's now using more ephemeral objects in her most recent work, so plant material has become a staple of her studio supplies. An array of dried seedpods fills boxes and baskets in the windows of Sara's light-filled studio. Wax-encased leaves, feathers, and insect wings line shelves that run around the octagonal room. Pressed flower petals are stacked between sheets of paper.

On the sunny west side of the house is Sara's version of a cutting garden. Here she grows many of the flowers she uses in the studio. Dried alliums, coneflowers, and poppy pods, pressed anemones and poppy petals, the leaves of ligularia and hosta all find their way into paintings. Local florists and flower growers keep her supplied when her own inventory wanes, and she is constantly collecting new materials from farm stands and friends. At times she has much

more than she can use, and flower petals start to disintegrate before she has a chance to include them in a piece. Because she must harvest the materials while they are fresh, Sara's art and gardens are both strongly influenced by the seasons and the elements.

Trial and error has taught her which materials work in her unique process. Milk-

weed and poppy pods, acorns, and certain leaves hold their form and color when they come in contact with the molten wax. She can now sense what hue poppy petals might turn when they dry and which varieties of rose petals will hold their color. She has used the stalks of irises and the stamens of lilies to "draw" lines in some pieces. Pressing flower petals ensures that they will remain safely within the wax cocoon of the painting. Sara has experimented with flowers in three dimensions, also, but has found that curled petals will pull away from the wax as they shrink, allowing air to enter and cause the piece to deteriorate.

By carefully studying these natural materials, Sara discovers patterns that relate to and enhance the patterns she draws. In the resulting layered composition of pattern on pattern it can be difficult to tell where the drawing ends and the embedded object begins. It can still surprise her when she overlays a flower or a pod on a drawing, and the patterns fit together. As she works on a piece, the irregular natural pattern can become more regular, putting it in a different context. The object is thereby transformed to pure pattern, and its meaning changes. By combining the real and the drawn, the mathematical and the abstract, Sara says, she is attempting to "to select and catalog—perhaps deify—some small aspects of the natural world as they intersect with the human-made world of language and symbol and the world of the spirit."

The uncertainty of nature is something Sara has come to terms with, both in her art and in her garden. As with her art, she believes in experimentation in the garden. It's fine with her if a particularly vigorous plant takes over an area. If a new plant doesn't work out, she just tries something else. In an oddly shaped space between the living area and what is now her studio, water collects from several different roof sections. Instead of viewing this as a problem area, Sara used it as an opportunity to create a wetland garden where mountain laurel, ligularia, white irises, heuchera, and Japanese ferns have all grown large and lush. The excess water is directed down and away from the house in a

This simple stone trail helps to divert water away from the house to the moisture-loving mosses and groundcovers that grow in the cool shade of Sara's studio.

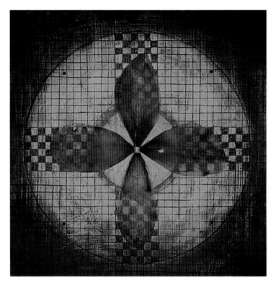

stream lined with beach stones (which have been known to wash away in heavy rain). In this shady corner of the backyard, lichen forms on the rocks, and mosses cover any unplanted earth as the cultivated gives way to the natural.

Implied in her work, Sara says, "are the themes of transformation and interconnectedness, which are part of being a mother, a partner, and a member of the human family. My work is inspired by the more ordinary aspects of the natural and human world, and what I sense as my place within it." She identifies this home, these gardens as the impetus to her work. "Living in this place has been very settling. My garden and my work have grown up together, slowly, right here."

TOP: The central shape in this untitled encaustic painting is created with dried tulip petals.
RIGHT: Surrounded by the natural objects that inspire her work, Sara scribes patterns into the surface of a series of panels.

Peter Milton

gardens in rhythm

LEFT: Peter uses a traditional Japanese method of tree support for the maple that provides the main color accent in this garden of tone and texture.
RIGHT: Pachysandra is one of the many groundcovers that thrive in the shade of these borders.

"This garden has become an elegy for itself —a creation that is done. I could add to it, but it doesn't need anything." The language Peter Milton uses to talk about his gardens is echoed in his studio as he discusses his artwork. Laboring over the large copper plate from which his next set of intaglios will be pulled, he explains, "So much is going on [in this print], it runs the risk of being cluttered. What I'm engaged in now is a conscious struggle to try and tame it." His prints, complexly layered and exquisitely rendered amalgams of engraving and etching, depict elaborately detailed architecture, interiors, and figures from various nineteenth- and early-twentieth-century historical and literary sources, balanced on a thin line between memory and imagination. He carefully burnishes a small area of the plate with the tip of a specialized tool, trying to eradicate any markings and soften the edges of what will become the globe of a gas lamp. In the final piece it will glow with the warm white of the paper on which it is printed.

An internationally recognized master of the art of printmaking, Peter has been granted more than a hundred solo exhibitions in the United States, Europe, Asia, and South America, and his work is in the permanent collections of the Metropolitan Museum of Art and the Museum of Modern Art

in New York City, the Bibliotheque Nationale in Paris, and the British Museum and the Tate Gallery in London. Five decades and hundred of prints have not diminished his passion for new work or his ability to enjoy what he has accomplished, including his gardens. In 1969 Peter and his wife, writer Edith Milton, moved to rural New Hampshire, where the artist devoted his time to printmaking and his young family. A decade later he began building a series of gardens that now encompasses most of the land around their elegant 1886 home. Each garden, conceived and constructed as distinct elements, is a study in composition and detail, independent of color. In certain light, a

pale green dome of perennial grass or the still water of a shaded pond might emanate a diffused glow reminiscent of the gaslight globe in one of Peter's prints.

Diagnosed with red–green colorblindness, Peter had long worked exclusively in black and white, so the elements he employs to compose his prints—line, shape, value, space, and texture—also became those of his garden. For his prints, he begins with a collage of photographic images, each carefully redrawn by hand with extraordinary draftsmanship. The final compositions, which often take months or even years to complete, are edited and re-edited until they are, according to writer James A.W. Heffernan, "spatially coherent . . . the components . . . are drawn into a three-dimensional world which they inhabit together. They are not simply juxtaposed."* The gardens have been treated in much the same manner. Says Peter: "Everything about [the gardens] is a momentary impulse—my sense of design tells me what the flow should be." Peter likens the gardens to collage. "I never know where I'm going when I start. For me, it's the discovery along the way that creates the magic."

*From James A.W. Heffernan, "Peter Milton's Turn: An American Printmaker Marks the End of the Millennium" Word & Image (vol. 16, no. 2, April/June 2000), p. 179. Reprinted in J.A.W. Heffernan, Cultivating Picturacy: Visual Art and Verbal Interventions (Waco, TX: Baylor Univ. Press, 2006), p. 258.

Starting at the back corner of the house, a great curving bed of shrubs, perennials, grasses, and specimen trees follows the property line. As viewed from the shaded patio by the back door, the bed distinguishes itself from the far wall of trees by virtue of its relative height and the contrast created by its bright and varied foliage set against the row of dark trunks beyond. A low layer of perennials and ground covers, each variety planted in large masses, creates an interlocking pattern of textures and tones within the bed. Ivy and periwinkle spread a bluish green blanket under native ferns and the chartreuse blooms of lady's mantle. Balancing the gracefully arching branches of plum

and crabapple trees are tall spikes of purple salvia and silvery artemisia, which surround a mass of burgundy bee balm and gold rudbeckia blooming atop sturdy stems. Those few notes of color act as points of bright light in the lush midsummer palette of green.

Peter achieves these same bright points of light in his etchings, where they serve to pull our eye around the composition. Then the details in the dark shadows draw us in as one set of figures or objects leads us to the next. Layer upon layer we travel deep into the imagined space, encountering faces that flash in our memory, buildings that feel familiar but not entirely so. But it is not necessary to solve the puzzle, to understand the

juxtapositions, or even to recognize the historical references to fall victim to their beauty and mystery. "Others imposed literary references. On my own I would just be involved in the composition and the light. My work is now similar to how I approach opera. You can enjoy it for the music without knowing what is going on." In much the same way, Peter is not overly concerned with being able to name plants in the garden. Each was chosen for its visual qualities and sited for how those qualities would react within the whole. A flower that blooms for a short time may add a temporary highlight to the scene, but when it fades, nothing is diminished— only changed.

> "For me, it's the discovery along the way that creates the magic."

BELOW: Hand-dug over many years, Peter's tranquil pond belies the property's in-town location. Freshwater crayfish live year-round in the deepest water.

NEXT PAGE: Although the stream appears to be entirely natural, Peter spent numerous summers moving the stones into a formation that diverts water to the pond.

dana salvo

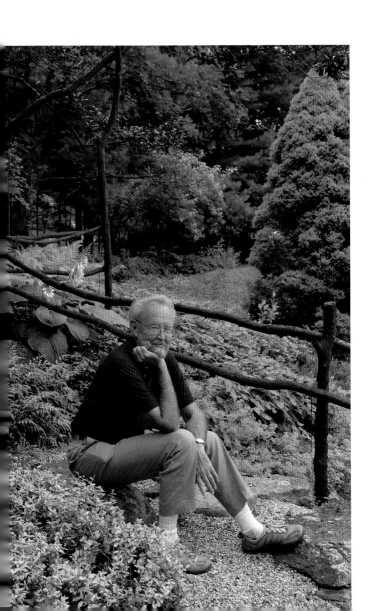

but not me. I only truly liked the making of it." In California, where he and Edith spend the winters, they have no gardens of any kind, and Peter expresses deep relief for that fact.

His studio work now has become all-consuming, and the current manifestation is a projected series of three new etchings called *Sight Lines*. The first is titled *Tracking Shot* after a filming technique in which the camera follows a moving subject. About it he writes, "Often my greatest motivation for a new piece is the prospect of solving difficult aspects of the previous piece; and the obvious solution of simplifying myself out of the hostage predicament must defer to the reality that elaboration is what I do best, what I want to do, and where I still find the most profound satisfaction."

Peter has recently discovered that his original aversion to computers was somewhat unfounded, and he is enthusiastically employing a software program in the editing stages of his printmaking process. By shortening the timeline a bit, this new way of working could leave him with moments to reconsider the garden. Yet he seems satisfied to leave its fate to nature. "Gardens change with every new migration, every aging clump, every retreating snow cover, every rascally rodent . . . but for now my intense involvement is finished." Although he may eventually choose to bring more space into the beds, as he would erase parts of a print from pull to pull, for the moment the garden will remain as it is—a beautifully composed and rendered study that has finally become a finished work.

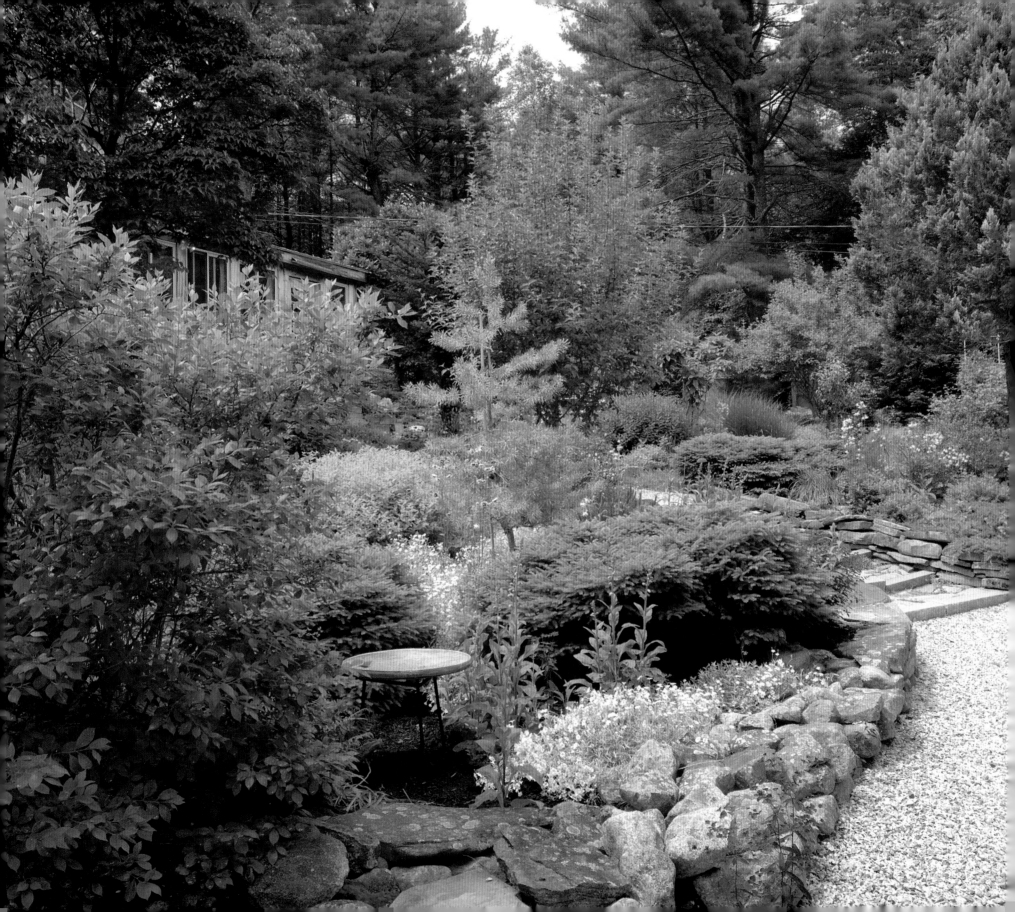

Paul Heroux
balancing form and detail

The growing season starts late and ends early in northern New England, compelling most gardeners here to plant perennials for foliage and bloom that last from mid-May until September. Early lilacs and bleeding hearts are quickly followed by profusions of poppies, peonies, and lupines. There is often a midsummer lull before the lilies, astilbe, and hydrangeas burst into color. Phlox, black-eyed Susans, and sedum can last until frost. Gardeners in this climate often plant spring and fall bulbs and summer annuals to fill the gaps throughout the season.

Until recently Paul Heroux was one of these gardeners. Before settling on a career as a fine-art potter, he seriously considered horticultural school. When he bought this wooded lot thirty-five years ago, the first plot to be dug was a perennial bed around his newly built house. As a faculty member at a liberal arts college, he had a teaching schedule that created what would seem like the perfect scenario for summer gardening. But as the garden expanded he became more interested in structure—trees, shrubs, and perennial grasses that would add year-round interest. In addition, for the last several years he has spent his summers in a coastal village with his partner, potter Scott Goldberg, where he gardens on a much smaller scale. Planning for fall, winter, and spring has now

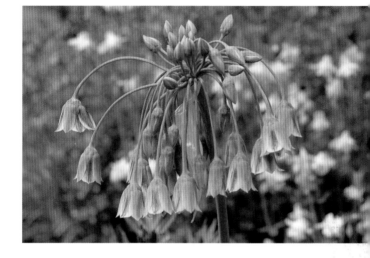

become Paul's focus for his original property, yet the result is a multilayered landscape that retains its beauty all year.

Many of Paul's choices in perennials tend toward the early- and late-blooming varieties. Double columbines planted years ago have been self-sowing throughout the yard, bringing pastels to the spring garden. Low-growing mounds of brilliant magenta and blue hardy geraniums add color into June, the deep reddish purple flowers of tiny-leaved clematis 'Etoile Violette' bloom for a full month and the tall stems of pink Japanese anemones and the large white trumpets of *Nicotiana* 'Fragrant Cloud' take the garden through September. But even in the dry heat of mid-August, this magnificent garden has an underlying color story.

LEFT: Walking up the stone steps to Paul's house, visitors are surrounded by a landscape of trees, shrubs, and perennials that provide color, texture, and form throughout the seasons. RIGHT: *Allium bulgaricum* transforms from a fountain form in summer to a cluster of upright spikes in fall.

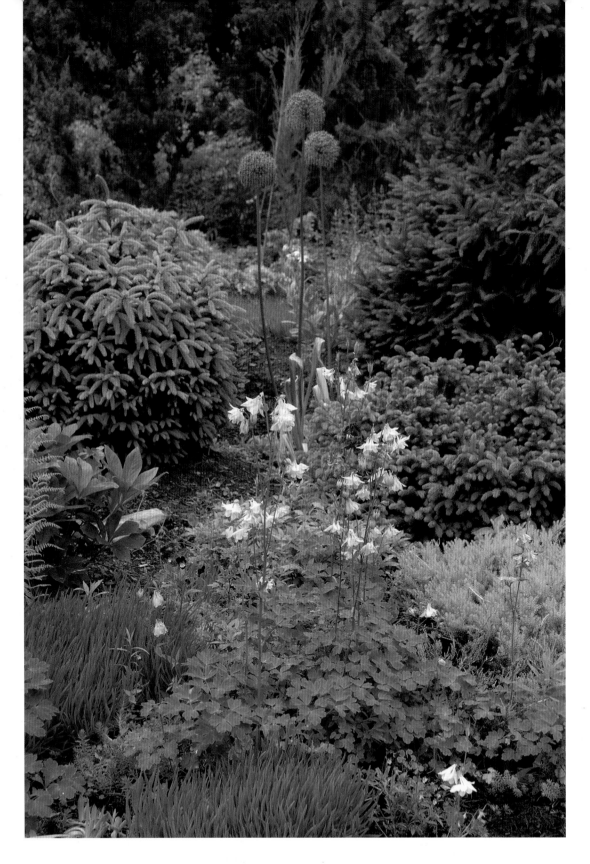

The summer flower palette starts out primarily purple, magenta, and pink, then shifts to yellows later in the season. But Paul is much more attracted by foliage, so leaves, stems, and needles in subtly shifting hues of green, dark red, purple, and chartreuse create a rich foundation for the transient buds and blossoms. The garden "reads" colorful throughout the seasons. Even in winter the blue-green of spruce in the surrounding forest contrasts with the butterscotch gold of Scots pine (*Pinus sylvestris* 'Aurea').

As an accomplished potter, Paul has an understanding of form that has been cultivated by his years in the studio. He alternates between creating classic vessel shapes and more complex geometric constructions. He uses the surfaces of his large, simple urns as "canvases" on which to create painterly imagery in scribed line and texture, layers of glazes, and lustres. On his multifaceted pieces the surfaces are less intricate, lending more importance to the structure of the object. He brings this considered relationship between form and surface to his beautifully realized gardens.

A series of rock walls and stairs leads from one level to the next, where each garden area is a thoughtful mix of trees, shrubs, grasses, and perennials. With more densely

LEFT: Purple allium and pale pink columbine add a hint of contrasting color to a bed designed in shades of green.

RIGHT: A path of stepping stones, pebbles, and groundcovers leads to a small garden shed at the edge of the woods.

planted beds nearest the house, the scale of smaller trees, such as a creamy white-flowered Japanese lilac and late-blooming magnolia, complements the modest size of Paul's home and studio. Where the garden melds into the surrounding pine groves, he has transitioned from cultured to wild with rhododendron, winterberry, Kousa dogwood, and golden threadleaf false cypress (*Chamaecyparis*).

Flowering trees are a focal point in many parts of the garden, adding height, color, fragrance, and evolving year-round interest. Paul's *Magnolia sieboldii* will bud for a full month before opening its pristine cupped white petals in June to expose a raspberry red stamen. The flowers drop away in midsummer to reveal a large ornate seedpod. By the end of summer, the rosy pod has turned watermelon red before displaying a cluster of shiny crimson seeds.

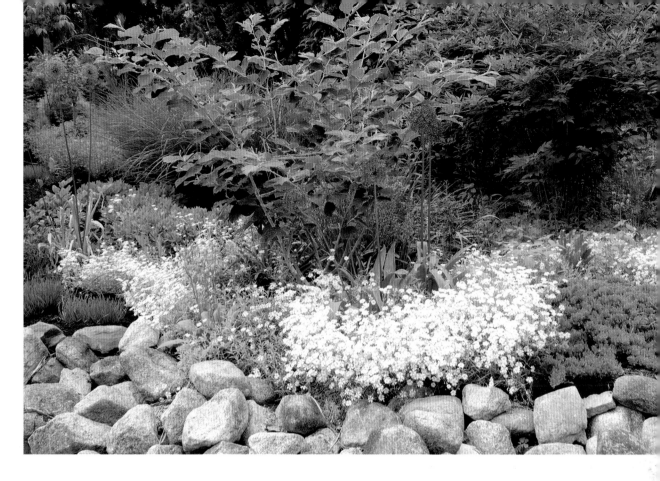

Early summer is also marked by the flowering of a fringe tree, *Chionanthus virginicus*, its showy feather dusters of white blossoms (*Chionanthus* translates as "snow flowers") set off against glossy dark green leaves. The female flowers of this member of the olive family produce clusters of oval fruit that turn blue-black as they ripen.

Although these trees add significantly to the winter landscape, Paul is also intrigued by more fleeting plant forms. Members of the allium family have much to offer with their tall, sturdy stems and great globes of starburst blossoms that retain their appeal long after the color has faded. Probably the most fascinating allium variety in this garden is the long-lasting *Allium bulgaricum*, with its drooping purple-tinged mass of bell-shape florets, which lift up as they dry to form a spray of spiked seed heads. Three varieties of root-hardy bamboo also retain their color and structure well into winter: Giant yellow groove (*Phyllostachys aureosulcata*); kuma bamboo grass (*Sasa veitchii*), which is used as a tall ground cover; and bright gold-and-green-striped *Arundinaria viridi-striata* (now known as *Pleioblastus viridi-striatus*) will all die back in the coldest temperatures, making them much less invasive in Maine than they would be in a warmer zone.

LEFT: Paul has created a naturalized transition from the gardens to the pine forest beyond. RIGHT: Bright, frothy white snow-in-summer spreads along a rock-edged raised bed.

Over the years, Paul has become an expert at creating tiers of color, texture, and form in the garden. Even the smallest vignette displays a range of heights, hues, and surface textures. His knowledge is partially a product of regular study. Always on the lookout for unusual foliage, he loves to read about new plant introductions and focuses his shopping where he can get expert advice. He is particularly drawn to in-state nurseries that carry only what they themselves can grow. He'll try new hardy varieties of trees and shrubs in small sizes until he is sure they will survive the winters.

And Paul keeps himself informed about horticultural techniques, both new and time-tested. To control the size and shape of his dusty-mulberry–colored smoke-bush, he uses a traditional English technique of cutting back the branches each autumn to a height of two and a half feet, encouraging a flush of dense new growth the following year. His approach to caring for the summer garden is also a product of much experience. Most of what he grows can survive the unpredictable Maine weather, long spells with no supplemental watering, and visits from hungry wildlife. Still, there are varieties that are equally attractive to Paul and the local white-tailed deer. Bar soap hung in mesh bags and an occasional spray of a cayenne, liquid soap, and egg mixture to the undersides of leaves can discourage deer from nibbling the new varieties. But once they develop a taste for a certain flower or foliage, no technique short of an eight-foot fence

ABOVE: A granite vessel provides the focal point within a garden bed.
RIGHT: Gently arching fern fronds echo the smooth curves of one of Paul's ceramic water bowls.

will deter them. As for weeds, without daily attention they can get out of control, even with a thick layer of mulch to keep them down. Paul sometimes will allow oxalis and ajuga to take over parts of the garden because, although they spread quickly, they're shallow rooted and not apt to choke out other plants. In this way he saves his weeding time for the most invasive intruders.

Plants aren't the only garden elements that vie for Paul's attention. The clay soil tends to heave with the freeze-and-thaw cycles of winter. Rock walls and steps constructed decades ago will need repair and rebuilding soon if they are to survive. The massive centuries-old terra-cotta olive jar that remains outdoors all year is capped and elevated in the fall to keep it from collecting moisture, which would freeze and crack its thick walls. Tucked into several spots around the yard are a sampling of the artist's elegant outdoor vessels—earth-toned birdbaths and large water bowls in graceful unadorned curves that harmonize beautifully with the varied greens of grasses and ground covers. The contrast between these outdoor pieces and Paul's other work is striking and intentional. In his contemplative approach to gardening, he defines the structure and allows nature to provide the decoration—colors, shapes, and textures that suffuse the landscape with ephemeral beauty. In the studio Paul has domain over both the forms and their surfaces, and he balances these two aspects with great precision.

On the bowls, jars, and boxes that are intended for indoors, Paul uses his painting background to create intricate compositions that wrap the surfaces with patterns and imagery from his surroundings. He responds to each form with abstractions of the landscape and the plant and sea life that have become part of his visual language. His simpler vessels pay homage to Asian and Japanese traditions, and he feels that living amidst the pine groves in winter and tide pools in summer lends legitimacy to his use of these themes in his decorated work. His early pieces made more literal reference to plant structure by employing monoprints of leaf and branch patterns in the glaze. Today the references are less discernible in the rich mix of drawn lines, fields of intense color, subtle patterning, and flashes of iridescence.

june lacombe

Paul's work invites the viewer to explore, both visually and tactilely, the inseparable relationship between structure and surface and also between everyday experience and artistic expression. In many ways, Paul's gardens speak to those same connections by creating an environment in which we begin to understand that with close observation and dedication to craft, our relationship to our surroundings can become both an authentic and an artistic experience.

Paul and his Portuguese water dog, Baco, relax for a moment in the garden, surrounded by a patchwork of evergreen shrubs, deciduous trees, mature perennials, and summer-blooming bulbs.

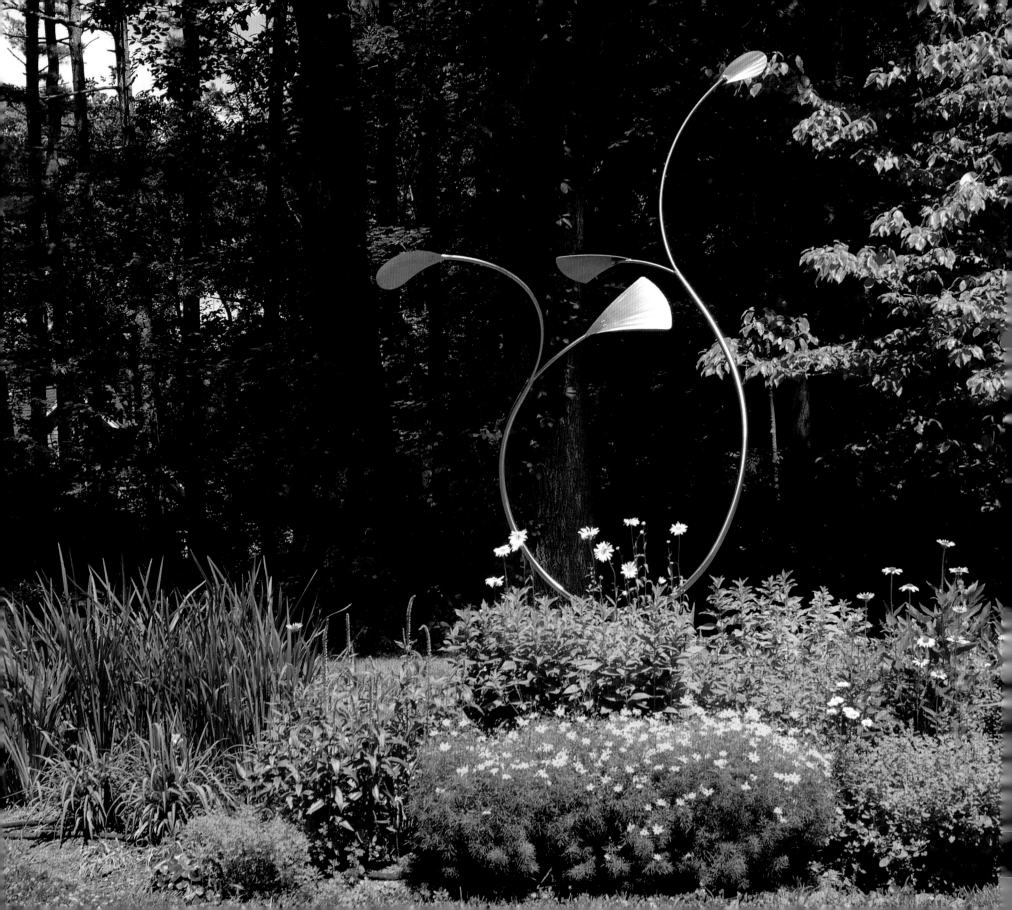

George Sherwood

in response to the elements

Against a long, undulating row of deep green hemlocks, late-day sun glints off the fluted surfaces of *Flock of Birds* in a resonant dance of light and color. With the slightest breath of wind, the brilliant stainless steel surfaces of the sculpture alternately absorb and reflect the light of the green trees, blue sky, and flashes of other colors that move in and out of the garden throughout the year. In constant motion, this sculpture by George Sherwood displays aspects of his varied career. It is just one example of many magnificent works where his feats of engineering are transformed by his human impulse and artistic nature.

George's yard, which he refers to as an outdoor laboratory, is dotted with sculptures in different stages of development. Some unfinished pieces are left here simply for his pleasure, but most are on their way to exhibitions or to grace the land and gardens of clients across the country. George has been creating kinetic sculpture full-time for ten years. His dual degrees in art and engineering, in addition to his earlier careers, are the foundation of his present artistic sense. While in art school, he studied mime and theater arts, which later led to stage performance involving physical movement with animated props. He blended art and engineering while working in the development of

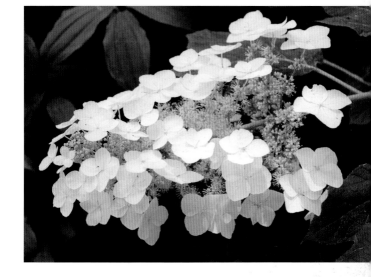

scientific instruments, on animation projects with software companies, and in concept development for Parker Brothers, Hasbro, and LEGO. It was an exhibit of the work of George Rickey that prompted him to become more deeply involved in sculpture. Rickey, together with his contemporary, Alexander Calder, brought kinetic sculpture into the vocabulary of American art; Rickey was the first to use the outdoors as his venue.

George's sculptures respond to the wind in partially predictable ways. He talks about the "rules" that govern the movement of a sphere constructed from smooth cylindrical rods. At any given time the sphere tumbles in two different directions depending on how the wind hits the surface of the

LEFT: *Circle of Life* makes a grand statement as it slowly moves in the wind above a garden of mixed perennials and annuals.
RIGHT: A cluster of creamy white hydrangea flowers may be all George needs to generate new ideas for his kinetic sculpture.

rods. But there always appears to be an element of chance—shifting air currents, which in turn shift the reflections of light off the polished surfaces. The work is ever changing, ever interesting to observe, as the time of day, time of season, and weather continually change. And by moving the sculpture around the yard or down to the open marsh nearby, George is able to evaluate his work in different settings and enjoy its beauty while his creative process is continually engaged.

The hundred-foot walk from house to studio is often all the artist needs to spark new ideas. In summer the varying forms and colors of a long perennial bed on one side balance a clipped hemlock hedge on the other. Small birds and insects dart in and out of the light and shadow, and dappled sunlight bounces off the shimmering leaves of nearby trees, their flat stems acting like torsion springs. In winter, the silhouette of branches against the sky suggests intricate weavings and abstract drawings, and condensation on the glass of a cold frame forms "ice paintings" in patterns reminiscent of floral wallpaper.

The house, built in 1903 as a summer cottage, is now a fully winterized home occupied by George, his wife, Rue, and their

LEFT: *Sunflower* relies on the graceful curves of two layers of opposing arcs to create the illusion of petal forms.
RIGHT: Phlox, peonies, and spirea fill part of the long perennial bed that borders the walk from the house to George's studio. He places pieces along the way to study how they react to the elements.

two daughters. George credits Rue for the gardens, characterizing himself as the "hired hand," but it is clear that he is quite in tune with what grows here, and the garden has played a critical role in his development as an artist. He likens the gardens to his sculpture, a slowly changing and constantly moving entity that responds to the elements in both predictable and surprising ways, offering something new each day.

George is drawn to the qualities of color in the gardens. The subtle variations of yellow in a patch of spring daffodils, the exquisite translucence of red and orange poppy petals casting a spectrum of warm hues onto the smooth surfaces of *Wind Orchid*, a small sculpture by the back door. Later in the season the bold architectural structure of blue balloon flowers and tall, rosy cosmos play back and forth with the green reflections of surrounding foliage.

George speculates that the garden is attracted to his work—the tendrils of a clematis vine grow toward and cling to parts of an older sculpture, perhaps enticed by the reflective surface, but finding something to climb on as well.

Much of nature is in constant motion, a phenomenon that many of us might not observe but George finds fascinating. The seemingly sudden appearance of early blue scilla, the winter aconite that opens its bright yellow flower in the rough winds of March, the constantly spreading evergreen foliage of blue periwinkle are all cataloged in his mind. His sculptures are based on movement that is both subtle and obvious. At times it appears his sculptures do not move at all, and at other times they are a flurry of activity reminiscent of the tall swaying plumes of late-season cimicifuga in an autumn breeze.

Some pieces are a direct reference to the open flower structures that permeate the gardens. *Sunflower* is a deceptively simple sculpture in which shallow arcs constantly form and re-form the shapes of individual flower petals. One could also speculate that

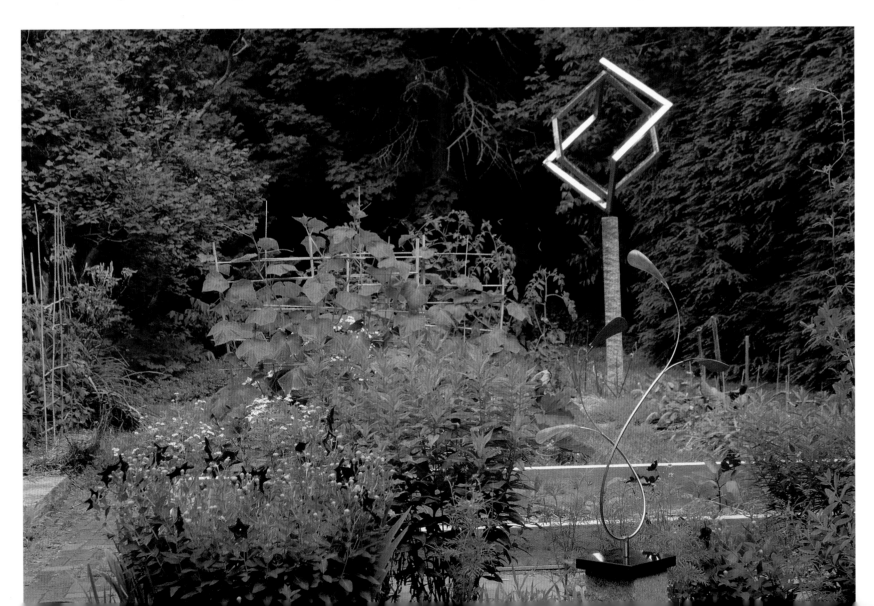

George's placement of his works within the gardens influences what choices are made for plantings. Sunflowers, with their array of single-petaled florets encircling a central disk, along with other members of the large Asteraceae family, are planted throughout. Daisies, coneflowers, coreopsis, and cosmos have the same structure. Some were planted before and some after the creation of *Sunflower*, making us wonder which came first.

George allows the garden to influence his artistic process, and he and Rue have structured the landscape to showcase his work. The long, repeating column of hemlocks provides a consistent swath of color and texture that the deciduous trees beyond would not. The effect is of a green gallery wall. The narrow lane of grass in front of the hemlocks presents a stage for some of George's taller pieces. Across a stone path, the lower-growing perennial garden hosts smaller pieces among spireas, peonies, and phlox. A few sculptures have also found their way into the raised beds of vegetables and cutting flowers. Because it is an important part of the "outdoor lab," the center lawn, edged by lily of the valley and mature trees, is purposely left open.

LEFT: In a protected site near the house, beds of annuals, vegetables, and herbs share the spotlight with *Wind Orchid* and *Cubix*.
RIGHT: George's studio is filled with mock-ups, small-scale works, and bits and pieces that help in the creation of his outdoor sculptures.

For now, George eschews the arbitrary application of color to his work and instead employs stainless steel to reflect adjacent colors. The surrounding elements in the ever-changing light reflect off the stainless steel designs in motion, mingling with and complementing one another exquisitely. For this and other reasons, he works outdoors as much as possible. Although this is a practical consideration, nature also gives him constant feedback. He begins by drawing a basic concept, then moves quickly to constructing a small model that approximates the final materials. Even though these models usually won't move exactly the same as the final piece, they provide him with a way to study the possibilities. His studio is filled with these bits and pieces and a dizzying array of small sculptures, offering a glimpse into the artist's process.

That glimpse into George's creative process can be all that is needed to begin seeing the landscape from a new perspective. We become more aware of the structure of flowers, leaves, and branches, color in broad strokes and in details, the quality of light throughout the day, the season, and the year. And we begin to appreciate how these gardens, in constant motion both great and subtle, have the power to inspire, and be inspired by, the art that fills them.

Gary Haven Smith and Susan Pratt-Smith
a reverence for the land

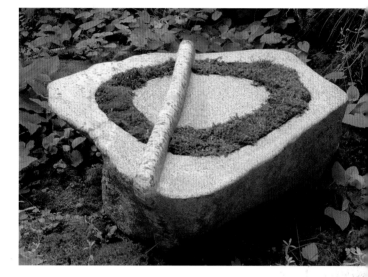

Gary Haven Smith is known as the man who bends stone. In his studio on a wooded hillside in southern New Hampshire, a great gray boulder of native granite slowly rotates on its massive turntable as it inches closer to the thick diamond-encrusted wire that will cut it. This diamond saw, a custom-designed assemblage of gears, cables, switches, and steel girders, is a far cry from the hammers and chisels traditionally associated with stone carving. Gary has spent ten years refining the machinery to a point where he can now "peel" an inch-thick curl of granite from a stone. "You could never carve this—this is pushing the material. In the beginning I would do it with brute force, tearing my body apart with air tools. Now I use more brains than brawn."

Keenly aware of how technology impacts his work, Gary acknowledges that his recent stone "curl" sculptures could not be accomplished without the use of sophisticated equipment. Many of his pieces also include spontaneous patterns of surface marks made with specialized high-speed diamond cutting bits. And he employs both digital photography and photo-manipulation software in the creation of his powerful lead and slate paintings. But Gary has so successfully mastered these tools that the work he produces from them is an intensely human ex-

pression of the link between past and present, man and materials. "I am trying to combine the technical world we are living in with the ancient aesthetics and art of other cultures. I believe there is a measuring stick or set of criteria that gets passed from generation to generation and becomes our truths. The materials I chose and the designs created are reflections on past cultures that continue to live for me."

Gary's wife, glass artist Susan Pratt-Smith, shares his reverence for tradition, and together they have become loving stewards of the land on which they live. This former orchard, purchased in the early 1970s, became the site of their tiny first house with its equally tiny first garden of spring bulbs that

LEFT: Gary's sculpture is as important an element in the landscape as are the trees, shrubs, and perennials. Wisteria vines cover a stone patio that is perfect for dining on warm summer evenings.
RIGHT: *White Line* is one of Gary's many stone pieces that were specifically designed to grow moss. Set in a shaded spot, they change slowly over time as the moss spreads.

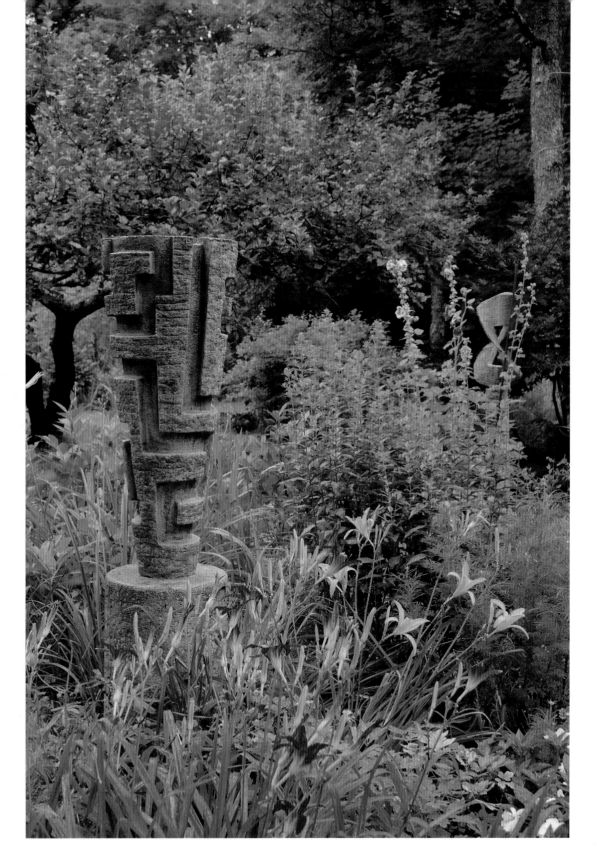

could be viewed from the kitchen window. Gary maintained a studio in Greece, then Italy, through the early 1980s, and did only hand-carving in his small New Hampshire workshop. As this house and studio grew to accommodate the couple's work and lives, gifts of plants from gardener friends began to fill the yard. Irises, peonies, yellow loosestrife, delphiniums, phlox, and hollyhocks bloom throughout the summer in the granite-edged garden beds that surround the house and fan out into the orchard. Great, twisted trunks of wisteria climb a simple wooden arbor to create deep shade on a dining patio. Paved in square stone tiles, the patio leads to a twenty-year-old koi pond designed in a geometric shape to lend a man-made sense of order to its natural surroundings. The pond, bordered by ferns and a small Japanese maple, is also home to a small family of frogs. On a warm day in August, they sun themselves at the mossy edge of the water.

Before the birth of Gary and Susan's son, Devon, the gardens were more elaborate and required constant care. By scaling back the plantings to more maintenance-free perennials and shrubs, and densely packing the beds to leave little room for weeds, Gary

LEFT: Older stone sculptures such as *Time Key* and *Rocaille* are now permanent elements in the flower beds.
RIGHT: Gary designed the straight-edged koi pond as a counterpoint to the organic natural shapes that surround it.

and Susan can enjoy the gardens without compromising their time in the studio. A small vegetable bed and a row of blueberry bushes provide fresh produce throughout the summer. The graphic patterns of green bamboo leaves cast their shadows on the landscape well into winter. An ornamental cherry tree, planted to commemorate a dear friend, blooms each spring by the gravel driveway. Backed by the brown wood clapboards of the couple's studio is an elegant little espaliered fruit tree, inspired by Gary's interest in shaping nature over time. This property also functions as a magnificent outdoor sculpture gallery for his work. Pieces in marble, granite, quartz, and steel are sited throughout the yard, amid the perennial beds, and on the stone patio. But for Gary and Susan the real showpiece of this fertile slice of New England countryside is the collection of beautiful old apple trees that grace the land with their ancient aesthetic.

Preserving these trees, and with them the legacy of this land, has become the focus of their gardening efforts in recent years. A surrounding forest of large evergreen and deciduous trees has grown up over the decades, plunging much of the orchard into shade. In order to expose the fruit trees to much-needed sun, some parts of the forest have been selectively thinned. In fall the apples are left to the local deer. These trees are revered for their sculptural forms, which grow more abstract and compelling in the starkness of winter silhouette.

The patterns of nature show up repeatedly in Gary's work. He uses stems, leaves, and flowers from the gardens as a basis for carved or painted or sandblasted motifs. Tending toward an eastern aesthetic, he uses the stems and leaves of bamboo and the lacy filigree of early-season wisteria as blueprints for line and pattern. Segments of tree bark and the layered petals of double peonies are digitally abstracted as shape and texture. The pure graphic quality of this imagery compels him to speak of his work in terms of design: "In the throes of the design process, one thing leads to another, and sometimes unexpected results can open the door to a new design opportunity."

It is the balance between planned and accidental, manipulated and natural, refined and raw that interests Gary. In his early sculptures he worked the entire surface of the stone into more traditional abstracted forms from nature. But the bits of untouched roughness, the raw edges, began to emerge as important elements as his work matured. His jagged, twisting stone monoliths pierced with geometric precision are visual and lyrical references to these relationships. In his latest work he has pushed the concept to new levels—balancing a great curled helix of stone atop a sleek, graceful pedestal, like a musical note perched on a tuning fork. The precise and polished geometric base is in perfect counterpoint to the sensual curve and raw edges of the granite coil.

Sculptors have different criteria for what makes good raw material. For ease of carving, Gary is partial to Canadian granite because of its texture and tight grain. Commercial users of stone value continuity and consistency, so they dispose of pieces with markings, occlusions, or streaks. For his large commercial commissions, Gary is often attracted to these remnants. But for both practical and artistic reasons he chooses to work mostly in materials found near his home in the Granite State. The stone for at least one piece in his outdoor gallery was dug from a neighbor's cellar hole. Many of the largest pieces he carves from are glacial boulders found on his own property or uncovered in local gravel pits. "Because they haven't been exposed to the elements, the

stones are like time capsules. When you cut through them, you find these colors—these incredible chromatic essences."

Part of Gary's creative process is matching the material to the idea. Although he is proficient in his handling of stone, he also works in a variety of other media. His paintings are actually constructs of metal, stone, wood, encaustic, and oil paint. He often combines imagery from the garden with scribed patterns and repeated geometric elements. "What is important for me in a painting is a relationship between the paint and the different materials such as lead, wood, and slate. My interest is to create a tactile surface that interrelates with these unexpected materials in a balanced way."

Out in his yard, without a conscious thought to design, he has created much the same effect, intuitively siting the sculptures to create a relationship with the apple trees that works throughout the seasons. In

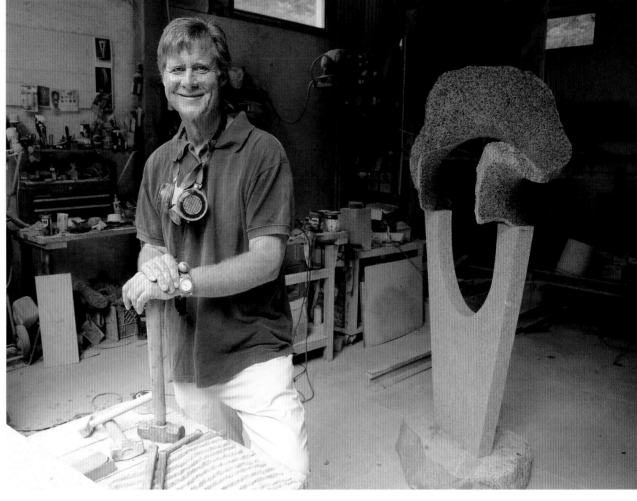

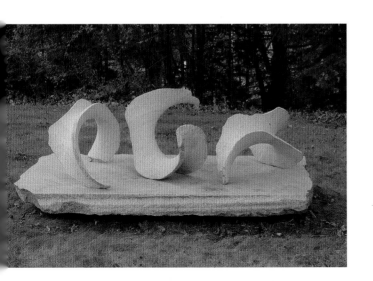

spring, summer, and fall, when Gary and Susan spend more time in the orchard, they can view up close how the color and texture of the stone contrast with the blossoms, leaves, and fruit of the trees. In winter, when the yard is primarily viewed at a distance from the house or studio, the couple can appreciate its striking graphic statement made in shape and shadow.

Whether slicing thin curves of stone from huge boulders, building an angle-edged pond on the rolling terrain, or planting moss in geometric patterns, Gary is constantly striving to impart a sense of order on the natural world. He sees his work in the studio and on the land not as the result of a grand plan, for he had none when he began, but as an evolving legacy. He has let the land teach him what it knows. He has taken its raw materials, and through skillful hands and a deep reverence, honored the land by returning a magnificent body of work.

Stone and Moss

Nowhere does Gary work more closely with the relationship between natural and man-made, his art and this land, than in his moss sculptures. "I couldn't have done these pieces if I lived in the city. The idea for them was found walking in these woods, along these streambeds." Most are rough-edged, bowl-shaped forms he has cut from local granite.

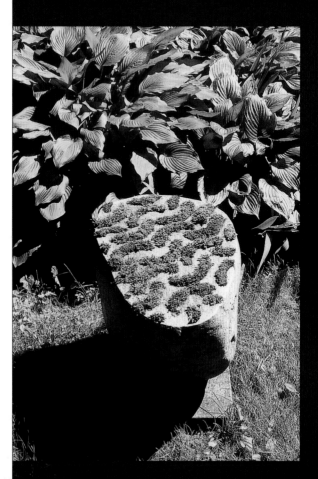

Using his computer drawings as patterns, he routes a series of shallow channels in the flat top surface of the stone. Then he harvests small amounts of moss from the woods to transfer to his prepared stone. Only the mosses found already growing on rock seem to work for this process; moss found growing in shady soil or along streambeds requires those particular environments to grow. He cuts the soft green mats into sheets and trims the moss to the size and shape of the patterns needed for each sculpture. He then "plants" it in the channels, watering diligently for the first several weeks. As the moss grows, it softens the clean edges of the patterns and, over time, can obliterate them. For an artist who is interested in the process of controlling nature gently, over time, this may seem to run counter to his character. But in an ongoing effort to strike a balance between opposing factors in his work, occasionally letting nature control his art seems just fine.

The pattern on this stone piece, *Back to Front*, was first created on computer then cut into the stone. Eventually the moss may obscure the design as it spreads across the surface of the granite.

In contrast to her husband, Susan Pratt-Smith works with brilliant color in the fragile and often capricious medium of glass. Her spectacular work in stained glass, often large, intricately designed windows, doors, and side lights, graces public and private buildings around the region, and her reputation as a master of the art grows with each new commission. A decade ago she began studying the process of fusing the versatile material and soon discovered the intriguing medium of dichroic glass. Containing multiple micro-layers of metal oxides, dichroic glass appears to be composed of more than one color depending on the angle of viewing.

Susan has created an impressive body of work that draws from sources that are meaningful to her, including the magnificent landscape she calls home. Her pieces often begin with drawings or paintings that she has created in her travels to coastal Maine islands, Martha's Vineyard, and the lakes region of northern Italy. Equally represented are the peonies and wisteria that grow in her New Hampshire gardens, and the forest that surrounds the apple orchard.

In all her work, Susan strives to create a sensation of depth. Her childhood in southeastern Massachusetts exposed her to the mystery of cranberry bogs. Covered by late fall's first sheet of ice, the berries, stems, and leaves remain suspended in slowly moving layers below the surface. This sense of depth is evident in her large fused pieces depicting brilliantly colored landscapes and also in her more abstract work.

The process she uses requires complex technical expertise and a thorough understanding of the nature of glass. Glass seems to be a solid material, but chemically, it is a "supercooled liquid"—the intriguingly rippled glass in ancient windows has actually flowed over time. It is sensitive to heat. In order to create depth in a piece, Susan slowly builds up layers to approximately one-half inch through the process of annealing—holding the temperature in the kiln constant at carefully calculated stages of the cooling process to evenly calm the molecular structure of the glass panel as it slowly returns to room temperature.

ABOVE: The stark shapes of apple trees in winter is the subject of *First Snow*. Along with peonies, Pee Gee hydrangea is one of the artist's favorite species.

Although Susan's large dichroic glass pieces are in many private collections, she has made her work more widely accessible by producing exquisitely detailed jewelry using the same materials. Each piece is a tiny work of art that requires the same thoughtful vision and dedicated craftsmanship she exhibits with her dichroic wall sculptures or stained glass installations.

Susan continues to explore the world of glass and the possibilities of combining it with other materials. She draws and paints for her own pleasure and as reference for her glass pieces. And each year she is inspired anew by the shapes, textures, and colors of the beautiful landscape that surrounds her.

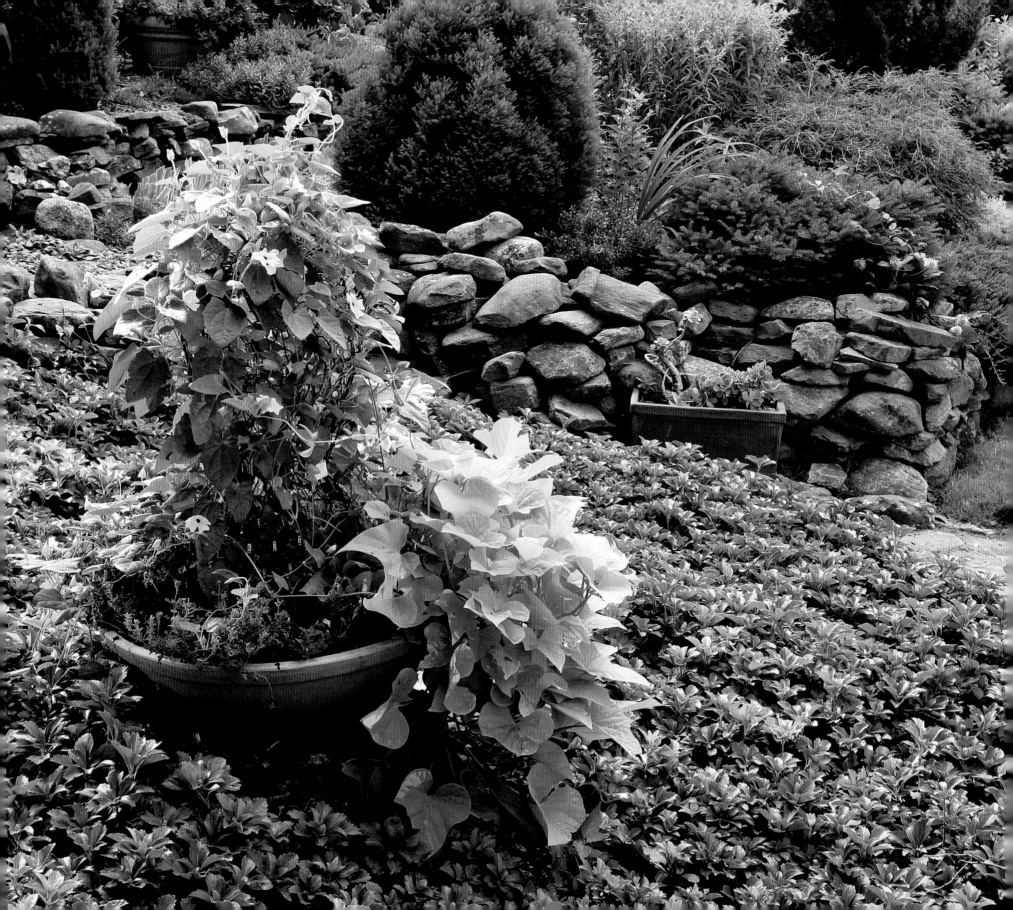

Harry White

the illusion of perfection

Harry White's enthusiasm for gardening—and, indeed, for life—is infectious. "If it ain't fun, it ain't worth doing!" he quips as he demonstrates how his summer dinner guests are greeted. Using a long pole, he opens a second-story door in his refurbished barn to reveal a lit chandelier hanging from the rafters above a dining table and chairs below. The barn, with screen doors, shelves bedecked with ephemera, and a view of the Belgian block patio festooned with potted annuals, makes dinner at Harry's an "event" long before the food is on the table.

Beyond the barn, the land slopes downward until it reaches a low, swampy area that curves around the entire property. At the central apex of the lot is its historic house, designed by artist and noted Connecticut suffragist Laurilla A. Smith in 1853 as her studio. Ms. Smith died before the building was completed, making Harry the first artist to work and live here. He answered his own question "Can I make art here?" by totally surrounding the house with a fabulous patchwork of gardens that provide raw materials for the intricately beautiful collages he creates almost entirely from plant parts.

The monumental task of landscaping took Harry seven years, beginning with leveling the area around the house and moving that soil to the edges of the lot. He cleared

suzanne mamet

the hillside of brush and in the process discovered a small stream meandering through the yard to the swamp below. To attract more wildlife, he removed invasive growth, encouraging native grasses. The trunk of a leaning ash tree cut on the property provided slabs to build a walkway to an island that houses his winter bird feeders.

About twenty thousand years ago this land was a lake that left its bed of sand in the otherwise rocky soil of central Connecticut. So Harry did what is pretty much unheard of in these parts—he bought rocks. With his own hands, he's built the verandas, walls, walkways, bridges, and terraces that make these hillside gardens possible. He chose trees, shrubs, perennials, and annuals that are agreeable to the existing soil conditions

LEFT: Harry has filled the front borders of his yard with a variety of low-growing shrubs and groundcovers, adding pots of annuals each year for color and variety. In the center of a mass of pachysandra a terra-cotta saucer holds black-eyed Susan vine (*Thunbergia alata*) and sweet potato vine (*Ipomoea batatas* 'Margarita').
RIGHT: Brilliant multi-color ranunculus bring color to the summer gardens.

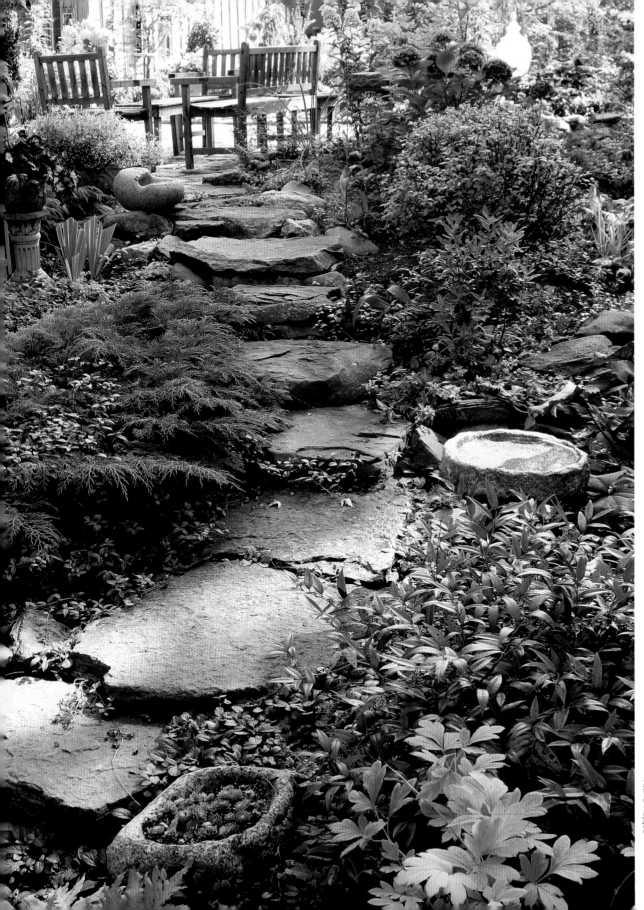

and planted them in a composition that stages the house as the heart of the property.

The gardens are arranged in tiers for aesthetic and practical reasons. Dwarf varieties of shrubs were planted closest to the house, both to show off flower boxes and to allow easy access to the windows. "July is window washing month," according to Harry, whose language is liberally sprinkled with such adages. He thinks "lawns are an English conceit," so, with the exception of the tiny remaining plot of grass, the entire yard is filled with shrubs, perennials and annuals. Some are kept alive by a watering system when the artist is away, but most are simply planted where they will do best on their own. Because the property is located on the town's main street, anything growing near the pavement has to withstand the winter road salt. On a warm August day, cheerful pink self-seeded portulaca blooms along the edges of the cracked asphalt.

Harry's design for the gardens evolved as the gardens were being built. He is inspired by the interplay of formal and informal, which entered the language of garden design at the turn of the twentieth century with Harold Nicolson's and Vita Sackville-West's Sissinghurst Castle garden in Kent, England. Each area of the garden that Harry completed told him what to do next; the result is a genteel balance between public and private, expansive and intimate. As soon as the gardens were finished, the stone patio was the setting of a formal dinner for sixty hosted by the local historical society. Behind

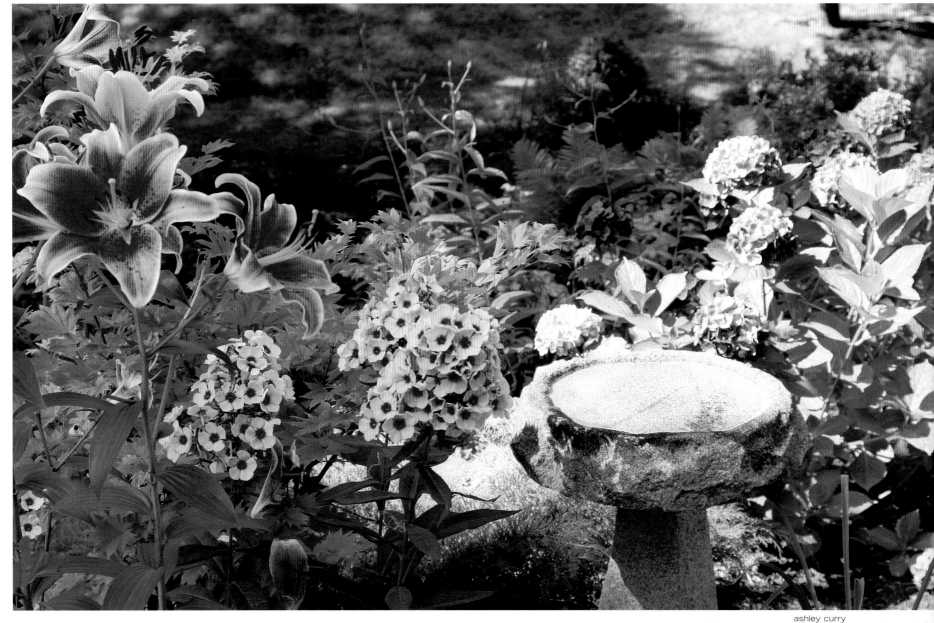

ashley curry

the barn, a rock staircase leads to a small stone platform and Harry's "margarita bench"—the perfect private setting for watching fireflies over the swamp on a warm summer night. Alongside the house, a stone path flanked by hundreds of spring daffodils and summer lilies is spanned by a wooden arbor that defines the beginning of the private yard. But the arbor also frames an inviting view of variegated hostas, white impatiens, potted peach-colored begonias, purple clematis, and pink fuchsias as the path wends its way through sculptural shrubs and trees to the gardens beyond.

Nearest the house are the cutting and herb gardens. Harry is constantly on the

FACING PAGE: One of the many stone paths in Harry's gardens leads to a sunny patio at the back of the house where the artist entertains on summer evenings.
ABOVE: In midsummer the pure pinks of lilies and phlox are a beautiful balance for the true blue of *Hydrangea macrophylla* 'Nikko Blue.'

lookout for flowers that will provide good color for his "fleurages." Black hollyhocks, blue lobelia, foxgloves, and morning glories hold their intensity well over time. Because hydrangeas can flower from blue to pink according to soil acidity, they aren't as reliable, although they're no less revered. Heaths and heathers, balloon flowers, old-fashioned phlox, arching sprays of exotic crocosmia, and full, flouncy clusters of sweet Asiatic lilies create a ring of color and fragrance that surrounds the house and patio all summer.

With such a wide variety of species growing here, one would assume that Harry has no favorites, but he does profess a deep affinity for blue delphiniums: "When I look upon them, it is as if time were standing still." They were his inspiration for becoming a gardener in the first place, and their intense blue appears often in his artwork. They are also the only plant that will compel him to amend his soil. A member of the Delphinium Society, Harry acquires his seeds from the active English club and stays

abreast of new developments in the breed.

As the gardens expand away from the flowering shrubs, small ornamental trees and ground covers are the main features. A series of raised gardens along the front of the house overflow the rock walls with boxwood, juniper, spruce, heathers, and pachysandra. Tucked in and among the walls are granite pools and birdbaths and an occasional bright glint of a geode from Harry's collection. Stone paths lead everywhere and turn into small staircases as the

suzanne mamet

suzanne mamet

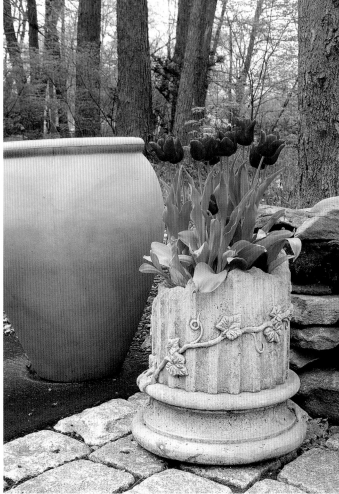

terrain changes. Harry wants a garden he can age with, so access on this sloping property is key.

The hillside tends to alternate between wet and dry and is planted accordingly. Japanese mountain maples in a mix of sizes, colors, and shapes are planted in mirroring pairs on either side of the stream. The saucer-sized leaves of *Acer japonicum* 'Oisami' show spectacular fall color and contrast beautifully with the crimson laceleaf of *Acer palmatum* 'Seiryu'. Native swamp irises, azaleas, and marsh marigolds bloom yellow in the spring wetland. Pink, purple, and blue monarda, irises, daylilies, and joe-pye weed work their way up the embankment. Moisture-loving ground covers such as ajuga and sweet woodruff have spread in all directions. Even pitcher plants and Venus flytraps have found a happy home in this insect-rich environment.

On most days, a steady trickle of water runs alongside the clam, oyster, and mussel shells that Harry has arranged at the edge of his little stream. The surrounding acidic soil is a fertile environment for moss, which he also grows elsewhere in discarded barrel hoops filled with old tennis court clay. As long as these bryophytes are watered, weeded, and kept clean of debris, they will flourish in any shady spot.

Harry has spent most of his life working with plants in one form or another. He has amassed quite a bit of knowledge and developed some definite opinions. It all started with the one-credit undergraduate course in flower arranging that turned his attention away from interior design. Today, gardening is the center of a multifaceted career that keeps Harry's hands in some part of the process year-round.

As a personal florist for a group of clients, Harry may provide arrangements weekly or just for special events. In either

case, he purchases most of the flowers, supplementing with his own when appropriate. Presentation is his forte. "I wrap presents like nobody's business," he claims as he shows off his impressive collection of ribbons and papers. He also designs gardens for others, functioning as a consultant in planning, altering, working out a problem area, or "adding the jewelry." Shopping with the client is one of his most valuable services; his focused and experienced eye can make the trip to the nursery quick and rewarding. Juggling work on his own property with these services keeps Harry busy from spring until fall. But even in the dead of a Connecticut winter, his garden is always at his fingertips.

After years of using pressed flowers as imagery, in 1975 Harry began to use the petals as paint, applying them in part or whole as color, texture, or pattern in a more abstract way. With the encouragement of art enthusiast Carolyn Sagov, he set out on a new venture that has distinguished him as artist and master of this exacting technique that he calls "fleurage." In one of his early pieces he created a national map using bits and pieces of each state flower. The collage was actually aided by a few states that would not send samples—Harry left those areas as open space in the composition.

The process of fleurage is really quite simple for a man with such an exacting eye. To prepare his palette, Harry sandwiches flower petals and leaves between ironed

ABOVE: A glazed cobalt blue pot creates a bright spot of color in the garden between perennial bloom times.
RIGHT: *Hydrangea macrophylla* 'Nikko Blue' thrives throughout New England, and its intense color has remained popular with gardeners even since the introduction of longer-flowering varieties. Its sturdy upright habit and lustrous foliage provide form in the garden when the plant is not in bloom.

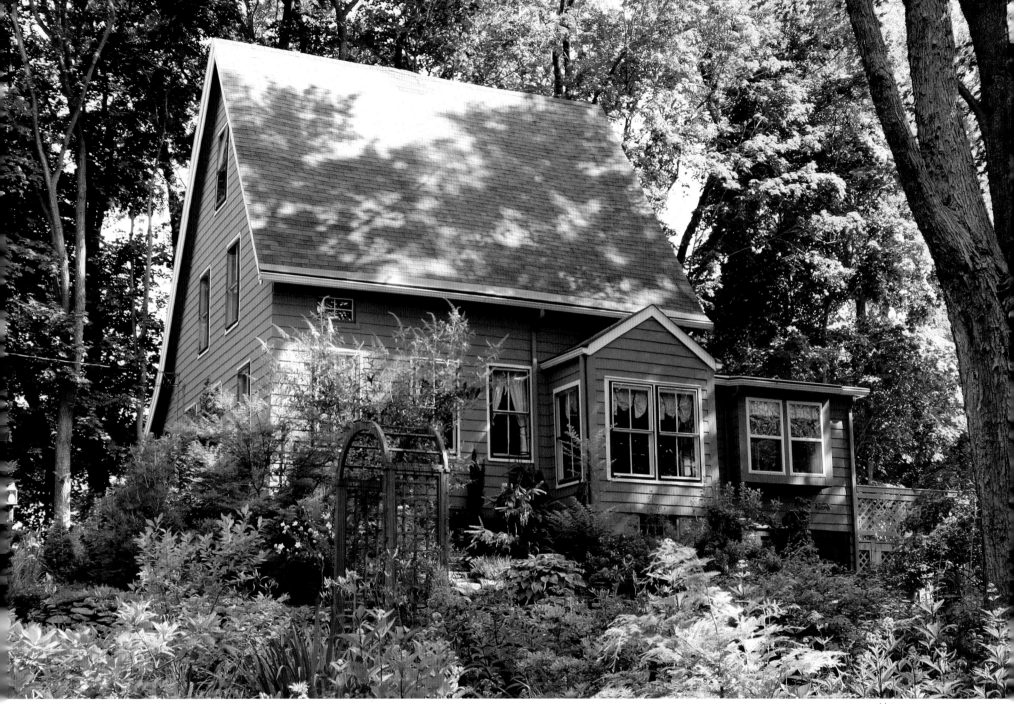

Designed by artist Laurilla A. Smith in 1853, Harry's house sits at the center of the property. He designed the gardens to present the house, terracing the rocky slopes that surround it and creating gardens that transition from cultivated to more natural as they move toward the wooded edges of the land.

ashley curry

sheets of facial tissue and presses them in phone books. Once they have dried, he sorts them by color and stores them between paper towels in large, flat files. Each composition is fully drawn out on museum-quality rag board, and the selected plant material is painstakingly cut to shape with a sharp art knife, a process that can take the better part of a winter in some cases. When the time comes to assemble the piece, Harry must work quickly because the archival bookbinding glue he uses is permanent. As soon as he touches this adhesive to the back of a petal or leaf, it will begin to curl, so in some cases he paints the board with glue first.

The surface of each finished piece is left untouched. The result is a surprisingly textural mélange. The natural sheen of tulip

ABOVE: In a rare moment of inactivity, Harry sits atop one of the many rock walls he built within a few years of owning this land.
LEFT: *Moon Shadow Mountain* utilizes the distinctively striped jack-in-the-pulpit as well as a variety of other flower materials in a process Harry calls "fleurage."

"Experimentation and mistakes are a large part of being an artist."

geoffrey stein

petals makes them appear lacquered; the stripes on the hooded flowers of jack-in-the-pulpit read like drawn lines; the spotted petals of foxglove introduce a painterly quality; garlic skin produces the most lasting white. Dried morning glory petals are so fragile that simply moving them through the air too quickly will tear them. "Experimentation and mistakes are a large part of being an artist," says Harry, who is constantly on the lookout for new ideas. While buying roses in Boston, he noticed the patterns being made by the clerk's sneakers in the dropped petals. Working with flower petals in his studio, he saw how the crushing action caused the color in the compressed patterns to darken like a stain, an effect that he has since learned lasts for years. Recently he has started to introduce non-plant materials to his palette. The pin-feed edges of computer sheets and the little paper tags from Hershey Kisses have found their way into his collages. Even bits of discarded cigarettes may be used; Harry reasons that tobacco is, after all, a plant. "If people are going to drop litter in front of my house, then it's fair game to end up in the work!"

Harry will occasionally use small amounts of soft pastel and watercolor for a particular effect. But because these collages are made primarily from plant material, their colors may shift, sometimes dramatically, over time: white petals turn brown, hues may either darken or fade, subtle differences can be lost. Their integrity, however, both physical and artistic, remains intact, and some collectors say the fleurages improve with age. In order to make his work available to a wider audience, Harry has had giclée print reproductions made of some of the collages. This relatively new process for creating fine-art prints with specialized ink-jet equipment results in high-quality, long-lasting, accurate color. Ironically, the color in these prints might just stay true longer than in the original materials.

The possible shift in color doesn't bother Harry. As a lifelong gardener, he knows that one thing he can depend on is change. No garden remains exactly the same from one year to the next, and every move made leads to another possibility. He revels in this constant motion. It is evidenced in the leaves and petals and bits of color that whirl and tumble across his collages, and also in the immense pleasure he gets from touring his property on a daily quest to discover what may have happened overnight. Seven years ago Harry bought this place and completely transformed it from a hillside of grass and brush into a luxuriant showplace that is both personal and social, refuge and inspiration. He defines art as "the illusion of perfection." By this standard, anyone who spends a day with Harry White will likely agree that his gardens—and, indeed, his life—are a work of art.

Tucked in spots throughout Harry's garden are pieces filled with plants or water or displayed simply for their form and texture.

ashley curry

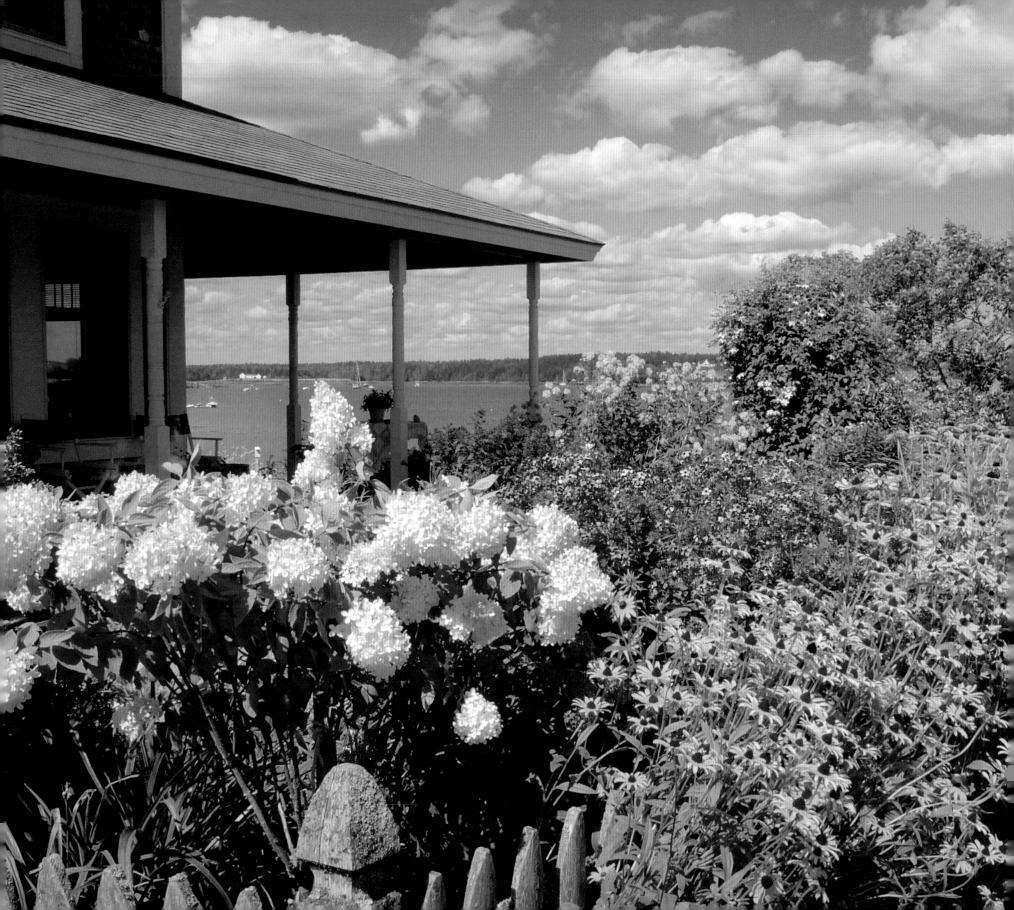

Ann Stein-Aaron
the resilient garden

In the painting *Twelve Cottages on the Green, Bayside*, a riotous tumble of tiny Victorian houses and overturned wooden dories cling precariously to the hillside as the twisting branches of towering maples give up their leaves to the strong sea breeze. Standing before this work, you can't help sensing this movement, feel the warm sunlight, hear the wind, and smell the salt air. "The viewer may be shocked, satisfied, delighted, or disturbed, but definitely should be affected at a gut level," says artist Ann Stein-Aaron. She has spent years refining her skills to elicit just this type of reaction, but it wasn't until she found Windy Corner, nearly twenty years ago, that all of the pieces came together.

Anchored near the end of a long peninsula in midcoast Maine, Windy Corner is the home, studio, and garden that Ann shares with her husband, author and playwright Hugh Aaron. They chose the name because of their new home's exposed coastal location, but it also refers to a favorite passage from E.M. Forster's *A Room with a View*. Living here has been both a challenge and an inspiration for Ann, and the impetus to develop her unique perspective. "I want to paint this powerful land, its heaving rocks beneath the surface, the rush of the wind over land, sea, and sky, the warmth and life in this earth."

In the same way that this spot has worked its magic on her painting, it has helped her create gardens of surprising resilience, exuberance, and beauty. Despite the relentless elements of wind and water, salt spray, and long winters followed by the soggy retreat that Mainers call "mud season," Ann's gardens reveal not a hint of their trials. In fact, they seem to defy nature by growing as tall and lush and vigorous as they would in any well-protected inland site.

For a woman who grew up on the eighth floor of a Florida hotel, this accomplishment is nothing short of remarkable. Potted geraniums on the balcony were as close to horticulture as Ann had gotten until she took what she assumed would be a summer job after her ninth year of teaching art in

LEFT: An exuberant midsummer show of phlox, rudbeckia, tiger lilies, and Pee Gee hydrangeas spills over the edges of Ann's fenced garden. RIGHT: A collection of beach stones and birds' nests create a composition in shades of gray.

public schools. That season of transplanting impatiens at a "greenery" on Cape Cod was the start of a new life for her. She never returned to the classroom, and her knowledge and love of plants quickly grew and deepened. She reveled in the humid warmth and scents of the winter greenhouses, and found that the meditative act of tending seedlings fed her soul.

Delivering orders from the greenery brought her to Provincetown at the tip of Cape Cod. There, window boxes overflow with summer blooms, hanging baskets burst with brilliant fuchsias, and exquisitely designed pocket gardens fill the dooryards of the restaurants, galleries, and B and Bs set cheek by jowl along the main street. When she began designing landscapes for the greenery's clients, she took to it immediately, and that experience has carried forward to the gardens she planted at Windy Corner.

In 1989, when Ann and Hugh married, they moved to Maine and settled in a venerable 1847 home in downtown Belfast. After four years, Hugh expressed his desire to live and sail on saltwater, and they began to search for a place on the coast. A homemade "For Sale by Owner" sign pounded into the center of an open field marked the spot. Borrowing from the local vernacular, they designed their cottage-style home and studios to fit the land and their lives. Ann's approach to planning this garden was pragmatic. Owning two acres of "temptation" and not wanting to become overwhelmed by too large a plot to tend, she limited the garden by building a low picket fence around a semi-square area the width of the house and its broad front porch. This outdoor entrance "room" is only partially protected by a few trees at the shoreline, so hardiness was a determining factor in plant selection. Ann's Belfast gardens had taught her well which plants survive the harsh winters and thrive in the too-short summers here. She transplanted new divisions of sturdy perennials she had previously rescued and revitalized from their abandoned, tangled masses in the overgrown yard in Belfast. Then she added other old reliables, including peonies, sweet william, lamb's-ears, *Artemisia* 'Silver Mound', and sweet alyssum. The garden continues to change a little from year to year thanks to

LEFT: The subdued colors of a vintage tablecloth provide contrast to the brilliantly colored garden beds beyond.
ABOVE: Reflecting the bright midday sun, California poppies (*Eschscholzia californica*) spill over the edge of a stone walkway.
RIGHT: A raised bed of yarrow 'The Pearl' provides brilliant white cut flowers in midsummer.

occasional neighborhood swap luncheons, complete with sunbonnets and wheelbarrows. The price of the lunch is taking home at least one division from the host garden.

Although Ann uses her knowledge of horticulture to choose the plants, the design comes directly from her artist's eye. This garden and yard, like her paintings, contain a marvelous mix of sizes, textures, and colors, arranged for the rhythms they produce throughout the growing season. In late spring, the weighty flower heads of Sarah Bernhardt peonies, deep lavender perennial bachelor's buttons, and bright orange Maine farmhouse poppies punctuate the green foliage of their later-blooming neighbors. Masses of tall pink summer phlox and orange tiger lilies towering over richly golden rudbeckia and annual Blue Victoria salvia compose July's bright palette. Well into fall the garden sustains its tempo with trellised *Clematis* 'Huldine', providing masses of white blossoms above the delicate periwinkle blue of cupid's dart.

In addition to the fenced garden, Ann has built rows of raised beds to grow a variety of summer vegetables. In a low bed nearest the house, she planted late-blooming fall *Clematis paniculata*; the sweet scent of its creamy white clusters is carried into the house on the prevailing southwest breeze. An outcropping of Jerusalem artichokes and self-sowing brilliant orange California poppies leads visitors onto the property. These cultivated features are connected by a wide

swath of neatly mown lawn. To sustain a sense of visual contrast, the largest portion of the field is left to grow wild, producing drifts of Queen Anne's lace and other wildflowers throughout the growing season. To unify the whole, manicured garden areas and rough fields are connected here and there by gracefully curving grass pathways.

Caring for this creation is a task Ann enjoys, but in order to have the time she wants to paint, she limits the maintenance work to one intensive week of weeding and mulching in early spring, another in fall for

dividing and cleanup, and only occasional deadheading over the course of the summer. Because the house depends on a well, she never waters. Having settled each plant into generously amended soil at the outset, she doesn't fertilize beyond the nutrients supplied by annual mulchings with seaweed hauled up from the shore. A practice common on the coast of Maine, spreading a thick layer of seaweed on flower and vegetable beds provides a number of benefits. The spongy texture retains moisture for a long time. Until it eventually washes away, the sea salt discourages slugs but is not concentrated enough to harm plants. As the seaweed decomposes, trace minerals enrich the soil. By layering thick mats of seaweed over otherwise inhospitable land, a gardener can create a rich growing environment.

The challenges of this location also revealed some pleasant surprises. The powdery mildew that beset Ann's phlox in Belfast is not able to take hold here in the continual gentle sea breezes. And heavy coastal dews revitalize the garden even during dry periods. Another unexpected benefit of moving to the area, and this close-knit village in particular, is the support and nurture their neighbors have given for both Ann's and Hugh's creative lives. The rugged drama of the Maine coast has long been a magnet

A wattle fence of wild alder sticks serves as a compost bin in a sunny spot near the garden shed designed in the same style as the house.

for artists and writers. Generations of local fishermen, carpenters, and shopkeepers have become accustomed to discovering that their new neighbors may be poets, actors, or sculptors. The shifting demographics of the state's shoreline villages have been a constant cultural and economic challenge for natives as well as the transplanted artists, made more intense in recent years by the surge in property values. Artists, musicians, writers, and performers in many coastal communities have become an integral part of the local character. It is not unusual for a village's only retail offerings to be a general store and an art gallery. On a summer afternoon for each of the past five years, area residents have gathered in the community church to hear their neighbors perform rehearsed readings of Hugh's full-length plays.

These villages, with their crooked old cottages, wind-sculpted trees, twisting dirt roads, and tilting hillsides strewn with heaved-up glacial boulders have become characters in Ann's work. The low, gentle terrain of Cape Cod, its sand dunes and beach grasses, its tiny hamlets strung like weathered gray pearls along the shore were often the subject of the quiet, earth-toned watercolors and pen-and-ink drawings that Ann produced while living there. Her surroundings set the tone of her work, and it felt right at the time. The move to Maine caused a seismic shift in Ann's creative vision that required her to find new tools and techniques. She felt that watercolors could not

capture Maine's vast, wild, surging terrain, the strength of life she felt in the earth and elements. The intense color and dramatic texture possible with oil paint gave her the power she wanted to interpret the landscape around her. Her work grew away from controlled, muted, faithful renderings into the strong and vibrant portraits she now paints.

The subject matter of Ann's work has varied during her years in Maine, but it has retained her unique style. One series of small paintings is a particularly good example of her ability to bring the viewer beyond the surface of the canvas to the level of a visceral experience. Her *Garden Heaps* portray mounds of natural debris—twisted and entangled twigs, branches, and vines—piled at the end of each growing season as farmers

and gardeners have done for centuries. In these domed constructions, temperatures rise and start the gradual process of decay that produces rich black compost. Through her use of vivid color, expressive brushwork, and masterful composition, these small canvases heave and breathe with the life and heat of nature on fast-forward.

In the real-time world of Windy Corner, compost is generated by these same garden heaps. Ann has contained hers against the property's signature element of wind with a cleverly designed enclosure. About every three or four years, she collects the long, slender whips of wild alders, which her neighbor helps cut, and builds a three-sided wattle fence by weaving the flexible limbs together. In the time it takes for the structure to decompose and become part of the pile, fresh alder whips will have grown tall enough for a new cutting.

The continual interplay between art and garden is evident in many of Ann's works, yet she does not credit one for the other. Instead, she leaves them to coexist and lets viewers draw their own conclusions about the relationship. However, when she speaks about painting, she could just as easily be referring to her gardens. "A painter creates a moment. Facing the blank surface, a painter must be willing and able to unleash his feelings and emotional responses. Of

course, we learn the chemistry and techniques of painting, but that knowledge serves only as background for the creation of very personal translations of our world. It sometimes seems that the more personal the artist's response, the more universally it is felt." A visit to Ann's garden can evoke the same emotional responses one might feel in a gallery of her work. The color and movement and energy evident in all of Ann's creative endeavors are fully realized here at Windy Corner.

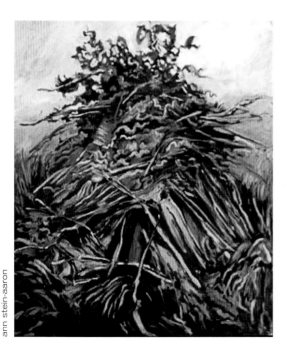

ann stein-aaron

LEFT: *Garden Heap, Early Morning* is typical of the bold brushstroke style Ann has developed to portray the powerful landscape around her.
RIGHT: The artist in the studio with her painting *My Mother in Her 79th Year*.

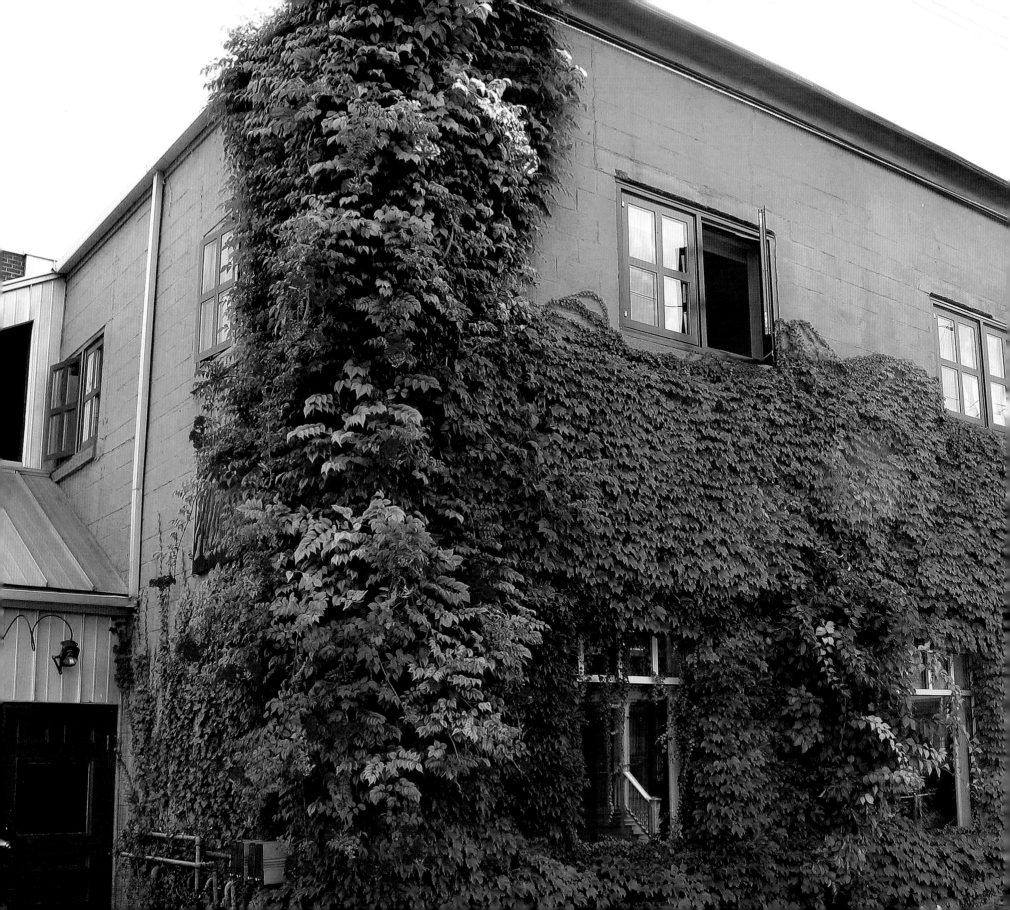

Gar Waterman
the vertical garden

Gar Waterman believes that nature always wins. In a series of "insect architecturals," his found-metal sculptures in the forms of wasps, dragonflies, and beetles, the insects perch on tall steel structures. Over the summer, tendrils of the hops and clematis planted at their bases slowly creep up and eventually obliterate them. As the foliage dies back in fall, the resilient sculptures reemerge, only to be consumed again the following season. This juxtaposition of the organic and the man-made, this confluence of the morphological and the architectural, is a recurring theme in Gar's work. It is also the foundation of his singular approach to gardening.

On a city lot at the industrial edge of an urban neighborhood in New Haven, Connecticut, this self-taught sculptor and his wife, artists' housing activist and developer Thea Buxbaum, have carved out lush and varied environments from what was once a paved parking lot. A stone terrace, a small fruit orchard, a set of large vine-covered arbors, and several raised vegetable beds define the cultivated areas. The back portion of the lot has become a wild field of unmown grasses and volunteer vegetation. But the centerpiece of this unusual garden is an 8,200-square-foot 1950s-era cement-block building, renovated and covered to the rafters with wisteria, trumpet vine, ivy,

ashley curry

porcelain berry (*Ampelopsis*), clematis, Virginia creeper, honeysuckle, moonflower, and bittersweet.

The couple's search for affordable real estate in the vibrant arts communities of the Northeast was quite a challenge. Gar's work is messy, noisy, and space consuming, so size and location were major considerations. But they were willing to invest their time and energy into this decrepit abandoned property, and they negotiated a deal with the city to acquire it for one dollar. Today this remarkable structure is gallery, studio, office, and home to Gar, Thea, and their son, Geffen, as well as loft apartments occupied by three artist tenants. Other artists now live and work in several handsome, newly renovated buildings on the same street, thanks to Thea's skill and dedication.

LEFT: The fiery red blossoms of trumpet vine stand out against the lush green foliage covering the front wall of Gar's home and studio.

RIGHT: The property's address plate is nearly obscured each year by the new growth of Virginia creeper.

gar waterman

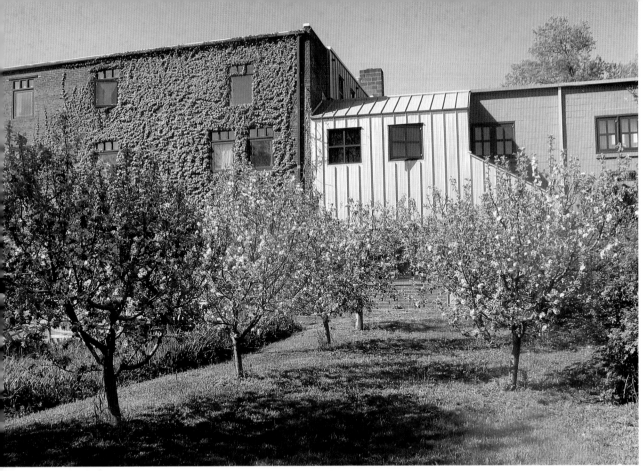

gar waterman

A self-proclaimed "mill rat" living and working in old industrial buildings, Gar had no experience with growing things, but he'd had a vision in the back of his mind of what this place might become. In the early 1980s, hoping to develop some skill as a stone carver, he traveled to Italy and ended up staying seven years. In the northern Tuscan town of Pietrasanta (literally, holy stone), Gar worked among international artists and artisans in the ancient tradition of carving in local marble. Renowned sculptors Igor Mitoraj and Fernando Botero have homes and magnificent gardens in this idyllic commune, and the town's central piazza affords a view of the quarry from which Michelangelo took the stone for his *David*.

Carving brought Gar to Italy, but what kept him there were the things that make that region so enchanting—the people, the food, the landscape. When he returned home he brought with him a deep appreciation for the beauty and serenity of the Italian garden. The design of typical modern Italian gardens reflects a centuries-old convention of melding the aesthetic with the pragmatic: stunning formal ornamental gardens and vegetable beds close to the house for easy tending and watering, and rows of fruit trees, vines, and berry bushes extending out to meadows of indigenous wildflowers and herbs. The Italians have managed to make a number of foreign species their own, such as the New World sunflower and the Middle

Eastern olive. The massive twining limbs and pendulous purple racemes of ancient Chinese wisteria (*W. sinensis*) are a common sight on the stone walls and arbors of nearly every town and village in Tuscany. It is not uncommon to see Italian sculptors working outdoors under canopies of wisteria and date palms. Gar promised himself that when he returned home and found a building of his own he would cover it in vines.

The only original vegetation growing up through the cracked asphalt and cement of this decaying structure was the tenacious bittersweet. It remains to this day, but perhaps because of the sheer number, size, and variety of other vegetation clinging to every surface, it acts uncharacteristically like an invited guest. Plants that might be considered

ashley curry

invasive in other environments seem to wait politely to show off their new leaves, flowers, or fruit. Gar's favorite for many reasons is Virginia creeper. Unlike the English ivy that has grown to monstrous proportions, Virginia creeper is easy to prune back because it loses its foliage in the winter months. When the new leaves appear in spring, they bear only a slight resemblance to their mature state, so as this vigorous native climber fills out, it appears to be two different plants intertwined. Its flowers are completely inconspicuous, but, come fall, birds are attracted by the ripening blue-black berries, and the glossy compound leaves turn a brilliant shade of crimson.

In an effort to cover as much surface as possible with vegetation, Gar didn't stop with the building. A privacy fence is covered with an unnamed climbing rose and more Virginia creeper. Out on the street, a utility pole completely wrapped in porcelain berry is filled with an intriguing collection of bees and wasps at midday. On one nineteen-foot-long wooden arbor that separates the cultivated from the wild portions of the yard, cold-tolerant northern kiwi vines bear their tiny, smooth, sweet fruit. A second arbor is

FACING PAGE, TOP: Rows of apple trees bloom in the side yard. Gar and Thea chose to mix brick, block, and steel in the renovation of their property. FACING PAGE, BOTTOM: One of Gar's "insect architecturals" set against the backdrop of West Rock, the area's defining geological feature. RIGHT: Gar's studio sign amidst the vines.

ashley curry

115

festooned with the fast-growing, tooth-edged foliage of perennial hops. Because Gar and his family don't use insecticides in the small, orderly orchard of Macoun, Red Delicious, and McIntosh trees, they harvest only a handful of edible apples each year. They enjoy the orchard mainly for its aesthetic qualities. But their *Prunus* 'Napoleon', 'Emperor Francis', and White Gold™ cherry trees produce a wealth of luscious rose-tinged yellow cherries, and raised beds and terra-cotta planters provide fresh vegetables and herbs throughout the season. The spiraling leaves and tangled branches of a large corkscrew willow furnish summer shade for a forty-year-old philodendron.

Gar and Thea have helped to define this section of the city as the perfect confluence of urban amenities and small-town values, and that extends to the rental portions of their property as well. Their tenants enjoy the privacy of appealing tree-shaded sitting areas as well as garden beds to plant as they wish. Encouraged to participate in the development of this lush environment, other artist-gardeners are drawn to the property, resulting in new and richer friendships and partnerships.

As this neighborhood has grown and changed in recent years, so has Gar's artistic life. Ever-expanding networks of galleries and collectors have discovered his extraordinary talent, and the professional success that

ashley curry

ashley curry

selves for the inevitable surge of energy that is germination. In comparison, the cycle of growth and maturity can seem like a brief moment in which the next generation of seed is born.

Just as feral seeds lie in wait for the right set of circumstances to be transformed into vibrant fields of brilliant blooms or mountainsides of lush foliage, this decaying patch of urban wasteland was transfigured by vision, commitment, and an absolute faith in nature's reign.

FACING PAGE: A sculpture in the wild back portion of the yard is framed by the deep green foliage of northern kiwi.
LEFT: The artist flanked by two of his large stone pieces.
BELOW: One of Gar's feral seeds carved from cocobola, rosewood, and ebony.

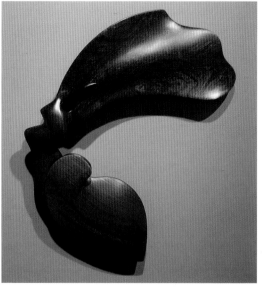

gar waterman

has followed caught him somewhat by surprise. The son of accomplished parents, Gar had a childhood colored by his father's unorthodox career as an underwater filmmaker. Gar spent his ninth year in Tahiti, and that exposure to the voluptuousness of its sea life and rain forest was the catalyst for a lifelong study of natural phenomena. His best moments as a young French major at Darmouth College, Gar recalls, were those spent tinkering in the school's studios and workshops. Uninspired by the prospect of a traditional career, he pursued art out of desperation and became proficient at transforming stone, metal, wood, and glass into forms as sensuous and dynamic as nature itself.

Certain forms emerge repeatedly in Gar's work and have become richer with each interpretation. Insects, shells, and cuttlefish have been frequent subjects over the years because of their structural, tactile, and aesthetic values. But the objects that have held the most fascination for this artist are the seeds of wild plants as they first begin to germinate. He has interpreted their forms in onyx and marble, ebony and rosewood, and brass and bronze. Some of his feral seed sculptures fit in the palm of a hand; others span the length of a wall. As models, they perfectly embody the visual rhythm that marks much of Gar's work. Paced to draw the eye along an extended curve, they culminate in a burst of activity, then taper off again. They perform visually in much the same way as they do naturally. These seeds can lie dormant for years, as if pacing them-

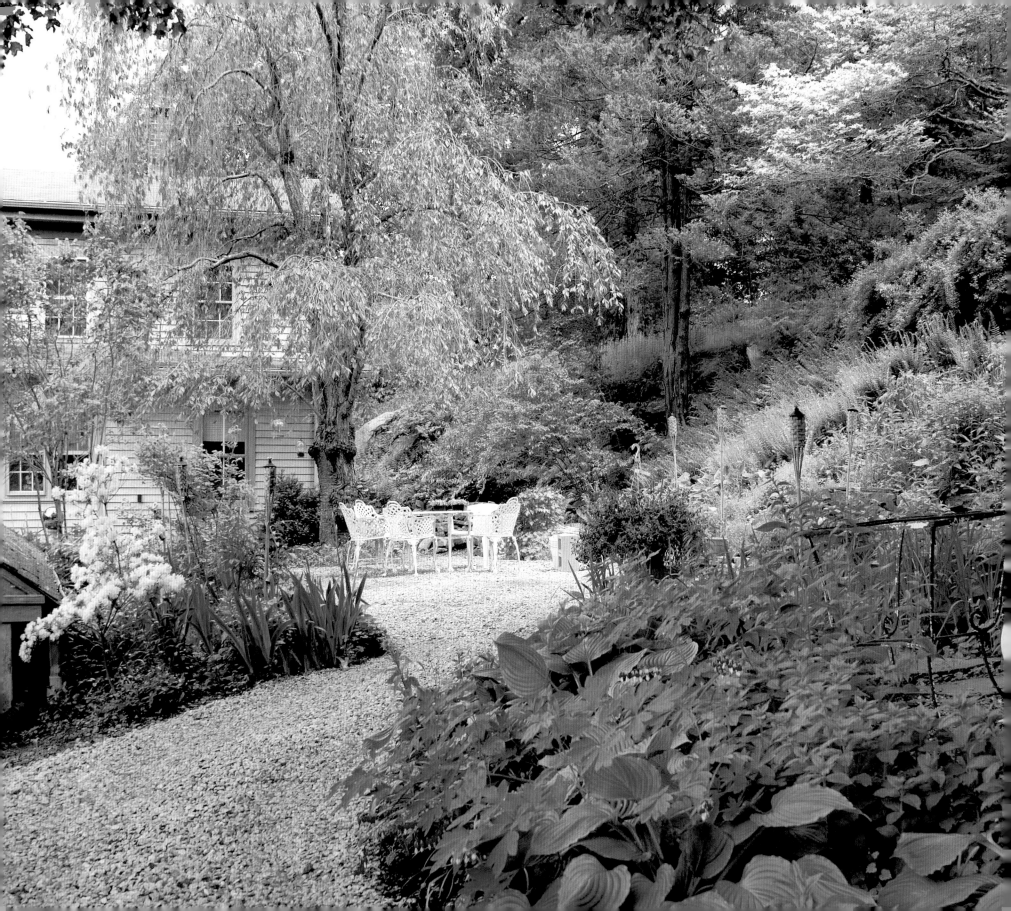

Leif Nilsson and Caryn B. Davis
a passion for process

ashley curry

Leif Nilsson strides through his gardens, pointing out works in progress: a stone wall he plans to alter, a failing tree that may be removed, a bed of perennials that is slated for transplant to a different location. He stops to point out how the morning light is grazing the eastern corner of his house and changing the colors in the shadows of the gray clapboards. In his studio he chronicles the shifting back and forth between brush and palette knife and how it has helped him develop his technique. While studying one painting of the garden, he speculates that the gravel path it depicts might look better built of large, flat stones.

For Leif the push-pull between gardening and painting is constant, with neither one remaining static for long. Because he paints exclusively from life in the plein air style, this connection is not only visual, it's physical. He'll keep working on a scene of his flowering cherry tree until the blossoms have dropped to the ground. Or he may decide to plant a flat of annuals to provide a particular color he wants to paint in the corner of a canvas.

Leif's gardens start as a series of raised beds and potted annuals in front of his studio, located in the town center of tiny Chester, Connecticut. The beds wrap around to a set of stone stairs that lead up along the historic building that houses his gallery and residence and continue to pea-stone paths and brick patios surrounded by mature trees, flowering shrubs, stone walls, and beds of perennials. From there the gardens fan out and continue to climb up a steep hillside crisscrossed with stone steps until they culminate at a common green space at the top of a ridge he shares with his neighbors.

The history of the gardens chronicles Leif's relationship with this location, beginning in 1990 when he rented the carriage house as a gallery for his impressionistic paintings. Unsuited to a sedentary life, he planted annual window boxes as subjects to paint during gallery hours. To discourage vehicles from blocking the door, he built wooden planters and filled them with snap-

LEFT: From the stone and pebble patio beside Leif's house, the gardens climb the hillside to a tree-lined ridge.
RIGHT: English ivy covers a multipane window in Leif's studio.

caryn b. davis

119

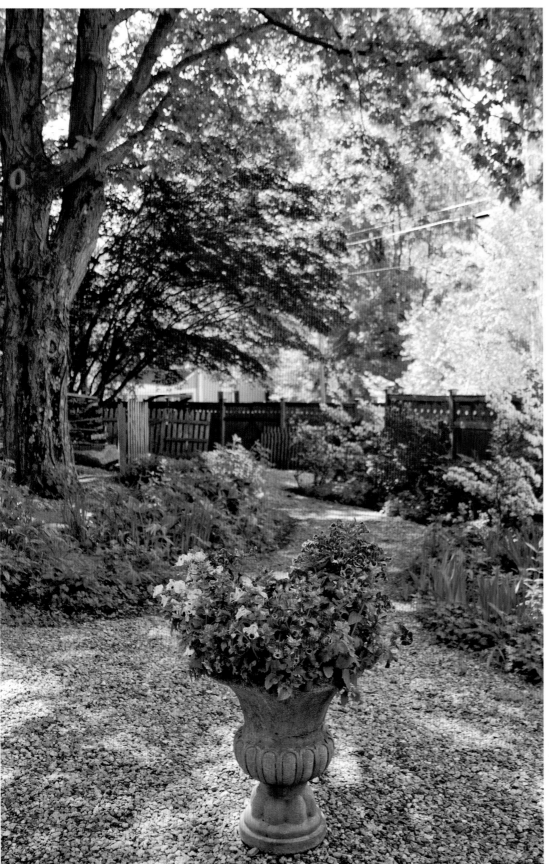

dragons, painting them from every angle for the next several years. In 1995 he bought the half-acre property, and the real work of creating the landscape began.

An infestation of termites in the house led to a major renovation and the rental of a tractor. Before building a new foundation, Leif had to break up the existing concrete patio and move huge piles of earth and stone from the old basement to elsewhere on the property. New wooden doors and windows, granite steps, a much-needed drainage system, and a handsome new brick courtyard, complete with outdoor lighting and a sound system, emerged from the dust. By the time the construction was finished, Leif owned his own earth-moving equipment and had set his sights on the backyard.

With nothing but a large lawn, some ground cover plants, and a few shrubs, the backyard looked much like a blank canvas to the artist. Inspired by a recent trip to the palace and fortress complex of Alhambra, in Grenada, Spain, Leif started by terracing the hillside. When British settlers first cleared the Connecticut forest for farming, one could hardly put a shovel into the ground without hitting a rock. Today, beautiful old stone walls meander though town and country all across the state and give the land its graceful rusticity. The ground still yields plenty of cobbles; with the rocks he unearthed, Leif

An urn of yellow and orange monkey flowers in the dappled shade of a stone path might become an element in one of Leif's many paintings of his gardens.

caryn b. davis

built walls and steps and walkways that helped define the gardens and provide access to the upper portions of the property. He used what he had learned from his grandfather, a professional gardener, and from his early jobs in landscaping to prepare the land, doing backhoe work with a local horse farmer in exchange for manure to enrich the soil. (He would later barter this same service for much-needed massage therapy.)

Ferns and hostas provided a base for the hillside garden. Leif added plants donated by family and friends: phlox, perennial

ashley curry

sunflowers, bee balm, and daylilies. Forsythia, rose of Sharon, and spirea grew to create a privacy screen on one edge of the yard. Along the street-side fence he planted shoots from his grandmother's rhododendrons and lilacs among the native asters and azaleas. He bought roses, peonies, and hydrangeas for the flower beds that wind around the pea-stone patio, planted his grandmother's English ivy to cover the walls of the studio and the ground under the cherry tree, and seeded annual sunflowers to greet visitors at the gate. He continued to carve out the hardscape, widening paths, redirecting walls, altering walkway surfaces. Over the years he has filled the yard to overflowing with dozens of species of trees, flowering shrubs, perennials, spring bulbs, vines, and ground covers as well as pots and planters of colorful summer annuals. As evidenced by many of his paintings, the gardens have long been a spectacular show of color and texture, shadow and sunlight.

Leif's enthusiasm for his garden seems to be at least partially rooted in his ability to transform it almost at will. (Each spring while most of the vegetation is still small, he gets the uncontrollable urge to move things.) In fact, hard work, determination, and a high level of skill with landscaping equipment are what have made these ever-evolving gardens possible. Rock walls have been dismantled and rebuilt to create new sitting areas, and mounds of soil have been moved and the resulting level areas filled with shrubs and perennials dug from other parts of the yard.

ashley curry

LEFT: A mix of ferns and hostas grows in the shadows of rock walls throughout the yard.
ABOVE: A bench built into a wall of native stone offers one of many opportunities to sit and consider the gardens.

BELOW: Caryn scours antique markets for pieces that will serve as focal points.
RIGHT TOP: A pale pink hydrangea in bloom.
RIGHT BOTTOM: Over the years English ivy has nearly covered one of Leif's buildings.

photos ashley curry

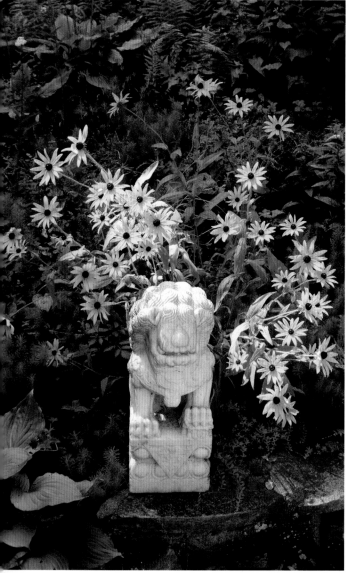

ashley curry

The physical activity suits Leif's high-energy personality and keeps him in shape. The other compelling force for this continual change is that it provides him new subject matter for the next series of garden paintings.

Since childhood Leif had been drawn to the solitary act of making art. He worked in pencil, watercolor, and acrylic through high school, then at eighteen he packed his supplies and embarked on a cross-country trip. He hitchhiked as far as South Dakota, where he stumbled upon the Black Hills International Survival Gathering and was inspired by Lakota activist and artist Russell Means to explore his own ancestry. He got to know his grandfather, then traveled to Europe for seven months, spending time in Sweden, where he lived and worked with his extended family. Once back home, he resumed working for gardening clients and, with a full scholarship awaiting him, was able to finish his art school education. He first focused on life drawing to build a solid base, but always knew that studio work was not for him. So after graduation he scheduled his workdays around plein air landscape painting.

Leif developed a distinct impressionist brushwork style perfectly suited to his favorite subject matter: streetscapes of his historic Connecticut town, the ever-changing light on the Connecticut River, summer flower gardens. In 1986 he studied with painter and color theorist Henry Hensche on Cape Cod and discovered the palette knife method of applying paint to canvas. After experimenting with combinations of brush and

ashley curry

knife, he spent a few years working back and forth between the two. By this time he had started landscaping his gardens, and, inspired by the act of making sweeping changes in his yard with his tractor, he began using the knife in bold and varied ways to create new depth and detail in his paintings. Today he achieves vibrant color and glistening light on his canvases using a palette knife exclusively. He seems satisfied with his current painting technique, but if Leif's history is any indication, he'll soon find a new source of inspiration and the next round of changes will start.

By midsummer the garden is in maintenance mode. Large bunches of broccoli and kale fill the front planter boxes, and morning glories climb the arched trellis over the gallery's side door. Potted tomatoes are moved daily to catch the afternoon light, and Leif finds this year's crop of burgundy sunflowers too perfect not to paint. Echinacea, rudbeckia, and phlox bloom brilliant purple, yellow, and pink in the back gardens, and a drift of white gooseneck loosestrife bends its collective heads toward the hillside. In the shade of a tall cedar tree, hummingbirds dance around the purple hosta flowers, while Stella de Oro daylilies offer their cadmium yellow blossoms to the sun. Amethyst globe thistle, pale pink mallow, and golden

The bright white of this ornate iron settee draws attention to the white balloon flowers blooming among golden yellow rudbeckia and the lavender spikes of hostas in the hillside above.

ashley curry

mustard bloom amid the euonymus atop the rock walls, and low-growing lady's mantle spreads its ruffled leaves over the edges of pebbled paths.

For a moment in time, the gardens resemble Leif's latest series of paintings. But from the top corner of the yard he surveys the layout and a new plan starts to take shape. He envisions a way to complete a circular path around the property, perhaps by building a bridge from the hillside to the studio or by constructing a staircase that completes the circle. Climbing hydrangeas might cover a tall privacy fence; native junipers, cedars, and laurels could flow down the hill. He may find the perfect spot for a magnolia if he cuts down one large spruce and donates it to the community for a Christmas tree; from a new sitting area at the very top of the property, he would be able to view that tree in the town square. And on a sunlit summer day he could set his easel in just the right spot in the garden and the cycle would begin again.

ABOVE: Leif stands in front of a large canvas depicting downtown Chester, Connecticut.
RIGHT: *Backyard Garden* is a spring view of the scene Leif has painted many times.

caryn b. davis

Caryn B. Davis

caryn b. davis

While Leif works on the layout of the landscape, his partner, Caryn B. Davis, concentrates on the details that create beautiful vignettes throughout the gardens. She walks the beaches in Connecticut and abroad in search of rocks and shells, and scours antiques shops for outdoor furniture and architectural remnants. A variety of pots and planters punctuate the patio with unexpected color, and wind chimes add their distinctive tone to the ambience. Often, when these elements come together in a particular way, Caryn is inspired to record them in photographs. She is attracted by contrast in the gardens, but also by color, an element that entered her visual vocabulary only in the last few years.

As a producer and director of documentary films in New York City, Caryn had an opportunity to travel the globe, which was the stimulus for her new career. Primarily self-taught, she was influenced by celebrated photographers Joyce Tenneson and Phil Borges, who encouraged her to choose a subject to record for a year in order to find her signature style. Today her extensive portfolio includes several series of in-depth studies on subjects ranging from Orbis International, a nonprofit organization fighting blindness in developing countries, to her recent *Chester Stories*, beautifully conceived and executed portraits of the residents of the town she calls home.

Until 2003 Caryn shot exclusively in black and white. On a trip to Nova Scotia with Leif, she found herself with a lot of time on her hands (his painting required that he stay in one location for an extended period). She began to experiment with color as abstraction and soon began to view the world in tones and hues, although she retained the strong graphic sense of her earlier work. Her photographs are sought by collectors and publications, in particular shelter magazines where her passion for interior and garden design is evidenced in her work. In the gardens, her creative touch is everywhere—in the brilliant red watering can against a gray stone step, the collection of beach stones on a rock wall, the vase of black-eyed Susans on a colorfully striped tablecloth, the placement of an antique bench. Although her career keeps her busy and mobile, she occasionally stops for a moment to capture a view of the fabulous gardens that she and Leif have built together.

ashley curry

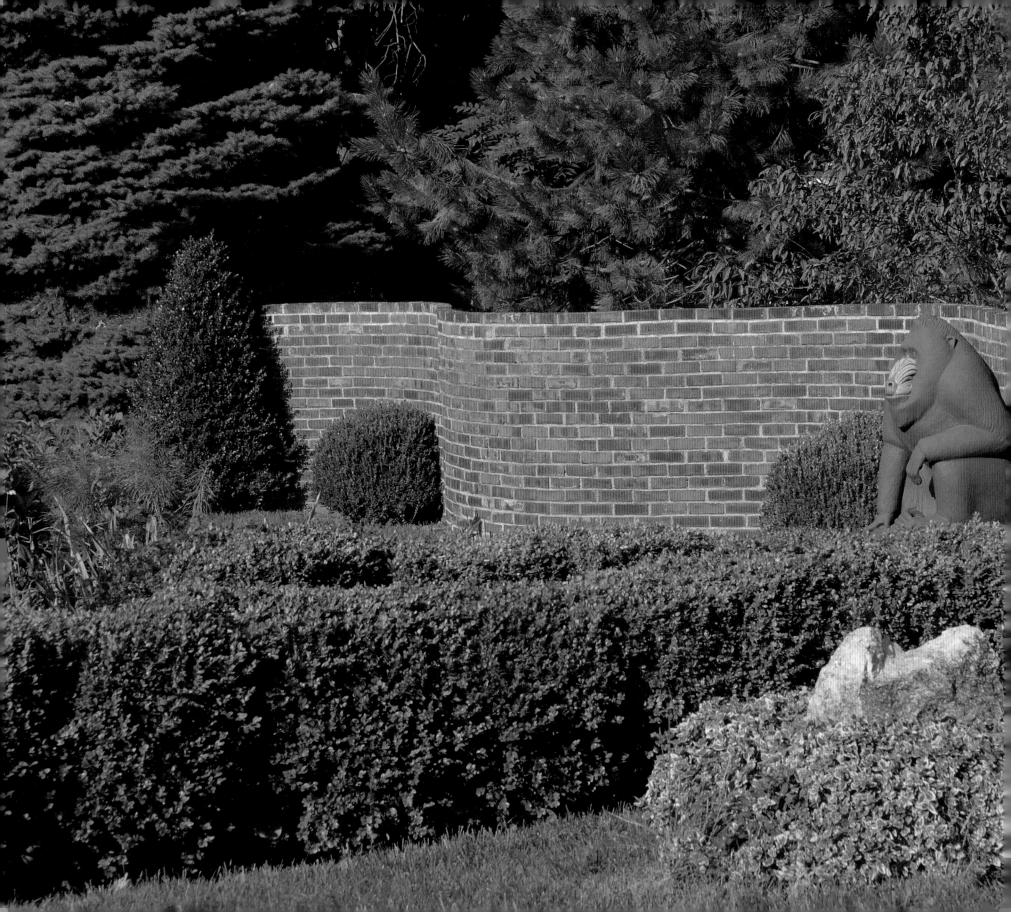

Penelope Manzella
focusing on structure

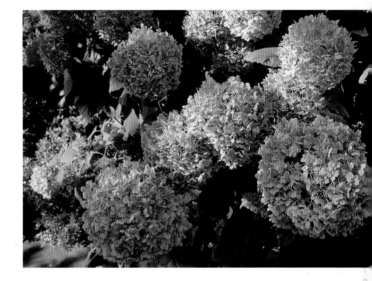

Artist Penelope Manzella is inspired by many things: images of exotic wildlife, fresh produce she grows in her yard, the decaying brick mill buildings that dot the cities and towns of Rhode Island. She's turned that inspiration into exquisite life-size terra-cotta sculptures of primates and birds of prey, detailed oils such as a series of paintings depicting the thick stalks and ruffled leaves of rhubarb in an imaginative range of scale and context, and an acclaimed body of large, somewhat surrealist industrial landscapes that emanate a disquieting familiarity with both their content and composition.

The gardens that wrap around her beautiful Italianate house on a riverbank at the western edge of the Ocean State have the same deliberate quality as her artwork. Each is unique in its scale and layout—their common allure is derived from a decided emphasis on form. "Every plant that's in any garden book has been in and out of these gardens at one time. I'm not as interested in the plant material as the structure—that's the permanent part."

Penelope has long been attracted to the formality of European gardens—rows of sculpted hedges, aerial views of French parterres, the symmetry and definition created by walls and paths. She has successfully translated these qualities to reflect her own

vision; in doing so, she has created a showplace for her extraordinary and varied talents.

In the four decades since moving to this location, Penelope has designed, built, and planted several distinct "rooms" into the landscape. Each room leads to the next in a directed experience that eventually reveals the full scope of the garden plan. At the entrance to the property is her first project—an ambitious enclosed brick courtyard complete with a working fountain of a magnificently sculpted mermaid balancing a large shell above her head. It is one of many figurative pieces that Penelope produced in the 1970s, but her only work in bronze. The water flows off the shell into a shallow brick pool edged with bluestone and surrounded

LEFT: A pair of serpentine brick walls define the edges of the back gardens where Penelope's large terra-cotta mandrill gazes out over the trimmed boxwood hedges.
RIGHT: Annabelle hydrangeas turn from white to green in the early fall.

by low shaped shrubs and mirroring beds of annuals and perennials. On an interlocking pattern of bricks leading to the fountain, the artist has painted a slightly altered version of the envoy from Robert Louis Stevenson's *A Child's Garden of Verses and Underwood*:

> *Go, little verse, and wish to all*
> *Flowers in the garden, meat in the hall,*
> *A bin of wine, a spice of wit,*
> *A house with lawns enclosing it,*
> *A living river by the door,*
> *A mockingbird in the sycamore.*

A trio of tall, narrow juniper trees and a shaggy topiary of the artist's beloved poodle, Daphne, covers the house's white clapboard wall on one side of the courtyard. The opposite edge is defined by the beginning of a series of wide boxwood hedges, their tops sculpted into a pattern of repeating scallops that are replicated throughout the gardens. In the far corner of the courtyard, a brick path leads to an open flagstone patio edged with beds of bright annuals and clay planters that change with the seasons. A bronze sundial that sits atop a handsome terra-cotta column is backed by rows of shaped conifers, and planters of colorful mixed coleus spill from the porch rail.

From a pair of antique patio chairs, one can enjoy a view of Penelope's second project. The highlight of this formal perennial garden is a set of densely planted beds defined by brick edging set in opposing wave patterns that refer to but do not mimic the hedge tops. In an expertly executed trompe l'oeil, the newest sections of edging are actu-

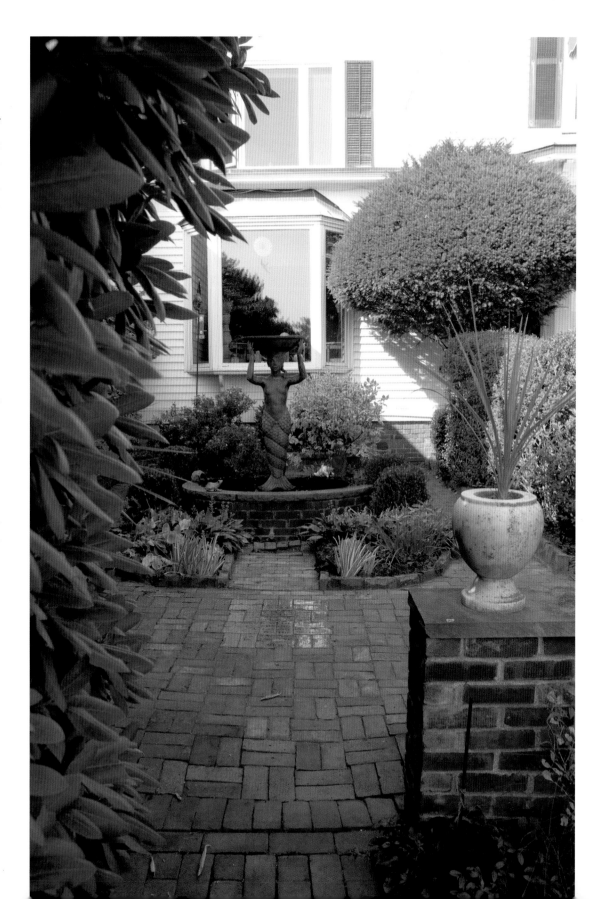

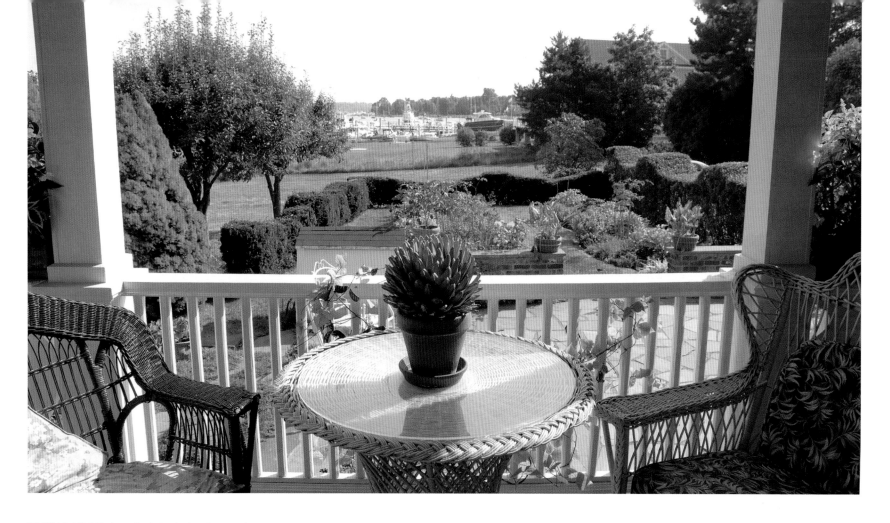

FACING PAGE: A wall of rhododendrons edges the entrance to a brick courtyard in which the artist's only bronze sculpture, a large mermaid fountain, is the central focus.

ABOVE: A porch with antique wicker furniture overlooks the perennial beds, sculpted hedges, and the marina on the river beyond.

ally poured cement that the artist painted to resemble the neighboring pavers. Beyond the far hedge, one can catch a glimpse across the river to the factory building that first captured the artist's eye and nudged her in a direction that would establish her as one of the region's most honored painters.

In order to simplify garden maintenance in recent years, Penelope limited her plantings to the most reliable varieties. In the perennial beds she chose peonies, daylilies, and sedums, planting them en masse for a continuous showing of foliage and color throughout the summer. Bordering the lengthy drive are dozens of lavender plants

backed by a long row of pink shrub roses. Select specimens of other favorites add alternating bursts of color and textural interest all year. In spring a massive lavender-pink rhododendron welcomes guests at the entrance to the courtyard, and vigorous wisteria turns one end of the sitting porch into a wall of pale purple. Frothy lilac-colored clusters of meadow rue flowers dance on leggy stems in early summer. In the lawn that leads down to the river, Penelope has planted peach and pear trees for their spring blossoms and delicious fruit. A copper beech adds a reddish counterpoint to a row of Colorado blue spruce and arborvitae.

Incorporating Sculpture

As the path continues around the house, it passes a large cherry laurel, whose habit resembles a lilac but which blooms in the fall. This row of bluestone blocks ends at a pair of Annabelle hydrangeas, punctuating the walkway with their late-season mop heads of lime green. Beyond the path, the yard opens out to a grand expanse of lawn intersected by a symmetrical pattern of sculpted hedges, perennial borders, rose arbors, and a sampling of Penelope's distinctive sculptures. Defining two edges of this space are a set of striking five-foot-high red brick walls constructed in a serpentine wave reminiscent of the borders in the small formal garden. The first wall was built in the mid-1970s by Penelope's husband, David, and a group of his students from the Rhode Island School of Design. Soon after, Penelope built the second wall herself. Positioned at each end of the far curve of brick are the massive green columns of a pair of perfectly trimmed Hinoki cypresses. Smaller pyramidal conifers enclose the ends of the side wall, and a small domed conifer is tucked into each convex section. Set against this backdrop of variegated brick reds, a bed of bright, lacy asparagus foliage creates an intriguing study in color and texture.

RIGHT: Penelope's stately Italianate home is perfectly suited to her love of formal design. By creating garden "rooms" with hedges and walls, she has created a series of diverse views from the home's porches and interior.

Although Penelope's magnificent bronze and terra-cotta pieces grace her gardens, she has also created sculptural vignettes from everyday objects such as this grouping of antique watering cans that pour out streams of rope "water" into the barrel below.

"I'm not as interested in the plant material as the structure—that's the permanent part."

In early summer the broad, creamy white lace-caps of climbing hydrangea flowers cover a long arbor that runs along the opposite edge of these gardens. In late September, clusters of deep purple Concord grapes bursting with their sweet scent create an edible canopy. Under the arbor, Penelope has constructed a living sofa with a seat of cedar and a back of boxwood hedging. In the midst of the mazelike arrangement of shrubs and hedges that characterize the garden, a variety of hardy roses blooms in succession alongside beds of bulbs and perennials.

The highlight of this masterfully designed garden is the placement of Penelope's imposing terra-cottas. Across this expanse of green, the powerful blue-faced mandrill holds his steady gaze as he faces off against the calculated calm of a giant condor. A giant crested saguaro seems to stand guard just out of range.

Although images of formal European landscapes have been the impetus for much of the layout and plant selection, Penelope's art has been inspired, in turn, by her own landscaping efforts. The grape-laden arbor, the blooming wisteria vine, the sculpted hedges, and the imposing mandrill are all depicted in her recent series of paintings, *In the Garden of Deadly Sins*. A departure in scale and content from her mill paintings,

A giant condor and crested saguaro are a few of the painted terra-cotta sculptures set amid the beds and hedges in Penelope's gardens.

these small panels depict primarily female figures content in the pleasures of lush green gardens. Yet the mill images and these paintings share a sense of odd symmetry, carefully edited detailing, and an ambiguous point of view that give all of Penelope's work an ethereal quality. Of her factory paintings, art critic Fish Bundy wrote that she "seems to be imposing order where chaos is taking over." Her deliberate design, her choice of plant materials, and her emphasis on structure seem to impose that same order in her landscape designs. Out of its classical proportions and sculpted precision comes an idealized version of "garden" made real by the vision and dedication of this extraordinary artist.

LEFT: *Wrath* from her series *In the Garden of Deadly Sins* depicts one of her terra-cottas. ABOVE: Penelope and Daphne sit for a moment on the cool shaded porch.

Penelope "seems to be imposing order where chaos is taking over."

Kay Ritter

composing with foliage

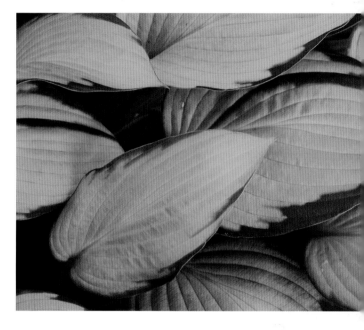

"**My technique** is painstaking and incremental in nature. I hope, through careful arrangement and the closest and truest observation I can manage, to produce for the viewer an emotional response to the common objects that surround us all."

Kay Ritter is referring to the exquisitely detailed and radiant still lifes of fruits and flowers that she has been painting over the last few years. She could just as accurately be describing her gardens. Her depth of horticultural knowledge, her command of design principles, and her sharply honed instincts are the product of the same deep curiosity and determination that have made her a successful artist. Her gardens, like her paintings, are the work of a master. What makes all of it even more remarkable is that in both disciplines Kay is self-taught.

A tour with the artist around her gardens makes it clear why, even in late September, there is a lush vibrancy that defies the season. "After a while every gardener realizes that foliage is the backbone." The colors and shapes of leaves, the structure of needle clusters, the habit of trees and shrubs are characteristics that interest Kay. She refers to plants by their botanical name and can recount the details of their growth through the year. Her talent for study, both intellectual and practical, has resulted in a sharp eye and

LEFT: This bed of varied form and texture is home to the waxy red-leafed tender perennial *Iresine herbstii* 'Brilliantissima', which can grow to five feet and is salt tolerant. RIGHT: 'Gold Standard' is one of the many hosta varieties Kay has planted in her shaded beds.

a solid understanding of what works and what does not. "I can now appreciate something in the nursery and not have to bring it home."

Twenty years ago, when she and her husband bought this house with its open side lot, Kay saw an opportunity to plant the purple beech tree she had always wanted. She then began to frame the yard with other favorites. Today, giant dawn redwood, blue spruce, and western red cedar flank katsura and gingko, sand cherries and beach plums, to create a wall of green around this now private space. Working inward from the tree line, she continued each year to add garden

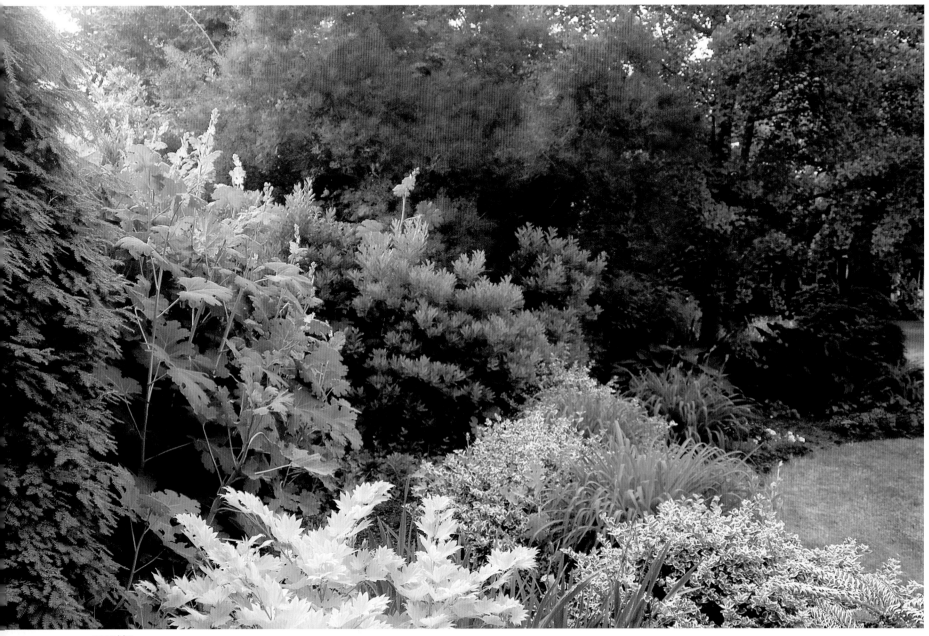

roger birn

beds and reduce the size of the center lawn. In spring she cuts and edges new areas, laying down newspaper and a thick mat of mulch to prepare the ground for turning and planting the following season. Over the years, applications of compost, manure, and peat moss have produced the rich soil needed to maintain this vigorous landscape.

Against a backdrop of form and texture, a progression of color pulls the perennial beds from one season to the next. Each border is designed as a separate composition that adds to a coherent whole. The dwarf rhododendron 'Ken Janek', whose intense

magenta buds open to pink before fading nearly to white, blooms over a bed of Spanish bluebells (*Scilla hispanica*) and the periwinkle blue flowers of *Vinca minor*. An ancient lilac provides the backdrop for deep blue-purple irises, the noteworthy chartreuse foliage of lambs' ears *Stachys byzantina* 'Primrose Heron', and wine-colored *Euphorbia amygdaloides* 'Purpurea'. The new leaves of a Japanese maple 'Orangeola' and purple-leaf sand cherries add a fiery glow to the spring palette. Summer arrives with the hot reds and oranges of fragrant Asiatic lilies, then cools to purples and blues with *Phlox paniculata* 'Blue Boy', *Geranium* 'Johnson's Blue', purple liatris, and woolly ageratum. The magnificent lilac-etched burgundy foliage of *Strobilanthes dyerianus* 'Persian Shield' reaches its full potential in late summer when deep orangey pink *Hemerocallis* 'August Queen' and Red Valeria *Centranthus ruber* are in full bloom.

By early fall the russet-toned foliage of heucheras and the deep purple of stately *Cimicifuga ramosa* 'Hillside Black Beauty' provide contrast to the dark green conifers and support the varied pinks of Autumn Joy sedum, Wave® petunias, and *Artemisia* 'Silver Brocade'. Kay is particularly fond of the wine-red spikes of *Salvia vanhouttei* 'Paul' that radiate from brilliant green foliage, and of the tender perennial *Iresine herbstii* 'Brilliantissima' for its waxy crimson leaves that last until frost.

For three weeks every May this dedicated artist is totally committed to her garden, preparing the beds in anticipation of another successful season. Then, throughout the summer she spends some time each day tending and weeding, often losing time to these activities she loves. But instead of seeing gardening as pulling her away from painting, Kay finds that the two disciplines enhance each other. The tiered hues and textures of the gardens often refer back to her paintings. Blues and blue-greens are set against reds and red-oranges in vignettes around the borders as well as in an oil of turban squash in progress in the studio. In a small gold-framed painting, a jar of frothy white marigolds casts its shadow on a satin cloth. The play of textures in the painting is much like that of the waterfall of the feathery Japanese grass *Hakonechloa macra* 'Aureola'

against the broad rugose leaves of Great Expectations hostas that edge the shaded borders of her garden.

Kay enjoyed a twenty-year career as a successful figurative sculptor. Her life-size, often humorous portrayals of individuals and groups provided her with a medium for her creative voice and much critical acclaim. Yet, when she felt she had said all she needed in sculpture, she embarked on a journey into two-dimensional representation, which soon brought her to oil paint. With a talent for and a love of rendering, she studied the masters of realism. "Most of my heroes are not still life painters per se. Martin Johnson Heade and Johannes Vermeer top my list, but I am drawn to and influenced by the Spanish painters Juan Sánchez Cotan

roger birn

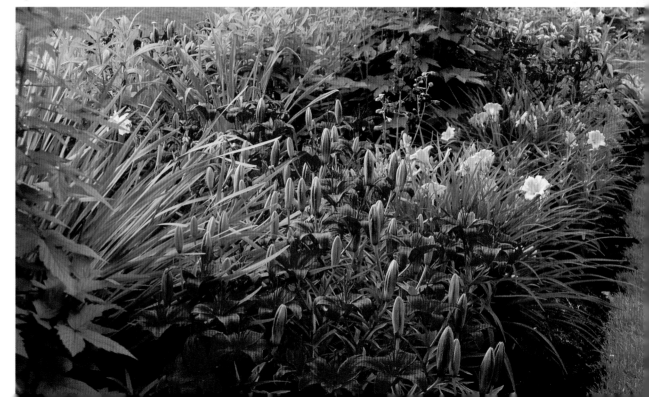

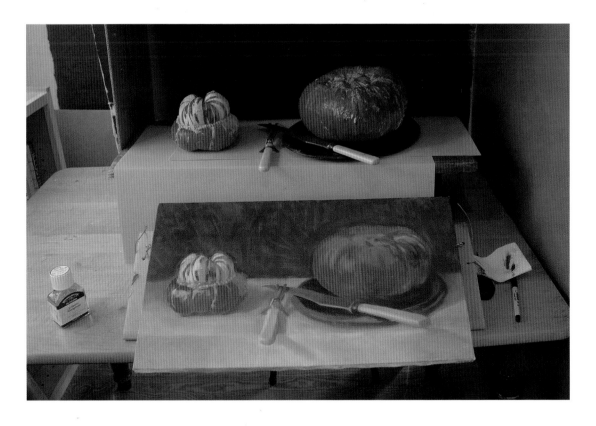

works from life, not photographs, the scale of her still lifes is faithful to the subject, each canvas befitting the size of the composition. She brings this sensitivity of scale to the garden by carefully integrating dwarf varieties of some of her favorite plants. Near the front door of her beautifully renovated home, she has planted dwarf rhododendrons and a tiny Hinoki cypress, whose emerald green branchlets unfold like a ruffle-edged fan. Tucked among lush, large-leaved hostas is a diminutive sport of Blue Cadet hosta named 'Blue Mouse Ears', the 2008 Hosta of the Year. With its soft, curvy, blue-green leaves, this dense little plant grows only a foot wide

and Francisco de Zurbaran, the American John Peto, and the French master of fruit and flowers, Henri Fantin-Latour." The extraordinarily varied work of Chilean-born realist Claudio Bravo provides contemporary inspiration for Kay's continuing development as an artist.

For the most part, Kay's paintings follow the seasons. Sunflowers from a local farm stand, squash from the produce section of the town market, and *Hosta seiboldiana* 'Elegans' from her own yard are brought into her light-filled studio. Perhaps because she

ABOVE: In the studio Kay has begun a new painting of a pair of squashes she found at the local farmers' market.
RIGHT: A trail of variegated ivy, a small Hinoki cypress, and potted mums greet visitors at the front door where the artist sits with her English springer spaniel, Willie.

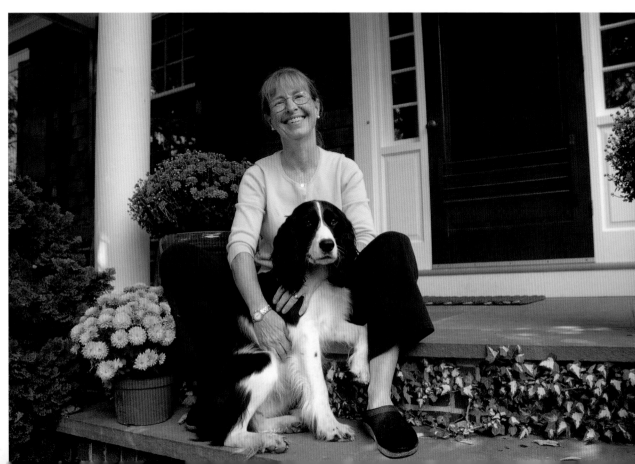

but retains its color and vigor all summer.

In contrast, Kay allows the giant white bell-shaped flowers of *Datura stramonium* L. (jimsonweed) that self-seed from the compost each year to bloom where they may, adding a bright accent to a late-season bed. Around a little bog garden she has built, the huge heart-shaped leaves of *Brunnera macrophylla* 'Variegata' provide contrast and texture long after their tiny blue flowers have faded. And this gardener isn't bothered by the invasive nature of plume poppy (*Macleaya cordata*) because she loves the busy edges and downy white underside of their big-lobed leaves and the way their tall plumes of pale flowers wave in the late-summer wind.

In the soaring wall of evergreens that lines the road is a small opening that offers a glimpse of the landscape within. Passersby often stop to look in and thank Kay for her beautiful gardens. When she recently lost a fabulous Japanese black pine tree to turpentine beetles, she decided not to replace it with another giant species but to let a smaller blue spruce fill the space yet retain a view from the road—evidence of her understanding of the relationship between private and public. As an artist she works in the solitary space of her studio in the intensely personal act of painting. Yet, in order to fulfill its purpose, "to produce for the viewer an emotional response," the work must be offered to the public. As private as her garden is, Kay still strives to share it with those who enjoy its beauty. The world is richer for it.

The Role of Foliage

The feathery Japanese grass *Hakonechloa macra* 'Aureola' (top), a slow-growing deciduous creeper that seems to cascade like flowing water, thrives in full sun to part shade. The color and form contrast beautifully with any number of different hostas. Zones 5–9

The deeply veined purple-pink leaves of Persian Shield (*Strobilanthes*) (middle) have an iridescent quality that brings a colorful accent to shady or partly shady locations. Though perennial in warmer climates, it does well as an annual in Kay's northern garden. Hardy in Zones 9–11

In early summer a flush of rosy pink flowers and coppery new leaves contrast with the chartreuse foliage of goldflame spirea (bottom). This dense, compact shrub, which grows to a height of two to three feet, will thrive in most garden soils and is nearly maintenance-free. Zones 4–9

"After a while every gardener realizes that foliage is the backbone."

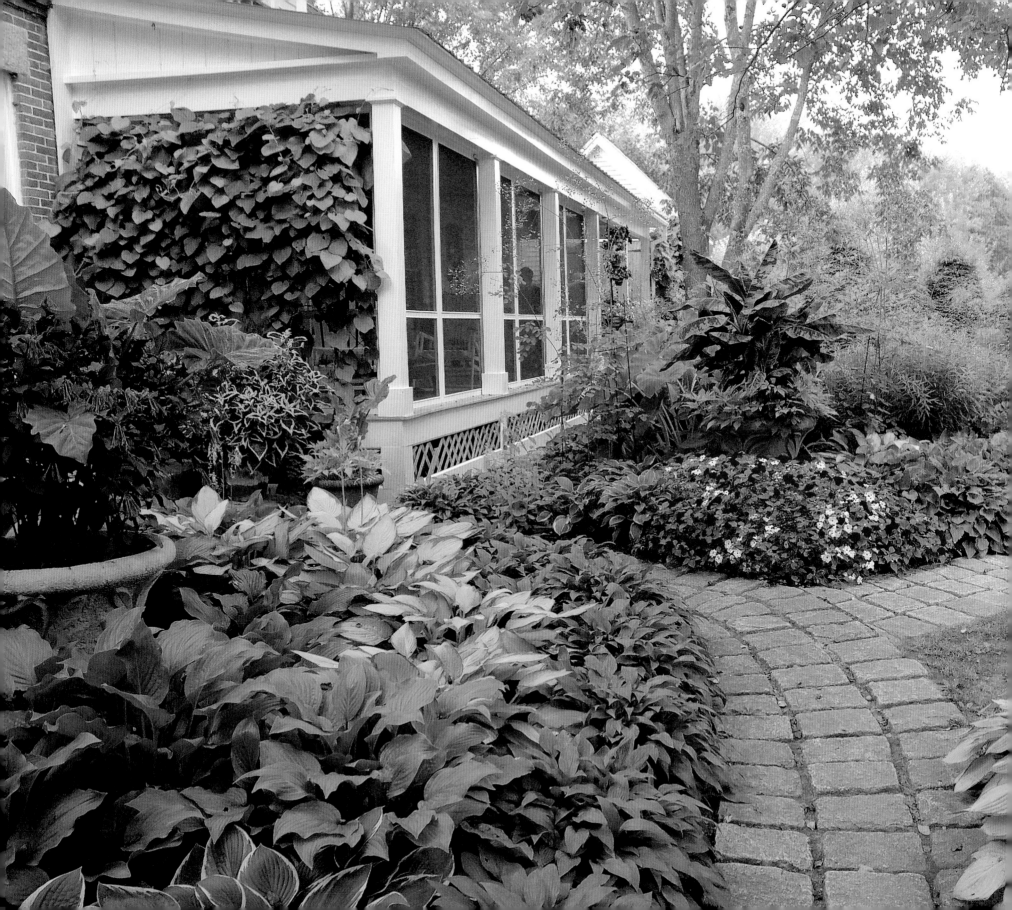

Eric Schottin and Joe Ferigno
celebrating nature

From the road there is no evidence of a garden. What you will notice is a little white Greek Revival farmhouse with a painted wooden sign in the neatly mowed front yard. At the base of the signpost, bright gold rudbeckias bloom amid delicate pink lacecap hydrangeas. In the midafternoon sun the closed blossoms of morning glories (*Ipomoea*) trumpet skyward from their vines. Against the house, massive flower heads of Pee Gee hydrangea glow their green-white of high summer. A handwritten card tucked into the screen door reads, "Give a shout—we're in the garden."

Fryeburg Harbor Antiques & Arts is the relatively new venture of ceramic artist and gardener Eric Schottin and his partner, Joe Ferigno, a painter, interior designer, and educator. The shop, opened in 2003, is a finely tuned mix of antique treasures, expertly upholstered furniture, and Joe's bold and joyful paintings. Exploring the artfully decorated rooms alone would be worth the trip to this tiny town on Maine's western border, but you would miss the best part.

So wander north through the stately stand of Norway spruces undergrown with pagoda dogwoods and great billowing mounds of chartreuse Japanese knotweed in full flower and find the beginnings of the stone footpath. This is Eric's favorite door

into his hidden world—a world that he has spent the last twenty years creating, where nature is celebrated on a grand scale and bravura is its own reward.

An endless variety of scale and texture envelops you the moment you set foot in this magical space. Every bed is a study in contrasts of size, shape, form, tone, and hue made all the more compelling by the sheer numbers of each variety. Where other gardeners might plant a handful of a single plant, Eric plants by the dozen and introduces unlikely pairings with astonishingly beautiful results. Through the growing season, blossoms come and go—some fade and drop; others fall victim to the strong winds and heavy rains of thunderstorms that frequent this area of the state in summer. Yet

LEFT: Stone walkways wend their way through the landscape, creating distinct gardens where Eric has mixed annuals, perennials, and vines in grand-scale compositions.
RIGHT: A pink lotus blooms in the water garden in late summer.

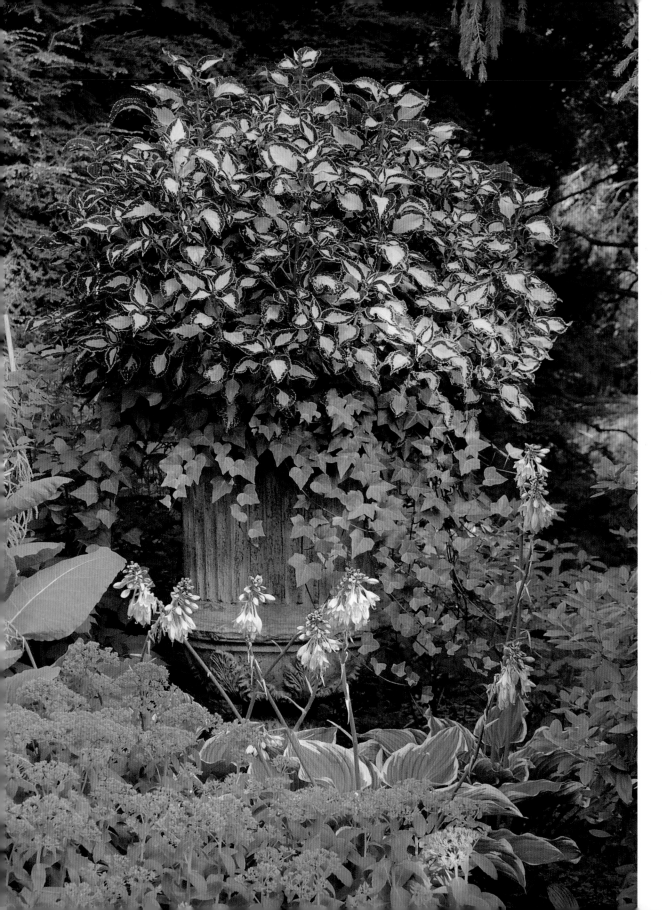

this garden remains a feast for the senses even in the flowerless dead of winter.

It doesn't seem possible that just twenty years ago this ground was barren of all but a few swamp maples. The garden seems much older—it's easy to envision Victorian children playing hide-and-seek among the neat row of hemlocks. The stone paths seem worn down by generations of farmers on their way to the fertile fields of the Saco River valley. Even the little pond dug just a few years ago suggests a long and mysterious history. And the way this garden is bounded on two sides by a feathery wall of Norway spruces and overhung with the many-fingered canopy of pine, maple, oak, and ash sets it in another time. Few discordant sounds of the modern world penetrate this verdant green cocoon.

Considering its young age, this place could be the product only of highly imaginative minds. As art students at Rochester Institute of Technology, Eric and Joe were drawn to the beauty and culture of southern Maine. For Eric, the attraction to the Fryeburg area was visceral—it looked and felt and even

LEFT: By choosing colorful annual foliage, such as this vibrant chartreuse and burgundy coleus 'Saturn', Eric adds focal points throughout the beds and borders. The size of this classical urn is in keeping with the proportions of the overall garden.

RIGHT: Eric delights in mingling the unexpected with the more commonplace. The exotic leaves of giant spade-shaped elephant ears tower over a bed of simple pink and white impatiens. Tall stems of *Eupatorium maculatum* 'Gateway' (joe-pye weed) complete the composition.

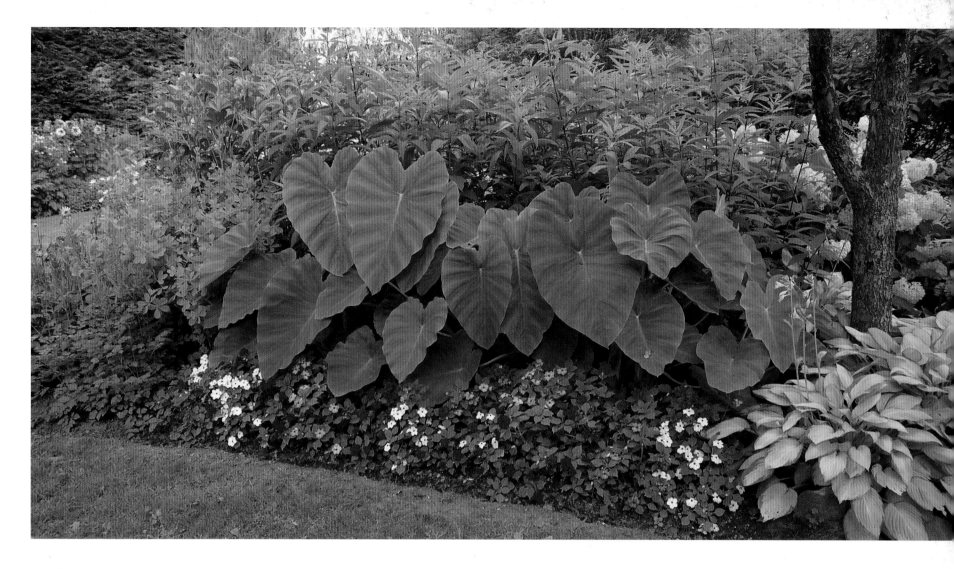

smelled like the vast, open farmland of his native upstate New York. Something resembling this garden was surely in his mind from the first time he saw the land.

The beautiful little brick farmhouse they now call home has undergone significant restoration at Eric's and Joe's skilled hands. Defining the size and shape of the garden was an exercise in discipline. For several years different parts of the fifteen acres were put to varying uses. At one point Eric and Joe planted a large perennial garden

from which they sold bedding plants and freshly cut flowers. But back surgery made it impractical for Eric to spend the time needed to tend the perennials. Most of the original perennial garden was given back to nature, and a self-imposed limit was put on the size of the gardened space—only what could be seen and enjoyed from the porches and windows on the south side of the house.

Measuring only fifty by sixty feet, this space is the ideal counterpoint to the giant species that grow within its bounds. The

leafy outer wall of evergreen is a visual and a mental perimeter—a perfectly sized canvas on which Eric can create the illusion of a long history. Within this leafy tent the effect is complete.

Eric's skill at evoking a sense of history grew out of his first experiences designing gardens for others. Several years ago he was asked to restore the gardens at Tate House, a pre-Revolutionary house museum in the historic Stroudwater district of Portland, Maine. The success of the Tate House garden led to

den cannot help being awed by the grand scale of nearly all the plant life. Eric creates both poetry and drama by punctuating great masses of familiar foliage with bursts of giant and exotic species. Not unlike the Victorian garden designer John Claudius Loudon, Eric displays these beauties in a way that showcases their abstract shapes and startling proportions. In keeping with the Victorian love of trompe l'oeil, the plants at first glance don't quite seem real. A dense, ground-hugging bed of satiny hosta leaves frames a ten-foot fountain of enormous elephant's ear. In urns on the house steps, the same scene is played out with plump purple-pink fuchsias and sage velvet licorice plants (*Helichrysum petiolare*) bowing to the earth as these great spade-shape leaves stretch to the sky. Not to be upstaged, rows of meadow rue (*Thalictrum*) shake their feathery lavender heads above the stone paths in a gentle breeze.

With no formal training in horticulture, Eric relies on his uncanny ability to remember virtually everything he learns about gardening. He puts that knowledge to good use in selecting just the right plant combinations. In early spring Eric scavenges commercial greenhouses for plants that have overwintered. The fact that they have survived untended throughout this long, cold period is a testament to their hardy nature—only the healthiest and most robust plants in the nurseries will take the trip back to Fryeburg. Once transferred to his own greenhouse, Eric can nurture them until it is time to plant

ABOVE: The retail shop, its sign partially obscured in late summer by rudbeckia, Pee Gee hydrangeas, and morning glories, is often the first-time visitor's introduction to this extraordinary property.

RIGHT: From a tiny arrangement of upright stones to a stand of giant white *Actaea racemosa*, each element in the gardens is precisely placed to create the full effect.

six years of living and working at the Marrett House museum, in Standish, Maine, where Eric rebuilt the extensive early-twentieth-century perennial gardens to their original splendor. He credits this work for his in-depth knowledge of uncommon plant species and his skill at designing spaces where these plants conjure a time long past.

First-time visitors to Eric and Joe's gar-

them outdoors. These resilient specimens are used to make the "instant" grand statements that are the hallmark of this garden.

Eric is first attracted by foliage—the soft texture of licorice plant or the deep veining of blue-green hosta 'Mississippi Delta'. Bloom season also strongly influences his choices. The spring view from the upstairs windows shows the puzzle-piece structure of the garden design. But it's late July through August when the gardens are their most spectacular—and when Eric and Joe have the time to enjoy it.

Designing a garden around bloom time is also key to Eric's work as a professional gardener. While he was living at the Marrett House, his work caught the attention of an interior designer who was writing an article about the museum. Word spread quickly of Eric's extraordinary eye, and a business was born. Every summer his skills are called upon to design and update several flower gardens for seasonal residents of an exclusive lakeside community in New Hampshire. Because the owners get to enjoy the gardens for only a brief time during this peak season, Eric emphasizes blossoms over foliage in these designs. Adept at producing immediate results on his own property, Eric knows just how to design the dazzling summer flower gardens that have gained him so much attention and admiration in the region.

But the true secret to the success of his gardens is this: Eric refuses to follow any rules, even self-imposed ones, when he is designing for himself or his clients. He be-

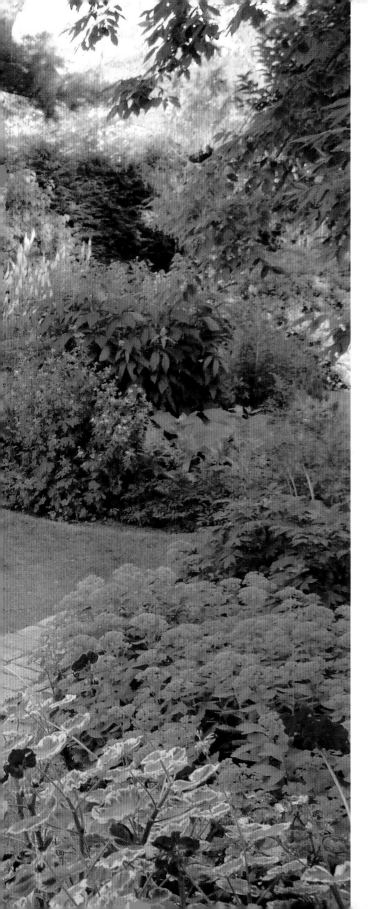

lieves that anyone can be a better gardener by creating something truly personal—a space with no rights or wrongs, no limits. Pink and orange and purple and blue all cohabit harmoniously if the structure, size, and placement of the plants are given priority. Instead of a single coleus variety, Eric plants a crazy quilt of speckled green, tricolor orange, and deep magenta. Then he calms it all with the broad gray-tinged leaves of Hadspen Blue hosta.

As thoroughly thought out as the garden plans may be, they are never drawn on paper for presentation to his clients. Eric's years of experience enable him to envision the final result completely and describe it in detail. His reputation for excellence is all that Eric's clients need.

At home, it works the same way. Joe's participation in the garden ranges from prep work to pruning, but he entrusts the rest to his partner's extraordinary vision. Unlike clients' summer lakeside flower beds, their home garden is vital year-round, so structure is key. In fall when the perennials are cut back, the underlying layout of the beds, borders, and paths forms a tightly knit pattern of

LEFT: A row of conical Canadian hemlocks (*Tsuga canadensis*) defines the back edge of the cultivated space, and a canopy of white pine, maple, oak, ash and hemlock keeps much of the garden cool in this area of Maine that often experiences the state's highest summer temperatures.

arcs and ovals. Lacking their colorful summer companions, rows of arborvitae and burning bush (*Euonymus alatus*) stand in proud formation anticipating the north winds. Oak and ash shake off their leaves to shoulder the inevitable burden of snow and ice to come.

There is little for a gardener to do in western Maine during the six long months of winter. The annuals are just a memory. Which of the perennials, trees, and shrubs will survive until spring remains a mystery for now. The greenhouses have been boarded up, and the new seed catalogs are not yet in the mail. This gardener, however, will not be idle.

From November to March, Eric abandons his garden for the winter warmth of the pottery studio. He was drawn to pottery by the same force that drew him to gardening: the urge to coax beauty from nature's primary element, earth. Nestled in the western wing of Fryeburg Harbor Antiques and Arts, Eric's pottery studio provides him with an outlet for his creative expression during the longest and coldest of Maine's months. The results are stunning.

In contrast to the fleeting nature of summer blooms, pottery is permanent. Perhaps because of this, Eric's approach to the pottery cycle is in direct counterpoint to that of his gardens. His pottery is anything but instant. His elegant forms and sensuous surfaces emerge from a deliberate, methodical, and disciplined process.

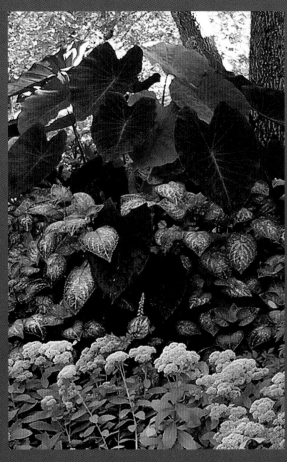

Actaea

(formerly *Cimicifuga racemosa*)

These shade-loving perennials can grow to eight feet in ordinary well-drained soil. Long spikes of tiny, very fragrant white flowers appear in late summer. The textured split leaves of some varieties are deep purple. Hardy to Zone 3.

Elephant Ears

(*Colocasia esculenta*)

The tuberous bulbs of this three- to five-foot tropical plant can grow in northern climates if they are dug and stored for the winter. They prefer shade and rich, organic soil. Show them off as border plants or in large containers. Perennial in Zones 8–10.

Joe-pye Weed

(*Eupatorium purpureum*)

An elegant, long-legged perennial with fragrant flower heads that bloom in late summer. This six-foot beauty, perfect for the edge of woodlands, thrives in moist soil in sun or part shade. Zones 4–8.

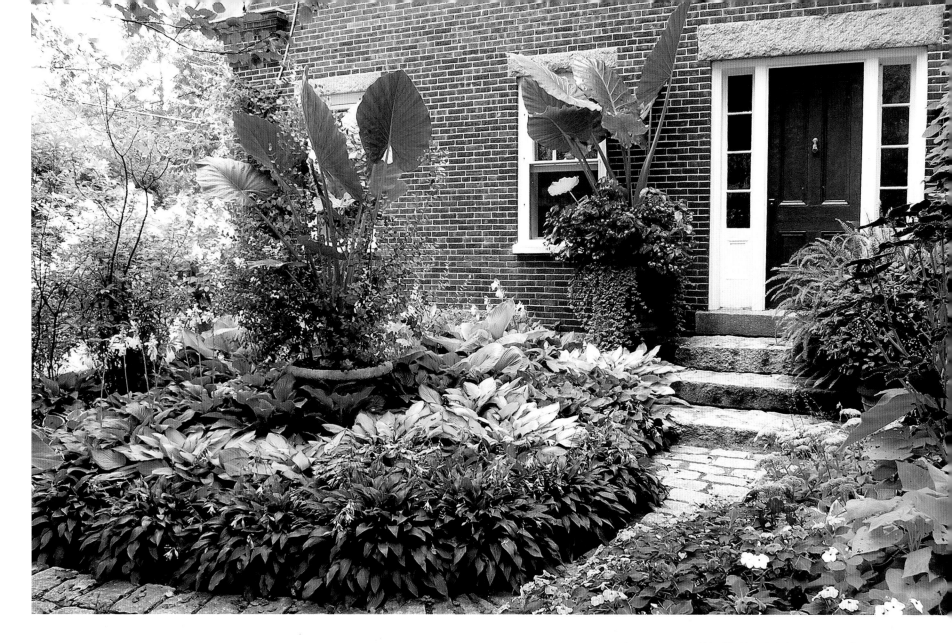

When he begins his winter work, all of the components of the final pieces—clays and glazes—are readily available in the pottery studio, so he purposely does not visualize the final piece until he is well into the process. He will work the clay with no preconceived notion of the object, letting one form lead to another until his hands settle into the rhythm of making. Hands that spend the summer months immersed in soil and mud spend the winter in clay and slip. Whether he produces one grand architectural vase or ten, one perfectly proportioned cup or a dozen, the final form inherits the qualities of the primal elements of earth and fire—beautiful, sensual, and unpredictable.

If something is not thriving or working visually in the garden, Eric thinks nothing of ripping it out and replacing it. In the short summer season he has no patience for

Eric fills the stately urns near the front door with a mix of annuals chosen for their size and habit. This year's choices include elephant ears together with drought-tolerant silvery *Helichrysum* (licorice plant) and coral-pink double begonias as well as upright gray-green eucalyptus.

hanced by layers of glaze. Then, one day in late winter, the building ceases and Eric bisque-fires all of his work in succession. He built the propane-fired downdraft brick reduction kiln to hold approximately a hundred pieces, so the firings go on continuously until all of the work is done.

Spring is spent in pursuit of the perfect surface for each piece. Whether the desired finish is an intense oxide red, a glassy sage-tinged beige, or a matte-patina green, the unfired glazes all look frustratingly similar—thick, chalky pastels. Using a palette of only four colors, Eric sprays layer after layer of this opaque liquid, relying on his years of experience to produce a surprisingly wide range of effects. In the same way that he can envision a client's garden before it is planted, he is able to create a mental image of what the final firing will yield.

mediocrity, so he makes these changes whenever they are called for. But unlike the fleeting summer flower border, his pottery will likely outlive its maker. It is here in the studio that Eric satisfies his desire for cer-

ABOVE: Eric surveys the gallery where he displays pieces produced during the previous winter's pottery season.
RIGHT: The coil-built handle on the lid of a wheel-thrown jar may be Eric's twentieth attempt to get the size, shape, and ergonomics just right, but lift that lid and you understand why no other handle would do.

tainty. In order to impose some controls on the unpredictable nature of clay and glaze, Eric follows a very structured schedule. In early November he begins to build, producing hundreds of pieces that fill the shelves and racks of the studio. Even in the unglazed greenware state, their shapes and proportions are intriguing.

Many pieces will be left untouched for the rest of the season. But some will be treated to exquisite details that may take as long to create as the original form. Eric is enticed by the act of creating marks that add a depth and richness not obscured but en-

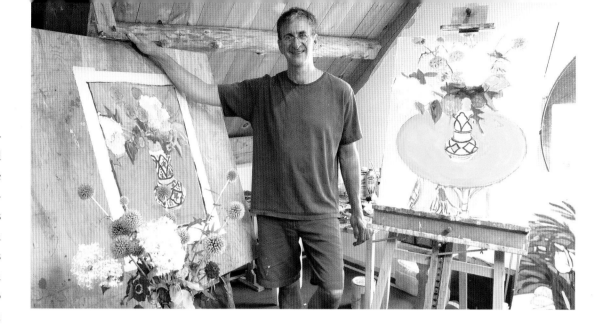

Eric is especially intrigued by how differently glazes can react to one another, and to the heat of the kiln, depending on where they are placed for firing. The movement created by black iron glaze with soda causes tiny dots to bubble up from the surface of an elegant little bowl—a pattern not unlike stars in the night sky. But this happens only on one level in the kiln. If the pot is placed too low in the kiln, the glaze turns mossy green; too high and it goes solid black.

These glaze firings take fifteen hours, each at a temperature of nearly 2,400 degrees Fahrenheit, followed by five days of cooling. This necessary waiting period seems an eternity. When the kiln is finally opened, it still takes Eric a few days to react to the work in its final state. In typical fashion, he chooses only the most extraordinary examples to sell in the shop; he takes a hammer to the rest.

By now it is nearly summer, time to return to the garden and begin the cycle again. Eric will spend the next six months in much the same way as the last six, balancing earth and water, heat and light, the desire for immediacy and the need for patience. But unlike the exquisite stoneware containers from the winter studio, the summer's forms and shapes, colors and textures change from day to day, from year to year, never to be experienced in exactly the same way again. But to one who follows the stone footpath into Eric's hidden garden, the impression is every bit as permanent.

The garden inspires Joe Ferigno to capture its fleeting beauty in paint. Whereas Eric carries his vision and sensibility from garden to studio and back to garden, Joe immerses himself in the moment, bringing broad strokes and fearless colors to his deceptively simple canvases.

With a degree in painting from Portland School of Art (now Maine College of Art), Joe works in cycles, from portraiture to still life to landscape and back. He draws his subject matter from what surrounds him at the time. He borrows the patterns and colors of Morocco or Central America during the couple's frequent travels. He paints landscapes of the farm fields and low, rolling mountains that encircle the town of Fryeburg. The subjects of his portraits are longtime friends and neighbors. His series of still lifes is inspired by each summer's gardens.

Joe works quickly when painting still lifes, layering color on color in expert strokes of the brush. Take too long, and the subjects fade or wilt. The immediacy of the process gives the work its vibrancy and clarity and a certain freshness that can be achieved only with paint. In a matter of moments, Joe places the translucent lavender petals of sweet peas against a field of pale yellow, and the viewer is instantly transported to a moment in midsummer. On another canvas, a brilliantly striped cloth grounds a green glass vase bursting with the spiky heads of variegated dahlias, and the scent of flowers almost fills the room.

Joe's involvement in the living landscape ranges from assisting Eric with design to pruning storm-ravaged foliage. Because Joe is a special education teacher, his schedule grants him free time when the plantings are at their most spectacular. He produces anywhere from ten to fifteen painting of the gardens each year, some of which he sells in the shop or in galleries around the region. Other paintings adorn the walls of their house—a constant reminder that Maine's shortest and most anticipated season is never far off.

creating the tactile garden

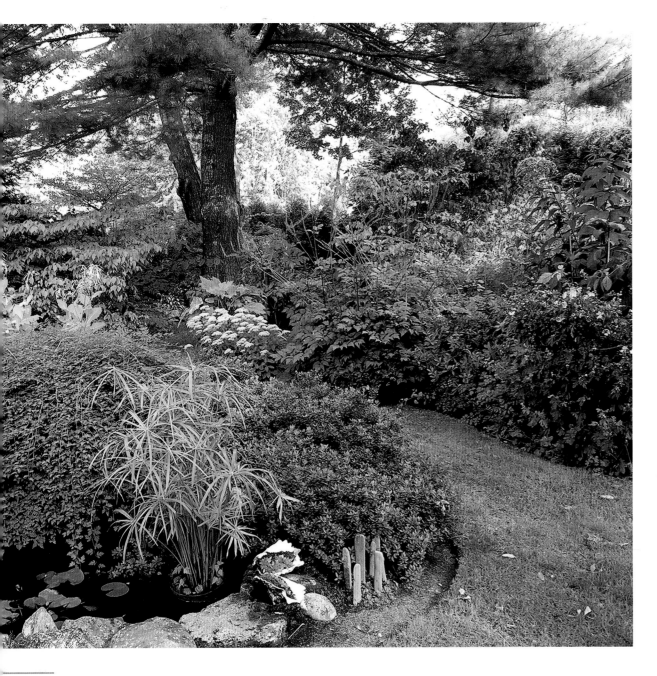

Long after the spring bulbs have lost their riot of colorful petals and the hypnotic scent of Asiatic lilies has faded from the air, Eric's garden remains a true sensory delight. Though color, scent, scale, and form play a major role in the design, the character of this garden stems from the artist's fascination with the power and subtlety of textures. Much as he does in his pottery, he overlays layers of patterns that differ in tone and scale, creating rich and often surprising results that last from season to season. Often gardeners overlook plants that produce unremarkable flowers, but these varieties can possess the qualities that add rich textural and visual balance to a bed or border.

Achieving textural interest in a garden is largely a matter of selecting plants primarily for their structure and grouping them in ways that highlight their characteristics. Leaves, stems, flowers, and seed pods can all possess distinctive shapes and patterns that, when repeated, create areas of tactile interest. New growth on many evergreens has a soft "furry" look and feel. Spiky clumps of ornamental grasses possess uncharacteristically straight lines in comparison to the more curvilinear forms of most other plants.

Although hostas (top) send up flower stalks in late summer, most gardeners plant this species for their low mounds of broad spade-shaped leaves that can created a swath of pattern at the edge of a border.

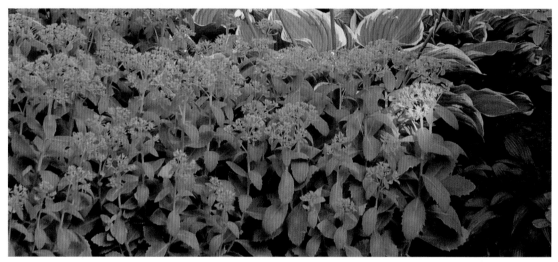

Even before they turn bronzy red in the fall, the wooly flower heads of sedum (middle) invite touch. Some varieties, such as Autumn Joy, remain upright throughout the winter, their forms creating stark silhouettes against the smooth white snow.

By placing an Umbrella Papyrus (*Cyperus alternifolius*), with its fireworks display of bright green, between the small-leafed arching stems of *Stephanandra incisa* and the upright gray-green leaves of *Rhododendron* 'Purple Gem' (bottom), Eric has drawn attention to the textural qualities of all three plants.

Leah Gauthier
sharing the bounty

For a few short months in the summer of 2007, the residents of Lowell, Massachusetts, had a chance to participate in something that, until then, many could not have identified as art. *Tomatoes* was a sculptural installation, a horticultural experiment, and a shared culinary experience—sensually seductive and wholly ephemeral. The "generative sculpture" by conceptual artist Leah Gauthier was the latest in a series of pieces that explore our changing relationship with agriculture.

Over the past several years her work has been concerned with the fleeting nature of the world around us. Feeling that time was passing too quickly, she constructed pieces that strove to slow the process, such as large, nearly figurative "vessels" of autumn leaves whose spectrum of brilliant colors could be experienced even after the season had passed. She worked in this way with a variety of living materials, including grasses woven into netting or installed in intricate patterns that covered gallery walls. But the materials inevitably aged and decayed; in the case of the netting, in its brown state the piece resembled barbed wire, both fragile and ominous. Prompted by a studio mate's observation that Leah was bringing in materials to watch them die, she began to consider approaching her work in a different way.

Lettuce was her first piece that dealt

leah gauthier

with the ephemeral nature of plant life from the other end of the growth cycle. Leah had been cooking since she was a child, and her sensitivity to the smells and tastes of fresh produce attracted her to heirloom varieties that were no longer available through the current U.S. system of industrialized farming. For *Lettuce*, she grew 150 heirloom plants from seeds purchased through Seed Savers Exchange, a non-profit organization dedicated to their conservation. She researched each variety and selected ten for inclusion in her installation. She started the seeds in a sunny location and then transplanted each one to a small metal mesh containers that she designed and built. For the exhibition the containers were suspended on wire

LEFT: The installation of *Lettuce* in this gallery space lasted only one day, but it represented the culmination of months worth of research, planning, planting and nurturing.
RIGHT: In harvesting and preparing fresh heirloom produce to share with event participants, Leah focuses on heirloom varieties that she grows organically.

andrea wenglowskyj

georgie friedman

strung across the expanse of a large gallery at Tufts University Arts Center. The visual impact—the translucent green leaves of the living lettuce against the stark architecture of the gallery space—accomplished only a portion of the artist's intent. The full experience of the piece was realized when visitors to the gallery were invited to harvest and share the

ABOVE: The lettuce varieties Leah grows have the robust flavors she remembers from her youth.
FACING PAGE, TOP: Leah nurtures the Marshall strawberry, once deemed by James Beard to be the most delicious strawberry ever grown, but now nearly extinct due to its incompatiblity with modern farming methods.
FACING PAGE, BOTTOM: A view of *Tomatoes*

lettuce as it was tossed and served in salad. This performance was a variation on Leah's ongoing pieces in which participants engage in preparing and sharing a meal of locally grown produce, an experience that brings into sharper focus their relationship with the foods they eat.

For her first outdoor piece, *Tomatoes*, Leah procured the use of a plot of land at a daycare center through an arts organization called The Revolving Museum in Lowell. She hand-turned the soil in two fourteen-by-sixteen-foot sections, then covered the surface with brown buckwheat hulls. When the tomato seedlings she'd started in her kitchen were large enough to transplant, they were

Lettuce

ripened peaches

of yesterdays ago

drip sweet juicy tears

down the chin

while my blood

runs into yours

through filaments

we can't see only taste

who tends your food

we take copious notes

as if explanations

could heal our wounds

but the scent of each other

grows fainter by the hour

there are histories

beyond what is human

the language of another

thrives in the dirt

i pressed my fingers

into the dark and moist

then felt a knock back

placed in tall cylinders constructed of the same metal mesh she had used for *Lettuce*, and installed in a three-foot grid on the plot. When the plants were still small, the arrangement resembled a piece of modernist sculpture; but as the tomatoes grew, it changed not only the visual but also the social impact of the work. Leah tended the plants weekly, assisted by the local community, who offered growing tips, progress reports, and thanks for her efforts. The exhibition culminated in a cooking and dining event on the final evening, which further built a new and different kind of relationship between artist and audience.

As Leah continues to explore her subject with work that encompasses both space and time, she hopes to expand the audience and the dialogue. In her upcoming piece, *Sharecropper*, she is stitching together a working micro farm from donated growing spaces spread across the five boroughs of New York City. About it she writes, "This work is a personal journey exploring agricultural plant matter, and wild edibles as sculptural material, community building through growing and cooking food, and ways of re-incorporating agrarian sensibilities and simplicity into modern life." With her work Leah offers us an opportunity to join her in the moment, savoring the richness of form and color, and also of smell and taste, that had been our agrarian past but could also be, if we choose, our future.

leah gauthier

mike bacigalupo

"This work is a personal journey . . . re-incorporating agrarian sensibilities and simplicity into modern life."

Acknowledgments

Researching, writing, and photographing this book were possible only with the help and encouragement of family and friends as well as the many artists, gallery owners, gardeners, and others we met along the way. We would like to extend our heartfelt appreciation to all the artists whose gardens are represented here. We feel honored and humbled by how graciously they opened their lives and their homes to us, the extraordinary talent they exhibit in their work and their gardens, and the time and attention they took from their busy lives to indulge our every request.

Heartfelt thanks go to Karin Womer, our dedicated editor at Down East. Special thanks go to Ashley Curry for her research assistance and wonderful photography of the gardens in Connecticut, as well as to Caryn B. Davis, Suzanne Mamet, Geoffrey Stein, Dana Salvo, Glen Scheffer, Andrea Wenglowskyj, Georgie Friedman, Mike Bacigalupo, Jay York, and Roger Birn for their images of gardens and artwork. We would also like to acknowledge Lea Poisson, June Fitzpatrick, Peggy Golden, and June LaCombe for helping us in our research; the Sharon Arts Center for providing valuable information about artists in New Hampshire; and Carol McIntyre for her editing insight. Thank you to Cheryl Michaelsen and Mike LaPosta at the Berry Manor Inn in Rockland, Maine, and to Jim and Carolyn Wagner for making our travels such a pleasure.

From Judy, special thanks go to Michelle Cheung and Kate Kaminski for their mentoring and encouragement through the writing process and to my wonderful husband, Jim Thibault, whose faith in my abilities kept me going long after my own was depleted.

From Nance, a big thanks to my family for all of their continued encouragement, support, and love through many long weeks of travel and shooting. Also, a huge thank-you to my "chosen family," Steve and Mary Dwyer, who were always there with words of support, love, and offers of home-cooked meals.

Bibliography

Bush-Brown, Louis and James
 America's Garden Book. New York, Macmillan, 1996.

Cox, Madison, and Erica Lennard
 Artists' Gardens: From Claude Monet to Jennifer Bartlett
 New York, Harry N. Abrams, Inc., 1993.

DeWolf, Gordon P. Jr., editor
 Taylor's Guide to Perennials. Boston, Houghton Mifflin, 1961.

Gilbert, Alma M., and Judith B. Tankard
 A Place of Beauty: The Artists and Gardens of the Cornish Colony
 Berkeley, California, Ten Speed Press, 2000.

Laws, Bill
 Artists' Gardens. Chicago, Trafalgar Square Publishing, 1999.

Lima, Patrick
 The Harrowsmith Perennial Garden. Ontario, Canada, Camden House Publishing, 1987.

Sgaravatti, Mariella, and Mario Ciampi
 Tuscany Artists Gardens. London, Verba Volant Ltd., 2004.

Tenenbaum, Frances
 Taylor's 50 Best Trees: Easy Plants for More Beautiful Gardens. Boston, Houghton Mifflin, 1999.

Williams, Paul
 The Garden Color Book. San Francisco, Chronicle Books, 2000.

American Hosta Society, www.hosta.org
The American Peony Society, www.americanpeonysociety.org
The National Gardening Association, www.garden.org
Brooklyn Botanical Garden, www.bbg.org
The Plant Press, www.plantpress.com
Help Me Find Roses, www.helpmefind.com